HOW TO WRITE ABOUT CONTEMPORARY ART

HOW TO WRITE ABOUT CONTEMPORARY ART

Gilda Williams

34 ILLUSTRATIONS AND 64 SOURCE TEXTS

Thames & Hudson

Contents

INTRODUCTION

SECTION ONE

The Job Why Write about Contemporary Art? 18

SECTION TWO

The Practice How to Write About Contemporary Art 42

SECTION THREE

The Ropes How to Write Contemporary Art Formats 106

CONCLUSION

RESOURCES

INTRODUCTION

The greatest thing a human soul ever does in this world is to see something, and tell what it saw in a plain way.

JOHN RUSKIN, 1856[1]

1

There is no single 'best' way to write about art

Instinctively we know there is no formula to any kind of writing, so *How to Write About Contemporary Art* seems at first an impossible book title. Even if you follow to the letter every suggestion gathered here, and try earnestly to write well about art, the truth is that anybody who ever succeeded invented their own way. Good art-writers break conventions, hold a few sacrosanct, innovate their own. They measure their limits by instinct, not by rote. Mostly they learn by seeing miles of art, and reading good literature in bulk. There is no substitute, for a writer, for possessing a natural ear for language; a rich vocabulary; a flair for varied sentence structures; an original opinion; some arresting ideas to share. I can teach you none of that. Finally, no book can teach you to love art. If you dislike contemporary art, put this book down right away. It is not for you.

Art in the 21st century—online and off—is experiencing a phenomenal boom, with the demand for written accompaniment raised to fever-pitch. Museum and art fairs boast ever-spiralling visitor numbers and expansions, while new art schools, specialized MA programs, international biennales, commercial galleries, art services, artist's websites, and gargantuan private collections seem to gain ground every day. Every role in the expanding art universe demands its own class of art-copy, whether aimed at artists, curators, gallerists, museum directors, bloggers, editors, students, publicists, collectors, educators, auctioneers, advisers, investors, interns, critics, press officers, or university lecturers. A worldwide virtual audience now absorbs art primarily through on-screen text-and-image, and artworks created by the youngest generation of post-postmodern, post-medium, post-Fordist, post-critique artists require decoding even for specialists.

As the readership swells and the need for communicative art-writing skyrockets, we notice that—although some art-texts are well-informed, imaginatively written, and genuinely illuminating—much contemporary

art-writing remains barely comprehensible. Banal and mystifying art-writing is a popular target for ridicule; scrolling through yards of unfathomable verbosity on *Contemporary Art Daily*—an art-information website with an open-submission policy—I too despair at what passes for plausible art-language. However, having taught and edited art-writing for years, I also hear the strain of raw inexperience behind these indecipherable texts. Odds are these struggling authors have been tossed into the art-writing deep-end without any help in navigating their difficult task: translating visual experience into written language. Make no mistake: for most newcomers, that job does not come easy. The purpose of this book is to provide some guidance to the art-writing novice—and perhaps offer the experienced writer a refresher as well.

In my opinion, contrary to popular belief, most indecipherable art-speak is not written for the purpose of pulling the wool over non-cognoscenti's eyes. On occasion art-impenetralia is penned by a big name, attempting to mask undeveloped ideas behind slick vocabulary or hawking substandard art; but the worst is often written by earnest amateur art-writers, desperately trying to communicate. Art-writing is among this industry's poorest paid jobs; this explains the fault-line running through the art-world, whereby fairly advanced art-writing tasks are assigned to its least experienced and recognized members. The cause of much bad art-writing is not so much pretentiousness, as is commonly suspected, but a lack of training.

Writing well about art is an intensely skilled job, yet even top art-writers' salaries pale next to successful artists' and dealers'. Four digits count as big money on the art-writing circuit. Usually people get what they pay for, and much art-writing is barely remunerated. The writers of the much-maligned and often inscrutable gallery press releases—which to me read like cries for help from the industry's hard-working junior ranks—rarely even benefit from the input of a professional editor. Routinely these raw texts are blithely distributed online in all their first-draft glory. A common misconception can emerge that because some art-texts seem meaning-less—because their writers are wrestling with clear expression—so too must be the art. If there's one single best reason to learn to write well about art, it's because good art deserves it. And sharp art-writing can make art-viewing all the better.

While I cannot correct lopsided pay scales, I can—for the benefit of those attempting this satisfying but underrated task—share everything I know. Having spent a quarter of a century professionally writing, editing, commissioning, reading, and teaching contemporary art-writing, I have reached the following paired conclusions:

Good art-writers, despite countless differences, essentially follow the same patterns:

+ their writing is clear, well structured, and carefully worded;
+ the text is imaginative, brimming with spicy vocabulary, and full of original ideas, which are substantiated in their experience and knowledge of art;
+ they describe what the art is; explain plausibly what it may mean; and suggest how this might connect to the world at large.

Inexperienced art-writers repeat similar mistakes:

+ their writing is waffly, poorly structured, and jargoned;
+ their vocabulary is unimaginative, their ideas undeveloped, their logic flawed, and their knowledge patchy;
+ assumptions are not grounded in the experience of art, which is ignored;
+ they fail to communicate believably the claimed meaning behind contemporary art, or its relation to the rest of the world.

The purpose of *How to Write About Contemporary Art* is not to dictate how you should write, but gently to point out common mishaps, and show how skilful art-writers avoid them. By laying bare successful and weak practices, you might steer clear of poor habits from the start, and set off thinking and writing about art in your own smart style. If that ambition appeals, then this book is for you.

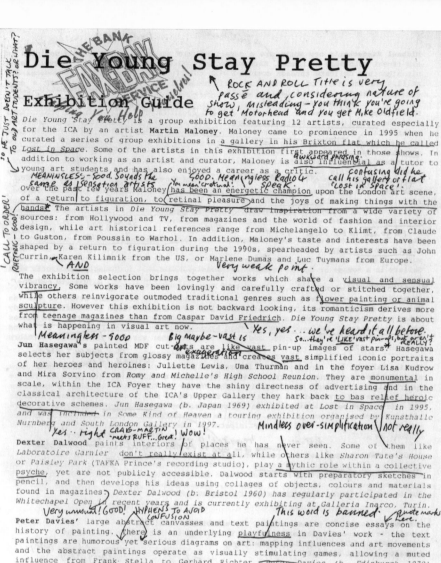

Die Young Stay Pretty

Exhibition Guide

Die Young Stay Pretty is a group exhibition featuring 12 artists, curated especially for the ICA by an artist **Martin Maloney**. Maloney came to prominence in 1995 when he curated a series of group exhibitions in a gallery in his Brixton flat which he called *Lost in Space*. Some of the artists in this exhibition first appeared in those shows. In addition to working as an artist and curator, Maloney is also influential as a tutor to young art students and has also enjoyed a career as a critic.

Over the past few years Maloney has been an energetic champion upon the London art scene, of a return to figuration, to retinal pleasure and the joys of making things with the hands. The artists in *Die Young Stay Pretty* draw inspiration from a wide variety of sources: from Hollywood and TV, from magazines and the world of fashion and interior design, while art historical references range from Michelangelo to Klimt, from Claude to Guston, from Poussin to Warhol. In addition, Maloney's taste and interests have been shaped by a return to figuration during the 1990s, spearheaded by artists such as John Currin, Karen Kilimnik from the US, or Marlene Dumas and Luc Tuymans from Europe.

The exhibition selection brings together works which share a visual and sensual vibrancy. Some works have been lovingly and carefully crafted or stitched together, while others reinvigorate outmoded traditional genres such as flower painting or animal sculpture. However this exhibition is not backward looking, its romanticism derives more from teenage magazines than from Caspar David Friedrich. *Die Young Stay Pretty* is about what is happening in visual art now.

Jun Hasegawa's painted MDF cut-outs are like vast pin-up images of stars. Hasegawa selects her subjects from glossy magazines and creates vast simplified iconic portraits of her heroes and heroines: Juliette Lewis, Uma Thurman and in the foyer Lisa Kudrow and Mira Sorvino from *Romy and Michelle's High School Reunion*. They are monumental in scale, within the ICA Foyer they have the shiny directness of advertising and in the classical architecture of the ICA's Upper Gallery they hark back to bas relief heroic decorative schemes. *Jun Hasegawa (b. Japan 1969) exhibited at Lost in Space in 1995, and was included in Some Kind of Heaven a touring exhibition organised by Kunsthalle Nurnberg and South London Gallery in 1997.*

Dexter Dalwood paints interiors of places he has never seen. Some of them like *Laboratoire Garnier* don't really exist at all, while others like *Sharon Tate's House* or *Paisley Park* (TAFKA Prince's recording studio), play a mythic role within a collective psyche, yet are not publicly accessible. Dalwood starts with preparatory sketches in pencil, and then develops his ideas using collages of objects, colours and materials found in magazines. *Dexter Dalwood (b. Bristol 1960) has regularly participated in the Whitechapel Open in recent years and is currently exhibiting at Galleria Inarco, Turin.*

Peter Davies' large abstract canvasses and text paintings are concise essays on the history of painting. There is an underlying playfulness in Davies' work - the text paintings are humorous yet serious diagrams on art: mapping influences and art movements and the abstract paintings operate as visually stimulating games, allowing a muted influence from Frank Stella to Gerhard Richter. *Peter Davies (b. Edinburgh 1970) participated in exhibitions at Lost in Space in 1995 and in Sensation at the Royal Academy in 1997.*

Gary Webb's futuristic sculptures use materials and surfaces reminiscent of 60s and 70s design. They possess a bizarre power: curious conjunctions of surfaces, colours and materials jostle with each other sometimes literally as in the kinetic sculpture *I Love Black Music* that greets visitors at the entrance of the Lower Gallery. At times they have an improvised feel which is at odds with their laborious production and their physical delicacy. *Gary Webb (b. Brighton 1973) had a solo show at The Approach Gallery earlier this year.*

fig. 1 <u>BANK</u>, *Fax-Back (London: ICA)*, 1999

2

'International Art English'

In the summer of 2012, the website *Triple Canopy* published a controversial essay titled 'International Art English: On the Rise—and *the Space*—of the Art-world Press Release' by artist David Levine and Alix Rule, a sociology PhD student.[2] In a bid to provide a scientific analysis of the linguistic quirks of what they dubbed 'IAE' ('International Art English'), the pair computer-fed press releases collated from the online art journal *e-flux*, and discovered such IAE tics as:

+ habitually improvising nouns (*'visual'* becomes *'visuality'*);
+ hammering out fashionable terminology (*'transversal'*, *'involution'*, *'platform'*);
+ abusing prefixes, with *para-*, *proto-*, *post-*, and *hyper-* leading the pack.

Levine and Rule's exposé was met with applause from some camps, but some insiders were skeptical of both its methods and results, and a heated debate ensued.[3] Poking fun at substandard gallery press releases was viewed by many as easy target-practice. Levine and Rule's 'outing' of contemporary art's dense verbiage illuminated an art-world curiosity that had, in fact, been a running joke for years. In a project called *Fax-Back* (1999; fig. 1) the British artists' collective BANK returned abysmal press releases to the guilty galleries, complete with corrections and comments ('Totally meaningless sentence. Well done!'). Aficionados and laypeople alike had grown wearily accustomed to the white-noise murmur of art-gibberish (which enlivened the 'Pseud's Corner' section of magazines from *Private Eye* to *Flash Art*), and instinctively diverted their attention to the smart art-writers also at work.

This bemused tolerance for the silliest art-writing may now have reached an endpoint; in the wake of *Triple Canopy*'s 'International Art

English' smear, it seems open season has been declared on pretentious writing. [4] In an *Artforum* book review responding to a pair of recent books on curating—two well-respected tomes from reputable publishers and written by professionals, not gallery print-outs by entry-level enthusiasts—critic and historian Julian Stallabrass lamented the 'thick and viscous vocabulary' he found there, rewording some sentences in plain English:

> For instance, here is [the] concluding section: 'Exhibitions are a coproductive, spatial medium, resulting from various forms of negotiation, relationality, adaptation, and collaboration between subjects and objects, across space and time.' Rough translation: people work together to make exhibitions using objects. They exist in space and time. [5]

Stallabrass's Dick-and-Jane rewrite, 'people work together to make exhibitions using objects', leaps from the page as the plain-speaking language conspicuously absent from much art-writing. The chorus of complaints about off-putting art language, coupled with the flourishing of specialist MA courses, [6] suggests that the field may be poised to attract the scrutiny that curating earned in previous decades. The professionalization of the art-world could hardly leave its writers and critics behind.

My purpose here is not to join the ranks of the anti-'International Art English' brigade, and mock the dialect's familiar features: a preference for complex sentences stuffed with specialist terms where a few simple words would do; the forced servitude of ordinary words like 'space', 'field', and 'real' to assume convoluted, alien functions; and a baffling disconnect between what we *see* and what we *read*. My aim is to offer practical advice to escape the IAE cul-de-sac. This book is *not* a bluffer's guide to artspeak. Bad art-talk (like bad music-speak, or clichéd movie-talk, or faked literary theory) can be mimicked in seconds, mastered in an afternoon. Instead, *writing about art plausibly, succinctly, in an enjoyable and believable manner, demands some thought and effort.* My aim here is to focus on the happier examples, whether academic, historical, descriptive, journalistic, or critical, to show how they succeed and help you to learn from them.

This book includes extracts that range from a short 19th-century treasure to a Walter Benjamin extract from 1940, to texts from the 1980s

and 1990s; but the chief focus is on recent examples. *How to Write About Contemporary Art* is not a compendium of 'best-ever' art-writers. Many excerpts are not by art-critics, but historians, academics, curators, journalists, novelists, bloggers, even a fashion writer, in texts published in magazines, books, and blogs. By including a broad range of examples, it offers a sampling of viable approaches, accompanied by short analyses. I adopt the term 'art-writer' for anyone tackling art as their written subject—partially, as a short-cut to avoid the streams of prefixes ('artist/dealer/curator/critic/blogger/"Kunstworker"/journalist/historian', see page 26) otherwise required to describe polyvalent art specialists today.

There is no uniformity of approach in the examples gathered here, which vary from politics to the artist's biography; studio methods; form and materials; the market; sociology; personal reflection; philosophy; poetry; fiction; art history, and more. Plenty of the finest art-writers—Yve-Alain Bois, Norman Bryson, T.J. Clark, Douglas Crimp, Geoff Dyer, Hal Foster, Jennifer Higgie, David Joselit, Wayne Koestenbaum, Helen Molesworth, Caroline A. Jones, Lucy Lippard, Pamela M. Lee, Jeremy Millar, Craig Owens, Peggy Phelan, Lane Relyea, David Rimanelli, Ralph Rugoff, Anne Wagner, and other notables—are absent. Discover your own 'best'. Like them, you will have to determine your own role in and angle on the art system. Good writing is good writing whether published in ink or online. (However, given that so much Internet-based commentary can be endlessly modified or deleted, often just vanishing into thin air, future art historians will struggle to find the range of texts that accumulated around a 21st-century artist's work—a disappearing act that is cause for concern for serious researchers.) My idea is to celebrate good art-writing rather than chime in about the bad, offer some basic advice to those just starting out, and maybe liberate a new generation from believing they must be leaden to be taken seriously. The finest art-writers enjoy their work; they love art, and their pleasure—emotional, intellectual, visual—multiplies when writing about it.

Section One looks at the myriad purposes for art-writing, and a brief history of art-criticism in relation to shifts and expectations today. Section Two is a 'how to', listing the most common pitfalls as well as offering problem-solving techniques. Section Three concentrates on particular formats—academic essays, museum website entries, reviews—and delineates

the tone and content usually expected for each, relaying some tested strategies and options, ending with a selection of comparative examples about one artist, American painter Sarah Morris. I look at short extracts, often by legendary critics, but plenty are less starry examples, in some instances competent, basic-level art-writing aimed at a general readership. The final Resources section suggests key magazines, blogs, and books for building a contemporary art library, so you can read and learn more; and lists some essential grammatical rules of the English language—still the art-world's *lingua franca* (but for how much longer?).

For the very green, my 'good' specialist examples may be as tough-going as the 'bad'. Art-writing is specialized, and some formats require fluency in terminology and proximity to current debate. This contrasts heavily with garden-variety 'International Art English' blather, which leaves both the outsider and the art expert in stitches. Novice art-writers (like inexperienced readers), despite their good intentions, can genuinely struggle to distinguish between tangled, unsubstantiated platitudes and a lucid, flawlessly argued editorial by their hero/heroine, be that Dave Hickey or Hito Steyerl. Good art-writers can enhance art's complexity: clearheaded writing should not be confused with oversimplification. This book aims to help you discern the difference, but does not advocate that all art-writing be geared toward the average open-minded kindergartner. If you are not yet fully conversant in contemporary art, that's OK; the 'how to' section of this book begins with a focus on basic-level formats, such as academic essays and short descriptive texts, usually encountered by the newcomer.

Nonetheless, a paradox haunts this book: *How to Write About Contemporary Art* is an introductory primer for an intensely specialized and complex job. Seasoned critics penning the more advanced art-writing texts included here (such as newspaper reviews and op-ed journalism) don't just write well. They *raise the best questions* and *make the most pointed observations*, skills drawn from an unquantifiable combination of experience, wisdom, and curiosity—qualities not acquired by reading 'how to' books. Notice too, in the best examples, how the author's sheer imaginative verve brings the text and the artworks to life.

Intuition tells me that the most fertile new art-writing ground may be that currently being charted at the fringes—such as art-related fiction

both *about art* and behaving *as art*; or philosophy at the intersection of art and literature—yet these daring examples are the least represented here. Any attempt to roadmap this experimental territory would be absurd; a hypothetical chapter 'How to Write Critico-Fiction' (as this new genre is sometimes called) would be the art-writing equivalent of 'How to Make Art'. Discover and experiment with these variants yourself. [7] Moreover, I have come to the conclusion that, weirdly enough, much contemporary art-writing is probably not actually meant to be read—much less scrutinized—at all, but fulfills mostly ritualistic purposes. 'I don't care what they write, only that they write *something*,' one artist friend confided to me. In the words commonly attributed to Andy Warhol, 'Don't pay any attention to what they write about you. Just measure it in inches': a marvelous but devastating comment for an art-writer of any stripe.

3

Anyone can learn to write competently about art

Just as anyone can learn to draw competently, anyone can learn to write about art. Learning to draw takes practice (daily, if possible), and the gradual understanding that you must *draw what you see, not what you think you see*. Drawing is about *understanding visual experience*, not mechanical skill. The same is true with art-writing. This requires practice (daily, if possible), and entails *writing what you see*, using the process of writing to understand art.

Begin by concentrating on the art. Help yourself by learning about how artists work and how art is seen. Keep your language varied, but straightforward. Exert your imagination. Enjoy yourself. Edit your texts ruthlessly. Look at the art for yourself, with curiosity. Learn as much as you can; write only what you know.

SECTION ONE

The Job
Why Write about Contemporary Art?

'Art-criticism, like art, should furnish something more and better than we can expect from life without it. What might that be?'

PETER SCHJELDAHL, 2011[8]

Why write about art? What can an art-text 'say' that an artwork, on its own, cannot? 'The aim of all commentary on art now should be to make works of art [...] more, rather than less, *real* to us', said critic Susan Sontag in the 1960s,[9] and this may be a good place to start.

The first rule for good art-writing might be the attempt, sincerely, to render artwork more meaningful, more enjoyable, attaching 'something more and better' to art and life (Schjeldahl) than without it.

Bearing in mind this simple brief—when writing, try to add 'something more and better'—might steer you on to a happy path right from the outset.

Notice that, in the opening quote to this section, *The New Yorker* senior critic Peter Schjeldahl refers to art-*criticism,* whereas the lion's share of contemporary art-writing today is not fully defined that way. Although not mutually exclusive, myriad non-critical new forms have joined traditional criticism in this menagerie:

+ museum website texts and audios
+ educational tools (for every demographic)
+ museum brochures
+ grant applications
+ blogs
+ extended captions
+ newspaper clips
+ glossy magazine shorts
+ collection blurbs
+ online art journals.

These exist side-by-side with the steady production of conventional formats:

+ academic and art-historical papers
+ newspaper articles
+ display panels

+ press releases
+ magazine articles and reviews
+ exhibition catalogue essays
+ artist's statements.

The initial distinction for an art-writer to make is between text that *explains* art (often, 'unsigned'), and text that *evaluates* art (often 'signed'). This distinction is blurry, but it is imperative that you consider this difference as you embark on your writing.

1

Explaining v. evaluating

Become aware of these two basic art-writing functions: *explaining* (contextualizing and describing) and *evaluating* (judging and interpreting) art. Some art-writing formats demand that you stick solely to one, but many overlap and require that you administer a dosage of each—such as the solo-exhibition catalogue text, in which details of an artwork are described (*explained*) in terms of their importance within contemporary art history (*evaluated*).

'Explaining' Texts

+ short news articles
+ museum wall captions
+ web collection entries
+ press releases
+ auction catalogue entries

Traditionally, 'explaining' texts were left unsigned. This voiceless anonymity is a fiction; there is always a flesh-and-blood person (or committee) with tastes and preferences coloring the 'objective' views implied by unsigned words. For example, even without a label, an artwork held in the collection of a world-renowned museum, purchased with state funds and on public display, speaks of opinionated value judgments. Increasingly, traditionally authorless texts are turning up with a named writer attached—such as museum labels bearing the author's initials, or press releases signed by curators or artists.

All texts are partisan and never truly objective, always penned by opinionated individuals or teams, whether signed or not.

Nonetheless, when producing a mostly 'explaining' piece you are usually asked to put your personal prejudices aside, and distill the most essential factual and interpretative information that you have researched, including:

+ artist's statements;
+ verifiable background information, gleaned from critics, historians, curators, gallerists, and others;
+ recognized themes or concerns observed in the art.

'Explaining' texts are meant to assist anyone approaching the work, whether for the first time or for the hundredth. You, the writer, are not asked to speculate excessively on its meaning, much less presume the viewer's reaction. 'Explaining' texts usually succeed when facts and ideas are communicated plainly, and specialists and non-specialists alike find them informative—rather than incomprehensible or patronizing.

A quote from an artist (or from a curator, or anyone else) is not a 'fact' for its content. **It is only a fact that the artist *said those words*;** its message might be perfectly outrageous. The artist may state his or her intentions, but we can question that self-appraisal, or ask whether these intentions are observable—or perhaps surpassed, or redirected, or negated—in the resulting art.

'Evaluating' Texts

+ academic assignments
+ exhibition and book reviews
+ op-ed journalism
+ magazine articles
+ catalogue essays
+ grant, exhibition, or book proposals

'Evaluating' texts are usually signed. Such authored texts—literally bearing your name, as their author—should not merely provide knowledgeable information but delineate a singular, substantiated opinion or argument. 'Having an opinion is part of your social contract with readers', is how Peter Schjeldahl describes the pact between himself and his readership.[10] You need to gather accurate information, and then tell your reader what you think, and why. You need to take a risk. This may entail posing astute questions, then attempting to answer them—perhaps prompting further, more penetrating questions. In an evaluating text, you are not merely encouraged to take some interpretative leap but positively compelled to do so. As *The Nation*'s Barry Schwabsky puts it, 'You must be putting to the test, not just the artwork, but yourself in your response to it'.[11]

Fledgling art-writers can fail to recognize the crucial difference between a principally 'explaining' text, and an 'evaluating' one. This confusion may account for at least two common art-writing calamities:

+ the rambling 'conceptual discourse' attempted in a news-oriented gallery press release;

+ a 'review' composed of little more than a descriptive list of the artworks, perhaps couched within the curator's mission statement.

The dividing line between 'explaining' and 'evaluating' is vital to grasp but, in practice, porous. Moreover, a fiction or poem that adopts the artwork as a springboard to launch the writer's unbridled imagination might not set out to accomplish either 'explanation' or 'evaluation'. Much contemporary art-writing is a hybrid:

+ **a skilful newspaper exhibition review** must explain to the layman the nuts-and-bolts while offering probing insight for the artist's dedicated followers;
+ **opinionated journalism** that evaluates art-industry behaviors must be upheld by convincing arguments that are clearly explained;
+ **a 'factual' museum label** may be supported by a skewed selection of evidence; its 'objective' voice concealing deep-seated ideological undercurrents and value-judgments;
+ **a catalogue essay** will often both explain the details of an artwork's fabrication and history, and propose terms for its positive evaluation;
+ **an 'explaining' news brief**, written by a thoroughly opinionless reporter who has culled 'evidence' from a gallery press release, might be as factual as a Disney feature;
+ **a magazine such as _e-flux journal_** straddles art-critical and academic styles, pulling in historical and statistical information to support highly biased opinions;
+ **an 'unopinionated' press release about an unknown talent**, which may constitute that artist's first-ever text, may be written by a struggling young gallerist who is taking more real risks—personal and financial—than an art-critic typing up her opinion after a brief gallery visit.

Even so, 'explaining' and 'evaluating' art remain the two poles of the job, and, traditionally, distinguish _art-criticism_ from any other type of art-writing.

2

Art-words and artworks

Why the volumes of art-texts, anyway? As I mentioned in the Introduction, audiences are widening, and levels of contemporary-art preparation vastly diverge. The most common defense for contemporary art-writing, critical or not, is that new art is unintelligible without the rescue of a written or spoken explanation. 'My task as a critic is to provide the context my readers need to get much out of [art] at all',[12] the late critic and philosopher Arthur C. Danto once wrote, summarizing this basic assumption: unfamiliar new art is mystifying without the provision of a *context*, which can be provided by the artist or another specialist art-writer, such as a curator, academic, or critic.

The expectation for artwork to gain meaning thanks to context—a pivotal contemporary-art concept and one revised countless times, particularly since the 1960s—originates for some in Marcel Duchamp's invention of the readymade, about a century ago.[13] When in 1913 Duchamp kidnapped ordinary objects (a bicycle wheel, bottle rack) and forced them to perform as art in a gallery, viewers could appreciate these unconventional sculptures only when supplied with a special nugget of information: that readymades qualify as art because they express a radical artistic gesture, not because they are finely wrought feats of craftsmanship. To judge Duchamp's signed urinal solely on centuries-old standards of measure (shape, color, subject matter, technique) was suddenly untenable. Supporters of avant-garde art across the 20th century also required new words:

+ readymade
+ abstract art
+ Minimalism
+ Conceptual art

+ Land art
+ time-based media.

Theorist Boris Groys has suggested that art-writing provides artworks with 'protective text-clothes': as if, without the cloak of written explanation, unfamiliar artworks enter the world naked, demanding to be dressed in words.[14]

Unlike ancient objects, recent art does not beg a written explanation because its distant meaning has dimmed over time,[15] but in order for viewers to tap into an artwork's conceptual or material entry points, and appreciate its contribution(s) to contemporary culture and thought. Since the advent of Modernist art, we assume that important new art—almost by definition—resists instant disclosure. Many cherish art as a special haven within an over-schematized world, where ambiguities can thrive.

If an artwork's message is self-evident, maybe it's just an illustration, a decorative non-entity, a well-executed craft object, hardly counting as 'significant' art at all. It's not just that without an explanation the viewer is lost; without some written framework to steady it, the art itself risks losing its way, never gaining traction in the contemporary art system. From this perspective, both viewer and artwork alike are as if handicapped without the art-words' special assistance. As curator Andrew Hunt writes, it may even seem that contemporary art is *completed* through criticism[16]—for better or worse, since many artists and other art-lovers resent art's quasi-reliance today on the written word.

In this scenario, an art-writer is a conduit, possessing specialist information that enables her to link unfamiliar artworks to a curious audience and pin down an artwork's potential meanings. An artist knows how and why she made it. Veteran art-critics have seen heaps of contemporary art over years, are in conversation with the artists, and may even make art themselves.[17] Rarely, if ever, is worthwhile art-writing produced from ignorance.

To write well in any art-writing format, the more you know and look, the better your writing will be.

3

Artist/dealer/curator/critic/blogger/'Kunstworker'/ journalist/historian

For art-writing to add 'something more and better' to art,[18] readers must trust their author. Museum wall labels once stood guard dependably next to an artwork, unassailably expressing the expertise of the august institution behind them; that implicit authority has today gone the way of the velvet-lined display case. To avoid the 'tombstone-label' effect, some museums offer multiple interpretative panels for a single work—a tactic with a potentially detrimental effect, alienating and confusing inexperienced gallery visitors rather than 'opening up discussion'.

In contrast to the often unnamed writer (frequently a curator and/ or communications officer) of these 'unsigned' labels, the art-*critic*—who emphatically attaches her name to her art-words—must repeatedly demonstrate that she is a reliable informant. Critics lose credibility if we suspect that they are ill-prepared, rushed, or—worst of all—picking favorites for private gain. 'You don't buy art and you don't write about your best friends', says *New York Times* critic Roberta Smith regarding her own self-imposed ethical restrictions.[19] Any partiality must, at least, be openly disclosed:

+ the artist or curator is the critic's wife, boyfriend, best pal, student, teacher, or other close associate;
+ the critic works or has worked for the gallery or museum;
+ the critic (or her family) owns *a lot* of this guy's stuff.

Private collection or auction catalogues may strain to sound objective but they hold great stake in the value of artworks, and are never impartial. Publicity or marketing material—from a gallery, a private collection, or an exhibition—must never be mistaken for 'criticism'. By definition, and however disguised as 'neutral' commentary or factual art history, such texts always serve a promotional purpose: to entice, publicize, and—often—sell.

The Frieze flip

Once upon a time, the art-world assiduously guarded against conflicts of interest; but the lines across the commercial, critical, academic, and public sectors are steadily eroding. Art-workers now move fluidly across the old divides, crisscrossing commercial/critical or private/public lines in a single career, and often devising new roles. A case in point is the role of Frieze as both a critical authority, publishing the eponymous specialist art magazine since 1991, and as an economic stakeholder, organizing massive art fairs in London since 2003 (and in New York since 2012). This schizophrenia may not seem more troublesome than the balance that magazines have always struck between review-content and advertising revenue, but Frieze's chiasmic identity split was unprecedented.[20] The conflict was perhaps lessened with the fairs' inclusion of a respected talks program (adopted from some existing art fairs, such as ARCO Madrid) and well-curated artists' projects, returning the Frieze brand to critical content.

In practice, Frieze's two-pronged identity may emblematize the figure/ground inversion of art-world priorities. On the printed page of the magazine, art commentary and criticism hold center stage while the ads huddle mostly near the exits, the front and back covers. In the Big Top at the fair, the spotlight shines on the private galleries, and critical reflection from guest speakers is pushed to the edges: a class act, but a sideshow. Frieze's critical/commercial inversion—from the magazine's founding in the early 1990s to its first London art fair in the early 2000s—might endure as a lasting symbol of the broader market-driven makeover across the art-world at the turn of this century.

One job that art-writing remains oddly unable or resistant to assume openly is the declared selling of art. Even publications plainly functioning as sales devices—auction catalogues, or the *Frieze Art Fair Yearbook*—commission texts cloaked in a language unlike that of any other sales brochure. This may partially account for the permanent identity crisis suffered by the gallery press release—disparagingly described by artist Martha Rosler as 'a long-form piece of advertising copy, with embedded key words'[21]—unable just to scream *'New! Bigger and shinier than ever!'* or *'Sale! Everything must go!'* For even the most unabashed commercial pitch—whose *admitted* purpose is to sell—to succeed, it must mimic the voice of serious art-criticism, unbought and unbiased. This may explain why new art-writing alternatives (fiction, journalism, diary-writing, philosophy) have recently gained appeal in some camps over straight art-criticism, which can sound like a dead ringer for the art-world's uniquely veiled style of sales pitch.

The art-critic as fully impartial, free-wheeling, and incorruptible independent, staking out uncharted ground with each ripping new text, remains a popular myth. The critic 'doesn't work for the Man' is how longtime art-world mascot Dave Hickey put it,[22] summing up the lone-wolf image of the job: the hero/heroine who 'asks hard questions that boosters may not want to hear', as *Art in America* contributing editor Eleanor Heartney asserts.[23] However, much run-of-the-mill art-writing that does not qualify as criticism—such as promotional blurbs from the commercial galleries, or private collection websites—is probably where this chorus of boosting is sung the loudest.

The old-school picture of the critic as a solitary crank, working feverishly as the impoverished good conscience of the art-world, is wearing thin. The hard-working single-minded critic of the past, 'armed with little more than her or his well-tuned sensibility, facing off against a similarly delimited object, a framed artwork', now must don many hats, building multiple links and circulations in order to operate, writes Lane Relyea in 'After Criticism' (2013).[24] Along with responding to artworks, a front-running 21st-century art-commentator chases the ever-shifting goal-posts of the art-world, reporting back with eye-witness accounts from the front line: the Biennale rush, the art-fair hangover, the pub conversation

after the symposium, the auction buzz. New printed publications and online magazines emerge, and demands for art-writing in the burgeoning art-industry multiply: for MA program web-pages; squeaky-new art services and consultancies; purpose-built private museums; art-specialized public relations companies, funding bodies, and investment firms; 'alternative' art fairs and summer schools. The best art blogs have proven adept at creating less self-conscious, unprecedented art-writing forms that chronicle a life spent on the art circuit, combining several formats:

+ journal-writing
+ art-criticism
+ gossip
+ market news
+ news-oriented journalism
+ interviews
+ opinionated editorial
+ academic theory
+ social analysis.

The successful 21st-century art-writer is publicized (or self-publicized) as a fully immersed jack-of-all-trades. Pablo León de la Barra[25] is described as an

+ exhibition maker
+ Kunstworker
+ independent curator
+ researcher
+ editor
+ blogger
+ museum/art fairs/collections adviser
+ occasional writer
+ snap-shot photographer
+ retired architect
+ aesthetic dilettante
+ *and more*.

Artist/critic/dealer John Kelsey—who prefers to describe himself as a 'hack', 'fan', and 'smuggler' rather than use the staid term 'critic'—has simultaneously figured in the magazines as advertiser, reviewer, and reviewee. Kelsey has suggested that art-criticism must invent 'new ways of making itself strange', perhaps corrupting its cloistered social position even at the risk of 'losing the proper distance from the object' and operating at the very center of the business transaction, both to prevent obsolescence and reassert criticism's ethical influence.[26] As an inspiring precedent for today's multi-tasking art-critic, Kelsey recalls (among others) the 1960s–70s Italian art-critic/poet/translator/journalist/novelist/actor/ filmmaker Pier Paolo Pasolini, who was able to adopt an incisive voice across multiple intersecting roles. For Kelsey the risk for the 21st-century critic is that—like so many of today's jobless—he will paradoxically become unemployed and be working *all the time*.[27] Frances Stark—another among the best-known of today's artist–writers, a list that includes Liam Gillick, Seth Price, Hito Steyerl, and others—suggests that critics should finally admit that their traditional job of understanding art forms is being phased out, replaced by tracking the complicated behaviors of a relent-lessly shape-shifting art industry.[28]

fig. 2 <u>LORI WAXMAN</u>, *60 wrd/min art critic,* 2005–ongoing.
Performance as part of dOCUMENTA (13), June 9–September 16, 2012

In fact, the age-old demand for art-writers—often the artists themselves—to verbalize how an art-object or -process might carry meaning still persists. In the summer of 2012, when *Triple Canopy*/Levine and Rule were reporting on the sorry state of the gallery press-release (see 'International Art English', page 12), young art-critic Lori Waxman spent long days in a makeshift office erected at dOCUMENTA (13), performing *60 wrd/min art critic* (**fig. 2**).[29] Waxman penned on-the-spot 'opinionated descriptions' of art, as she called them, in 20-minute pre-scheduled appointments with interested artists. This fast-food-style art commentary remarked not only on the dizzying rate at which volumes of instant responses to art are generated, but the swathes of artists eager for hard copy, left ignored by the art press.

4

Out of the blue: where art-criticism came from

Unlike art, art-criticism has no broadly agreed narrative history. Western art-criticism as a recognizable genre continuing into the present first emerged during the 17th and 18th centuries in relation to the Salons in Paris and (later) the Summer Exhibitions in London (established in 1769), with substantial shifts occurring across the mid 19th century: Charles Baudelaire in France, John Ruskin in England, and others.[30] In 1846, Baudelaire—considered by some as a viable antecedent to the modern-day critic—described art-criticism as 'partial, passionate, political': a rousing definition with which some might still identify today.[31]

In pre-Revolutionary times an artwork needed chiefly to please king and clergy to acquire validation; artists mostly (but not always) catered to the tastes of these and a few other powerful patrons, whose opinions were the only ones that mattered.[32] Arguably, art-criticism can be counted

among the side-effects of sweeping political changes, and was born when existing standards of measure were thrown into doubt, one by one—a gradual dismantling process arguably still underway. Without the thumbs up or down of king or cardinal, who could pronounce this wild new painting by Boucher or David good or bad? Enter the art-critic, whose early self-appointed role was to:

+ provide a compass to navigate unknown artistic waters;
+ offer informed opinion and new criteria of judgment;
+ vociferously defend artists whose work he believed in, often displaying extreme partisanship.

Once considered the principal function of art-criticism, 'judgment' is now a prickly term. In a survey taken among American newspaper art-critics in 2002, most professionals considered passing judgment as 'the least important factor in reviewing art'; as art historian James Elkins wrote of this astonishing reversal, it's 'as if physicists had declared they would no longer try to understand the universe, but just appreciate it'.[33] Art-critics today rarely climb the moral high ground of such luminaries as Clement Greenberg (1909–1994), who believed that his defensive championing of some avant-garde Modernist art and artists would actually help save the world from the dehumanizing effects of mass culture.

Conventional wisdom has it that once Greenberg—the last of that tremendous ilk—had had his Modernist ascendancy disputed by a subsequent generation (many of whom considered him a mentor), art-criticism fell irrevocably into crisis and has been languishing ever since. During the 1960s, artist and critic, hitherto separate players, in many ways overlapped in the one-man band of the Conceptual artist, who created artworks that simultaneously commented upon the conditions of their own display, as Duchamp's readymade had done.[34] Trained to verbalize meaning for their art, these artists definitively put to rest the cliché of the inspired but semi-mute creator, dependent upon the critic to supply the words. The invention of the portable tape-recorder in the same decade (a technology spearheaded, in its early days, by an artist: Andy Warhol) was quickly applied to produce instant art-copy in the form of the interview.

Many players besides the critic contribute to the validation of new art: curators, some of whom now occupy more high-profile public roles than critics; dealers and collectors, long influential behind-the-scenes figures whose heightened visibility today seems to have grown in direct proportion to the mounting uncertainty around the critic. Yet new art-critics emerge with every season, and established voices have proven indispensable, regularly summoned to contribute to art-industry debates or offer commentary on artworks on view in the gallery, museum, or booth. The art-critic remains an opinionated and credible insider whose influence persists—yet whose impact and sphere of influence, in practice, resists precise contours.

The 'new art history' of the late 1960s and 1970s, often associated with *October* magazine in the USA, proposed (among other things) that the art-critic(/historian) does not so much judge art as examine the conditions of judgment. Figures such as Rosalind Krauss admired Greenberg but questioned his methods, and turned her attention toward artists and movements the elder critic had dismissed.[35] Many of her generation set out to understand artworks not solely as 'developments' occupying their due place within an art-historical lineage based on form, style, and medium, but as objects able to possess multiple possibilities of meaning depending on chosen terms of interpretation. Suddenly, from the 1970s, an art-critic's qualifications extended beyond traditional *connoisseurship*, which entailed:

+ scholarly training in art history;
+ the ability to attribute and appraise artworks;
+ technical knowledge of media (painting, sculpture);
+ familiarity with the artists' lives and careers;
+ an instinctive sensibility for quality in art, code-name 'taste'.

The critic's job—like art itself—became more broadly situated within other currents of contemporary thought. It was proposed that the analysis of contemporary art might benefit from the tools offered by other fields, to include:

- structuralism
- post-structuralism
- postmodernism
- post-colonialism
- feminism
- queer theory
- gender theory
- film theory
- Marxist theory
- psychoanalysis
- anthropology
- cultural studies
- and literary theory.

For some, a set of lionized theorists (mostly) based in France,[36] and the editorial teams at American journals such as *October* and *Semiotext(e)*— supposedly buoyed by a stream of mistranslation and earnest post-grads who mimicked the high-brow sound of stilted Anglo-French—are to be held accountable for much of the hyper-wordy, self-conscious art-writing we encounter today.[37] In truth, that 1970s/80s generation of 'new art historians' (along with innumerable other critics working across the period, worldwide) helped revitalize a discipline sorely in need of updating. Across the 1960s, artists were thinking beyond Modernist painting and sculpture, and inventing vitally new artistic alternatives—from Happenings to Junk Art, Performance, Land Art, and much more. The art-language responding to this new art urgently needed to rejuvenate. Have a glance at stodgy 1960s specialist magazines to see how out-of-sync most of these were in relation to the game-changing art occurring all around them. Many articles and reviews from the period are bursting with antiquated art-talk:

'virile painterly composition'
'organic versus inorganic form'
'receding picture planes'
'contrasting impulses of harmony and dynamism'.

We can recognize that the heaviest 1980s and 1990s theory-drone has probably grown stale today, and welcome refreshing alternatives to that

model, without tossing aside the achievements of the postmodern generation of art historians wholesale, or laying at their door the blame for scores of wannabe sound-alikes. Art-language evolves collectively, over time and in response to the new conditions of art—not as the outcome of some unholy plot, masterminded by a posse of nefarious art-writers.

Across the late 20th century, the critic's age-old task of 'judgment' was gradually replaced by 'interpretation', which recognizes that there might be contradictory yet equally valid responses to art.[38] 'Interpretation' explains why those who deem this art 'good' have arrived at their positive conclusion, but admits there are diverging responses, including the reader's own. Another preferred term is 'contextualization', or the informational bedrock on which an artwork lies:

+ what the artwork is made of;
+ how it fits within the artist's lifetime of activity;
+ what has been said about this art previously;
+ what else was happening when the work was created.

Such context may illuminate the conditions that brought the artist to reach certain art-making decisions. Rarely will an art-writer introduce all this background, but it remains at the core of any strongly research-based text, whether a two-line museum wall label or a multi-volume dissertation.

Some dispute the very assumption whereby artworks are begging to be 'read', to have meaning extracted and fixed through language, and instead prioritize their uniquely subjective art experience. In this scenario, art-writing 'translates' a visual and emotional experience into pure creative writing, untethered to any obligation toward artwork, artist, or audience. 'Criticism is an art form in its own right',[39] claimed the late Stuart Morgan, echoing the words of Oscar Wilde (1856–1900) who, about a century earlier, had reversed the words of a much older treatise on the function of art-criticism. Wilde's predecessor had claimed that the critic's job was 'to see the object as in itself *it really is*'; Wilde dryly inverted it:

'The aim of the critic is to see the object as in itself *it really is **not***'

OSCAR WILDE, 1891[40]

Wilde's transformative function for art-writing—to spin off in any direction from the artwork, and pen some fully idiosyncratic response—has been proposed as legitimate since the birth of modern art-criticism, particularly in the impassioned writing of Denis Diderot (1713–1784). An art-critic and philosopher, encyclopedist, and playwright, Diderot boldly re-interpreted paintings to embroider his own speculations about unseen, deeper meanings. For example, in responding to Jean-Baptiste Greuze's painting *Girl with a Dead Canary* (1765), which shows an anguished girl weeping over the corpse of her little bird, Diderot surmised that the lifeless pet symbolized the girl's real despair, over her lost virtue.[41] At the time, Diderot's proposal—that an artwork can carry implicit meanings that may not be explicitly apparent—was a daring move. Today, a writer responding to art enjoys far greater interpretative freedom. Written responses to art in the 21st century might belong to any genre whatsoever: a science-fiction tale or political manifesto; philosophical theory or screenplay; song lyric or software program; diary entry or opera libretto.

The love-child spawned by art-criticism and fiction has recently returned as a promising 'new' breed of art-writing; in fact this was pioneered in such exemplars as Guillaume Apollinaire's *Le Poète assassiné* (*The Poet Assassinated*, 1916) and continues more recently in the work of art-inspired fiction-writers such as Lynne Tillman, active on the New York art scene since the late 1970s. The *Wunderkammer*-style journal *Cabinet* (founded in 2000), defines itself as a 'sourcebook of ideas', and rarely mentions the 'A' word (Art) at all.[42] When in 2008 the writer, editor, and filmmaker Chris Kraus won the Frank Jewett Mather Award for Art Criticism (among the most respected prizes in the field, given by America's College Art Association) for her unconventional crossover style that overlaps autobiography, artist's biography, criticism, and fiction, this was taken as an official stamp of approval for hybridized forms of criticism, even among academics. Despite an initial impression that 'critico-fiction' is undisciplined, free-form prose, the finest examples can reflect a level of preparation, imaginative thinking, and rigor in writing technique unmatched in more conventional art-writing.

Such innovators probably owe more to early 20th-century cultural commentator and literary scholar Walter Benjamin (1892–1940) than to Greenberg and *October* combined. Benjamin's otherworldly discussion of a small, faint ink drawing from 1920, Paul Klee's *Angelus Novus* (**fig. 3**), written some 75 years ago, remains a staggering instance of visionary art-writing:

A Klee painting named *Angelus Novus* shows an angel looking as though he is about to move away from something he is fixedly contemplating. His eyes are staring, his mouth is open, his wings are spread. This is how one pictures the angel of history. His face is turned toward the past. Where we perceive a chain of events, he sees one single catastrophe which keeps **piling wreckage upon wreckage** [1] and hurls it in front of his feet. The angel would like to stay, awaken the dead, and make whole what has been smashed. **But a storm is blowing in from Paradise** [2]; it has got caught in his wings with such violence that the angel can no longer close them. The storm irresistibly propels him into the future to which his back is turned, while the pile of debris before him grows skyward. This storm is what we call progress.

Source Text 1 WALTER BENJAMIN, 'Theses on the Philosophy of History', 1940

Benjamin spins to vast proportions the impact of this, frankly, modest fellow, who is pushed center-stage in a world-changing tragedy, single-handedly stemming the whole tide of 'progress' and gathering round him the innumerable lost histories piling up at his feet. This text is hardly attempting to judge or contextualize Klee's drawing—which Benjamin owned, and must have stared at a lot, until the strange man in the picture seemed actually to move. Benjamin is borderline hallucinating:

[1] the accumulation of 'wreckage' isn't *really* there;

[2] the 'storm from Paradise' is an extraordinary invention, if not verifiably evidenced in the picture.

There is considerably more Benjamin than Klee in this text; for art-writers in training, that is a rocky road to follow. (*Note:* If you possess anything like Walter Benjamin's astonishing intellect, fierce imagination, and writing craft, by all means: take a leap. But first, drop this guidebook immediately. You do not need it.)

Some critics have fully put into doubt whether even a poetic 'mediation'—from art experience into language—is ever possible, following the influential 1950s literary critic Paul de Man who disputed any translation between disciplines. For de Man, the gap between the world of 'spirit' and that of 'sentient substance' is unbridgeable.[43] De Man-like skepticism throws into question the ancient practice of *ekphrasis*.

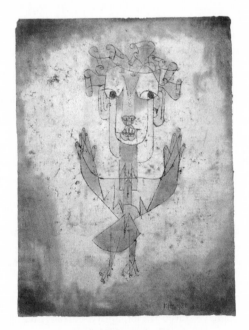

fig. 3 PAUL KLEE, *Angelus Novus*, 1920

Ekphrasis: 'a literary description of or commentary on
a visual work of art' (Merriam-Webster), or the conversion
from one discipline (art) to another (the written word)

'Writing about art is like dancing about architecture, or knitting about music', some have said, to drive home the paradox of the endeavor.[44] In this scenario, all art-writing is a doomed, compensatory activity that will forever fall short of its subject. 'Translating' political art into language, in particular, can be accused of treacherously softening its blow, normalizing through language what antagonism sets out to destabilize.[45]

There is a long tradition of critic/poets:[46]

> Charles Baudelaire
> Guillaume Apollinaire
> Harold Rosenberg
> Frank O'Hara
> Richard Bartholomew
> John Ashbery
> Jacques Dupin
> Carter Ratcliff
> Peter Schjeldahl
> Gordon Burn
> John Yau
> Barry Schwabsky
> Tim Griffin.

You might expect these critic/poets to produce the diciest texts, but—perhaps out of their vocational respect for both art and language—they often compose sterling art-writing. Some artists write well not just about their own work but about other artists too; Minimalists Donald Judd and Robert Morris are two prime 1960s examples, among countless other influential artist/critics.

5

Art-writing *sans frontières*

If text-based knowledge in support of an artwork is seen today as an almost indispensable framework, pressing questions come to the fore:

+ does meaning *adhere* to art, as an intrinsic core buried inside the artwork, extracted by the attentive writer/observer?
+ or is art's meaning *produced* by the critic's inventions?
+ do art-texts—as skeptics accuse—attempt to conjure a kind of spell, transforming ordinary things into precious art through *the incantation of special words*?
+ are art-writers *'talking (or writing) artworks into existence'*?
+ is art-writing *a parasite*, a surplus cleaving itself to artworks better off without them?
+ or is it like *a helpful companion*, trotting alongside artworks like a subservient, modest guide dog?

Do critics *owe* anything to art? Critics no longer uphold any recognized canon for the evaluation of art, with the result that their work hinges on the articulation of their own parameters of criteria. Do critics carry a primary responsibility toward artists, or their audience? Senior *frieze* critic Dan Fox, irritated by what he saw as a flood of sloppy newspaper criticism in the wake of Nicolas Bourriaud's 'Altermodern' exhibition at Tate Modern in 2009, declared:

> Critics have responsibility to [their] readers—the responsibility of arguing why something is bad, rather than just dismissing it with one withering phrase. The responsibility of conveying facts. The responsibility of describing what a work looks like or actually taking the time to sit through an artist's video, no matter how interminable it may be, before criticizing it.[47]

A critic's methods, sense of ethics, and commitment will be assessed as much as their insight, choice of artist, or quality of published prose. Critic Jan Verwoert says that his art-writing impetus arises from a feeling of indebtedness to the art experience.[48] Immersed and articulate art-writers can support artists by elucidating or furthering their ideas, and act more as collaborators than external commentators. At the very least, art-writers owe it to art and to their readers to be accurate. (In one carelessly proofread blog, an image from Carolee Schneemann's performance *Meat Joy* [1964], which showed a scantily clad female performer striking a provocative pose, was erroneously—if invitingly—captioned *Meet Joy*.)

In 1926, Louis Aragon—a poet, political commentator, and fellow-traveler of the Surrealists—described arts-journalists as 'morons, creeps, bastards, swine. All of you, without exception: glabrous bugs, bearded lice, burrowing your way into reviews [...].'[49] Today's critics may not be as powerful as they once were, but we're perhaps not as despised either. Occupying almost the bottom economic tier of the art-industry pyramid, critics are least affected by cycles of boom and bust. When art bubbles burst, art-writers often have more to write about and nothing special to worry about. As Boris Groys asserts, since nobody reads or invests in art-criticism anyway, its authors can feel liberated to be as frank as they please, writing with few or no strings attached.[50]

Leaving aside the weakest examples of art-blogging—with their inane commentary and disastrous fact-checking—in my view the most promising of the Internet independents have been a boon to art-writing (see Art blogs and websites, Resources, page 252). Somehow less self-conscious than when committing their words to paper, online art-critics have invented an unprecedented format combining first-hand insider information, sophisticated contemporary-art knowledge, and intensely opinionated commentary, from both the hosting website and *anyone logging in and leaving a comment*. As with professional art-writers, if these commentators have persuasive, substantiated ideas to offer, they may earn a place within broader contemporary art debates. [51] If the democratization of art-opinion in Revolutionary France can be said, broadly speaking, to have ushered in art-criticism, the web's open access and total collapse of borders may spell a new chapter for 21st-century multivocal art-writing.

SECTION TWO

The Practice

How to Write About Contemporary Art

'Art-writing is an anthology of examples.'

MARIA FUSCO, MICHAEL NEWMAN, ADRIAN RIFKIN, AND YVE LOMAX, 2011[52]

1

'Fear is the root of bad writing'

So claims horror novelist Stephen King, and this gothic-inflected observation may hold doubly true for bad art-writing.[53] The most quixotic press releases, baffling academic essays, and punishing wall texts are often written by the art-world's most frightened initiates: interns, sub-assistants, and college kids, cutting their art-writing teeth. They are not just inexperienced; they are terrified about:

+ sounding stupid
+ displaying ignorance
+ missing the point
+ getting it wrong
+ having an opinion
+ disappointing their supervisor
+ making choices
+ questioning the artist
+ leaving things out
+ being honest.

Fear accounts for the common sightings of what I call a 'yeti': the all-too-common, Janus-faced art description:

'familiar yet subversive'
'intriguing yet disturbing'
'bold yet subtle'
'comforting yet disquieting'.

These self-contradicting, hedged adjectives reflect a writer wracked with worry, unable to commit to a single descriptor, hiding behind the ambiguity of art to escape staking a position. Like the mythical big-footed beast, a *'yeti'* is impossible to pin down, and vanishes into nothing if you

attempt to observe it closely. Usually, weak art-writing does not fail because the writer boldly attempted to express their art experience, and fell short. No; fledgling art-writers are so overcome by the task—writing thoughtfully about their experience of art—that they abandon this endeavor before even trying. They take all sides, or seek refuge in 'conceptual' padding ('*the demands of Greenbergian dogma*') and stock concerns ('*the complexities of life in the digital age*'). Be brave, look at the art, and train yourself to write simply, only about what you know. Just by trusting yourself—and becoming informed—your texts will improve dramatically.

> *The first time you write about art*

Like writing about sex, verbalizing an art experience always verges on the overwritten embarrassment. No one excels at art-writing from their earliest attempt. Have a read of the comments scrawled on blogs or in gallery visitors' books to know what untutored art-writing sounds like:

> 'Thank you! Wonderful ☺'
> 'A waste of taxpayers' money'
> 'What a magnificent way to work with chicken wire'[54]

Everyone's first attempt at substantial art-writing is a tortuous endeavor. To cope, one might resort to echoing whatever's on the press release or website: '*Cindy Sherman's photographs deconstruct notions of the male gaze*', that sort of thing. This parroted art-talk is as unsatisfying for you to write as it is for anyone to read.

Virgin art-writing usually begins with a phrase like, '*When I first entered the gallery, I was struck by...*'. Venturing further—though omitting to describe the exhibition—the novice instantly forgets the art, and lets memory take him...somewhere else. The discussion becomes all about the writer, not the art, and swamped beneath a rush of ill-formed notions, anecdotes, half-baked interpretative angles, and inexplicable associations, all plagued by the writer's uncertainties:

+ where to start?
+ how many, and which, artworks to discuss?

+ where to end?
+ how to balance description and factual information about the artist/exhibition?
+ where to inject my own musings?

In an attempt to 'cover everything' the newcomer tosses in a slew of worn, abstract notions such as:

'subversion'
'disruption'
'formal concerns'
'displacement'
'alienation'
'today's digital world'.

Concepts pile up like colliding automobiles in a wreck, flying off in every direction, leaving a trail of unresolved ideas in their wake. As the last paragraph approaches, the flagging writer—aware he has little left in the tank—will tack on a panic-stricken finale involving a complete or partial reversal. Initial impressions are dramatically deepened or dimmed with the revelation that the artwork/exhibition/experience was not as initially imagined. It was deep rather than superficial, traditional rather than unfamiliar. It was flat yet round, open yet closed, painting yet photography, personal yet academic, *ad infinitum*, as the writer attempts a budding stab at an original idea. This incipient thought, alas, leads nowhere. The writer will omit the actual title of a single artwork, misspell the artist's name (twice), and forget to sign his own.

Most of us have written a lame art-text like this; there is no shame in taking your first baby steps. This is probably a necessary rite-of-passage in every art-writer's life-cycle, but reflects a tadpole phase you want rapidly to outgrow, because this type of early text

+ does not reflect or deepen the experience of art, but only *solves the problem of writing about it*;
+ has nothing to do with the art, but *only with the writer*;
+ cannot trace for the reader *how conclusions were reached*;
+ ignores the reality that *most art experiences change in*

meaning the more you think about them. (Even bad art changes over time, proving more shallow and detestable when you are forced to spend time with it.)

You want to *start* where the beginner's text *ends*. Drop the first three paragraphs and keep only the last—albeit preserving, and probably expanding, the descriptive prologue. Once your prolonged art-looking begins to mature, winnow down most of the preamble, and think through your own viable idea. *Start there.*

In truth, that business about the text having 'nothing to do with the art but only with the writer' is, actually, what art-writing is always, inevitably, about: its writer. Wicked reviews mostly reflect the reviewer's own foul mood (although bad art can exacerbate an incipient migraine). As you continue art-writing, you will learn to obscure—or exploit—this fact. But be warned: indulging in your idiosyncratic mood swings can turn ugly. Ignoring your gut reaction, however, is to blame for much of the tiresome art-writing out there. Where your own opinion is *not* requested, such as wall labels or institution websites, push your ego gently aside and research hard information, specific facts. In every case, *really know what you are writing about.*

> *'The baker's family who have just won the big lottery prize'*

One memorable example of first-rate art-writing was composed over 100 years ago. This gem is fewer than a dozen words in length, and attributed to 19th-century writer Lucien Solvay (among others) commenting on Francisco Goya's *The Family of Carlos IV* (*c*. 1800; **fig. 4**), who are described as:

The baker's family who have just won the big lottery prize.[55]

This tiny snippet **synthesizes what the artwork looks like, why it's meaningful, and the bigger implications of the painting**, too. For Solvay, this royal group looked like 'the grocer's family...on a lucky day', a phrase later polished to its well-known form.

Keep it simple. 'Omit needless words.'[56]

Why might this razor-sharp mid 19th-century comment prove exemplary for the budding art-writer today? Because:

+ **this phrase employs few, ordinary words.** It does *not* say: '*Collectively, we, politically savvy onlookers, are free to imagine another, perhaps more deprived, class of family—possibly engaged in some non-regal profession or pedestrian trade such as the vending of baked goods—enjoying the luxuries and splendor that good fortune might gift* en masse *to its unsuspecting, lucky-ticket-holding recipients.*'

+ **it pulls together what the picture looks like** (an overbred, overdressed family) **with what it may mean** (these people aren't 'regal', just lucky). Looking at the painting, we are not mystified as to how Solvay landed upon this idea, but instantly comprehend his words. *We enjoy the art more* thanks to this keen-witted observation.

+ **it has been worded with care, and features concrete nouns.** Solvay's 'grocer' was good, but the later 'baker' is bang on target, resonating in the King's doughy face, the Queen's baguette-like arm. The wealth of visual details that Goya piled into the picture—*which we can plainly see*—substantiate the writer's ideas about this art.

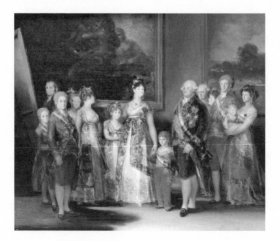

fig. 4 <u>FRANCISCO GOYA</u>, *The Family of Carlos IV, c.* 1800

+ **it situates the art within a bigger world picture.** 'Lottery' hits the bulls-eye. Goya's political point might be: 'This is no divine family! These are ordinary folk who randomly won "the lottery of life", ruling our country generation after generation. Let's revolt!' [57] After-effects of the surprise windfall might explain the wide-eyed, startled look on the Queen's multi-chinned face, and all those round, vacant eyes, as if caught by surprise. *The closer we look at this painting, the more these imaginative words add to our enjoyment of the work.*

+ **it does not exclude other responses to the art.** Like the artist, this writer was fearless and original, taking a risk. These words are so inventive, so unexpected, they encourage others to think about this painting creatively for themselves. Solvay's interpretation may be a cracker, but it is not the final word, and it invites other onlookers to match his imaginative wit.

Certainly, the power behind this comment owes everything to the quality of Goya's superb painting. Art-writers are perpetually at the mercy of what critic Peter Plagens has called the timeless art ratio, '10% good art: 90% crap'.[58] It is no easy task to write a smart, supportive text about barren, uninspired work. Such writing will sound like hokum, because it is. Write first about artists whom you genuinely revere, the art you most believe in, so you don't have to fake it. And if a work fails, say so with gusto. Faked feelings rarely produce good writing.

As a rule, dial down any bloated and grandiose statements:

'This art overturns all definitions of visual experience'
'This video questions all assumptions of gender identity'
'Viewing this art, we question our very being, and ask ourselves what is real, and what is not.'

Get a grip. Very rarely, great art and poetry can aspire to feats of this magnitude; an overexposed Polaroid of the artist's bull-terrier probably does not, and should not be burdened with such weighty expectations. You can support art without prostrating yourself before it.

Your first question when approaching any piece of art-writing might be: how much of my opinion is required here? Secondly, *do I know enough*

The three jobs of communicative art-writing

All art-writers can concoct a written response to art (the easy part). Good writers show where that response came from, and convince of its validity (the hard part; discussed in more detail in 'How to substantiate your ideas', page 53). Communicative writing about artworks breaks down into three tasks, each answering a question:

Q1 What is it?
(What does it look like? How is it made? What happened?)
Job 1: Keep your description of the art brief and be specific. Look closely for meaningful details or key artist decisions that created this artwork, perhaps regarding materials; size; selection of participants; placement. Be selective; avoid overindulging in minutiae, or producing list-like descriptions that are cumbersome to read and largely inconsequential to job 2.

Q2 What might this mean?
(How does the form or event carry meaning?)
Job 2: Join the dots; explain where this meaningful idea is observed in the artwork itself. Weak art-writers will claim great meanings for artworks without tracing for the reader where these might originate materially in the work (job 1) or how they might connect to the viewer's interests (job 3).

Q3 Why does this matter to the world at large? *(What, finally, does this artwork or experience contribute—if anything— to the world? Or, to put it bluntly: so what?)*
Job 3: Keep it reasonable and traceable to jobs 1 and 2. Answering this final question—'so what?'—entails some original thought. And remember that the achievements of even good art can be relatively modest; that's OK.

to make my contribution worth reading? In all cases—whether evidence-led (explaining), opinion-led (evaluating), or mixed—your texts will only stand up if you can substantiate your claims (see page 53).

> *The three jobs of communicative art-writing*

Here is a short extract from a catalogue text by critic and curator Okwui Enwezor.

In the late 1970s, [Craigie] Horsfield commenced one of the most sustained and unique artistic investigations around the governing relationship between photography and temporality. Working with a large-format camera, **he traveled to pre-Solidarity Poland, specifically to the industrial city of Krakow, then in the throes of industrial decline and labor agitation** [2]. There he began shooting a series of ponderous and, in some cases, theatrically anti-heroic **black-and-white photographs comprising portraits, deserted street scenes and machinery** [1]. Printed in **large-scale format** [1], with tonal shifts between sharp but cool whites and velvety blacks, these images underline the stark fact of the subject, whether its of **a lugubriously lit street corner or a solemn, empty factory floor, or portraits of young men and women, workers and lovers** [1]. The artist worked as if he were **bearing witness to the slow declension of an era** [3], along with a whole category of people soon to be swept away by the forces of change [...] With their stern, stubborn mien, **they stand before us as the condemned** [3].'

Source Text 2 OKWUI ENWEZOR, 'Documents into Monuments: Archives as Meditations on Time', in *Archive Fever: Photography between History and the Monument*, 2008

How exactly does Enwezor's text fulfil the basic expectations of communicative art-writing? He answers three questions (see page 49):

Q1 **What is it? What does the artwork look like?**

A Enwezor describes what appears in the images, as well as the photographs' size and technique [1].

Q2 **What might the work mean?**

A The writer explains in brief the artist's project [2].

Q3 **Why does this matter to the world at large?**

A Enwezor's original interpretation is that Horsfield's 'unique artistic investigations' did not just document the decline of an era, but immortalized those doomed to go down with it: Horsfield's subjects appear as if resigned to death row [3].

If you favor a clipped journalistic style, you might balk at 'relationship between photography and temporality' or 'theatrically anti-heroic', but Enwezor always returns to the actual artwork in order to move his thinking forward and prevent lapsing into meaninglessness. You may not agree with Enwezor's conclusion, and can freely re-interpret Horsfield's portraits (fig. 5) in your own terms; but the writer has taken the reader step-by-step through his knowledge and his thinking to *substantiate* his interpretation.

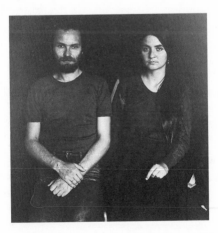

fig. 5 <u>CRAIGIE HORSFIELD</u>, *Leszek Mierwa & Magda Mierwa – ul. Nawojki, Krakow,*
July 1984, printed 1990

Even Walter Benjamin's far-flung interpretation of Paul Klee's drawing *Angelus Novus* explains how this tiny smiling angel became the linchpin in his philosophy of history, and fulfils the art-writer's three-part job. (See Source Text 1 on page 37, and fig. 3.)

Q1 **What is it? What does the artwork look like?**

A 'A Klee painting named Angelus Novus shows an angel looking as though he is about to move away from something he is fixedly contemplating.'

Q2 **What might this mean?**

A 'This is how one pictures the angel of history.'

Q3 **Why does this matter to the world at large?**

A '[H]e sees one single catastrophe [...] what we call progress' —a 'progress' that always smashes what was once whole, leaving behind a heap of debris that gathers lost histories.

This is heady, speculative stuff, but Benjamin traces how his immense re-conceptualization of all history was launched by the little Klee figure floating before him.

2

How to substantiate your ideas

New art-writers usually find this part tricky: how do you strike the right balance between visual description, factual research, and personal input (or one's own imaginative spin)? Other immediate questions that you might have:

+ this is *art* we're talking about; can't I just write whatever pops into my head?
+ isn't my opinion as valid as anybody else's?
+ why do I need to do research?

Presumably, if you are reading this book, your aim is to produce strong, persuasive art-writing rather than just scrawl '*Thank you! Wonderful* ☺' in a gallery visitor's book. The difference between the two is: *substantiation*.

Substantiation explains where your ideas came from: your reader feels illuminated by your words, not frustrated. Substantiation is the difference between a gallery puff piece, gushing over how 'wonderful' and 'alluring' the art is, and a believable text that allows the reader to see the art afresh. Substantiation is what makes 'the baker's family who have just won the big lottery prize' as a response to Goya's portrait so terrific. I can *see where the writer found that idea* in the over-carbed appearance of those pudgy royal limbs and necks, or the assortment of badges, sashes, and medals flourishing on the King's prodigious chest, so shiny they look purchased the day before. (Francisco Goya's *The Family of Carlos IV*, c. 1800, as described by writers including Lucien Solvay, see page 46 and fig. 4.) Substantiation turns watery artspeak into wine. The two main ways to substantiate art ideas are:

+ **by providing factual or historical evidence:** doing research, the backbone of academic writing and quality journalism;
+ **on the basis of visual evidence:** extracting information from the artwork itself.

Either way, the good art-writer substantiates ideas by paying close attention, and by tracing the logic of their thoughts, from artworks to art-words. These two forms of evidence—material evidence in the artwork, or in its history—can be combined and prioritized in myriad ways, but *they usually uphold the most persuasive art thinking.*

> *Provide factual or historical evidence*

This is key for academic writing. The following text by art historian Thomas Crow is steeped in valid historical evidence.

Painters and sculptors coming of age in California shared all of the marginalization[1] experienced by Johns and Rauschenberg in New York, but they lacked any stable structure of galleries, patrons, and audiences that might have given them realistic hopes for worldly success. The small audience they did possess, particularly in San Francisco, tended to overlap with the one for experimental poetry, and in both the majority was made up of fellow practitioners. One couple, composed of a poet, Robert Duncan (1919–88), and the artist Jess (b. 1923), provided a focus for this interaction from the early 1950s. **Duncan had distinguished himself in 1944 by publishing an article in the New York journal *Politics* entitled 'The Homosexual in Society'[2]**, in which he argued that gay writers owed it to themselves and their art to be open about their sexuality [...].

Jess began in the early 1950s to work toward forbidden areas of reference [3], in collages drawn from everyday vernacular sources. One of the earliest, *The Mouse's Tale* of 1951/54 [**fig. 6**], conjures a Salvador Dalíesque nude giant from **several dozen male pin-ups** [3].

Source Text 3 THOMAS CROW, *The Rise of the Sixties*, 1996

In substantiated texts such as Crow's, even abstract concepts such as 'marginalization' [1] are supported by evidence, in this case the backlash resulting from Duncan's 1944 article in defense of openly homosexual writing [2]. Along with historical facts, ideas can be rooted in visual evidence; Crow hones in on a specific collage by Jess, *The Mouse's Tale,* and pinpoints the elements that prompted an unfavorable reaction [3]. Crow's text is top-notch art-history writing: its content is informed and specific (all dates; artwork titles, exact publications are given) and this hard information forms the basis of his interpretation. He makes every word count.

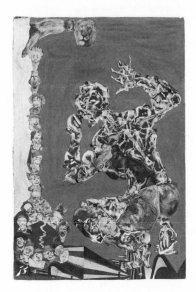

fig. 6 <u>JESS</u>, *The Mouse's Tale*, 1951/54

> Beware of unsubstantiated waffle

Every sentence in convincing academic art-writing introduces new information and supports a meaningful point. 'Waffle' is overwritten and emphatic text, puffed up with—

+ platitudes and partial information;
+ unnecessary words and banal repetition;
+ common (or assumed) knowledge;
+ throwaway references and empty name-dropping;
+ conceptual padding and clumsily applied theory.

'Waffle' is weak text, because it raises more questions than it answers.

Waffle: *'Aside from the important and well-known artists in New York...'*
Q **Which important and well-known artists?**
A Substantiated text: 'Johns and Rauschenberg in New York...'.

Waffle: *'Californian artists achieved much less recognition than their East Coast counterparts.'*
Q **Why did the Californian artists achieve less recognition than those in New York?**
A Substantiated text: 'Painters and sculptors coming of age in California [...] lacked any stable structure of galleries, patrons, and audiences'.

Waffle: *'In the work of unconventional couple Robert Duncan and Jess...'*
Q **Who are Robert Duncan and Jess? When were they active? Why have they been chosen here?**
A Substantiated text: 'poet Robert Duncan (1919–88) and the artist Jess (b. 1923) provided a focus for this interaction [between art and poetry]' from the early 1950s.'

Organize your text in sensible order, working from the general to the specific, introducing an idea ('painters and sculptors coming of age in California [experienced] marginalization') and then supporting it with evidence (a published article; an artwork; historical proof). Pick your text clean of overblown or self-evident sentences.

> Rambling text is mostly skimmed off the top of the
> writer's head; the simple cure is to read more, look more,
> collect more information—and think more.

> Extract visual evidence

The following example examines a text by one of contemporary art's most influential—if divisive—critic/historians, Rosalind Krauss. Her text is about Cindy Sherman: a great artist, but sadly the target of choice for much hackneyed undergraduate 'analysis', all *'male gaze'* and *'masquerade'*.

Rosalind Krauss's contribution to art history and theory since the 1970s is formidable (see Beginning a contemporary art library, page 250). From my own informal survey, no one divides opinion more starkly: to many she represents the very pinnacle of quality art-writing; for others Krauss occupies its most turgid, least enjoyable ebb. I will *not* be joining the Krauss denigrators; there is much to learn from her. Rosalind Krauss must really love art, given the lengths of time she dedicates to looking and thinking about it, omitting no detail, thinking through every shred of visual evidence—and yes, demanding that her readers really sweat to keep up. You don't need to mimic Krauss's dense language to appreciate her close, attentive art-viewing.

Here, in a monograph essay, Krauss offers a rebuttal to the 'male gaze' platitude that consumes much Sherman literature, by contrasting the details found in two photographs from the *Untitled Film Stills* series.

Sherman, of course, has a whole repertory of women being watched and of the camera's concomitant construction of the watcher for whom it is proxy. From the very outset of her project, in *Untitled Film Still #2* (1977), she sets up the sign of **the unseen intruder** [1]. A young girl draped in a towel stands before her bathroom mirror, **touching her shoulder and following her own gesture in its**

reflected image[4]. A doorjamb to the left of the frame places the 'viewer' outside this room. But what is far more significant is that **the viewer is constructed as a hidden watcher by means of the signifier that rewards as graininess**[5], a diffusion of the image [...]

But in *Untitled Film Still #81* (1979) there is **a remarkably sharp depth of field**[6], so that such /distance/ is gone, despite the fact that doorways are once again an obtrusive part of the image, implying that the viewer is gazing at the woman from outside the space she physically occupies. As in the other cases, the woman appears to be in a bathroom and once again she is scantily dressed, wearing only a thin nightgown. Yet the continuity established by the focal length of the lens creates an unimpeachable sense that **her look at herself in the mirror reaches past her reflection to include the viewer as well**[2]. Which is to say that as opposed to the idea of /distance/, there is here signified /connection/, and what is further cut out as the signified at the level of narrative is **a woman chatting to someone (perhaps another woman)**[3] in the room outside her bathroom as she is preparing for bed.

Source Text 4 ROSALIND KRAUSS, 'Cindy Sherman: Untitled', in *Cindy Sherman 1975–1993*, 1993

OK, so I too am stupefied by what '/distance/' accomplishes as opposed to plain-vanilla 'distance'. Nonetheless, Krauss examines the visual evidence closely to suggest how these two Sherman photographs function differently: one seems to imply voyeurism, the other collusion. In the first, *Untitled Film Still (#2)* (**fig. 7**), the woman is spied upon unknowingly, perhaps threateningly [1]; in *Untitled Film Still (#81)* (**fig. 8**), the woman is aware

of her onlooker and casually engaging with her/him [2]. Krauss notices that in both photographs, the door partially frames the woman, hinting at a viewer outside the bathroom. She pinpoints the two kinds of implied gaze: that of an 'unseen intruder'; and that of a friend, someone of whom the pictured woman is perfectly aware, 'perhaps another woman' [3].

Krauss identifies the elements in *Untitled Film Still (#2)* that indicate the woman might be spied upon:

+ the blonde is fully absorbed by her own movement, seemingly oblivious to anything beyond [4];
+ the hazy quality of the photograph—suggests a voyeuristic viewer, someone perhaps taking these pictures on the sly, maybe (I will add) with a high-zoom lens [5].

She describes the contrast with the woman in *Untitled Film Still (#81)*:

+ the brunette is looking past her own reflection in the mirror; possibly chatting with the viewer [2, 3];
+ the image quality [6] reflects that no one is straining to take this picture from a distance.

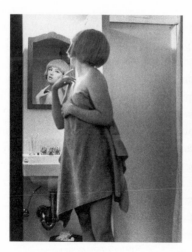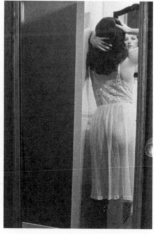

figs 7 and 8 <u>CINDY SHERMAN</u>, *Untitled Film Still*, (#2) 1977, (#81) 1980

From these details in the picture and the photographic styles, Krauss is constructing a larger point: *why must we assume that any image of a lone woman invariably positions her as 'objectified'?* If we look carefully, we see that not all Sherman's women are at a disadvantage with respect to the 'viewer' holding the camera—a man, a woman, possibly just a tripod.

Both Crow and Krauss show how they arrived at their conclusions, whether derived from historical events (key life episodes, such as Robert Duncan's censored article in Crow's text) or visual evidence (homoerotic subject matter in Jess's collage, for Crow; contrasts in the print quality and composition observed in a pair of Sherman's photographs for Krauss). To be sure, another art-writer may re-visit these very works and reach opposing conclusions, or prefer to hone in on other salient details from the artwork or historical data to validate a different interpretation. These two excerpts are not lauded as the final word on those artworks, but as examples of well-argued art-writing, as practiced by two noted American academics.

> *Pay attention*

Rosalind Krauss's text also illustrates how, as with Cindy Sherman, *not all an artist's works function exactly the same way*. Bear this in mind the next time you hear talk about '*a Gursky photograph*', indifferent to whether the large-scale Andreas Gursky C-print shows a Midwestern cattleyard or the Tokyo stock exchange; or '*a Peyton portrait*' as if it makes no difference whether painter Elizabeth Peyton pictures Georgia O'Keeffe or Keith Richards. With rare exception, all artworks by one artist are *not* perfectly interchangeable. It may be acceptable art-fair shop-talk to speak of '*the fantasy atmosphere of a Lisa Yuskavage painting*' or '*the surreal quality of a Do Ho Suh installation*' but beware of bulking together a lifetime of work into a convenient soundbite. A good art-writer pays singular attention to each work, noticing what each does similarly and how they differ.

Keep your eye fresh; look at artworks one by one. Specify exactly which animated film by William Kentridge or which Subodh Gupta metallic sculpture you mean. If you pen an entire exhibition review without once plucking out a precise artwork, complete with title and date, and have

mentally compacted the show into a homogeneous megalith, go back and look at each in turn. If you choose to group some artworks together, do so knowingly.

Here's a little exercise that might help you to pay close attention. Consider the following fast-action online comments by critic Jerry Saltz, who zeroes in on a few favorites seen on a whirlwind tour of three art fairs, back to back.

Anna-Bella Papp, *For David*, 2012

One of an array of sixteen little clay landscapes or paintings or metaphysical maps, all laid flat. Each reads as a world, design, or tile. Wonderful Morandi-like internal space. Want. [**fig. 9**]

Martin Wong, *It's Not What You Think? What Is It Then?*, 1984

This artist, who died young in 1999, is way overlooked. And much better than people realize. The intricate brickwork makes the painting look like a labor of love, a piece of flat sculpture, and a wall from the artist's memory. [**fig. 10**]

Source Text 5 JERRY SALTZ, '20 Things I Really Liked at the Art Fairs', *New York Magazine*, 2013

fig. 9 ANNA-BELLA PAPP, *For David,* 2012 fig. 10 MARTIN WONG, *It's Not What You Think? What Is It Then?,* 1984

Although such Tweet-like commentary should not pass for fully fledged art-criticism, and is symptomatic of the volume of artworks that dedicated writers must rapidly process, attempting this concentrated format can help you to focus your art-viewing attention and find ways to express your intuitive art-thinking.

+ **What is it that turns you on?** Be specific; be honest. Use your own words.
+ **Write your thoughts down precisely in 40 words or fewer.** Paste a picture at the top of your file: do your words add richness to its viewing, or contradict the picture, or make zero connection?
+ **Test your demi-text out on a friend.** Do your words make sense to her?

This drill can help you write succinctly, and directly from looking—not from artspeak habit.

Try this little work-out when you next see an artwork that instinctively appeals. Put into a few words—just a two- or three-line bonsai version of the *what is it?/what does it mean?/so what?* triumvirate—exactly why you like it.

> *Follow your thinking*

In Okwui Enwezor's catalogue essay on Craigie Horsfield, the art-writer shows the reader just what he is looking at in Horsfield's photos that led to his stunning interpretation: these men and women appear as 'the condemned' (see Source Text 2 on page 50, and **fig. 5**). Here's a decades-old example (published in a *Modern Painters* magazine article) from legendary critic and historian the late David Sylvester, in which substantiation is not based on factual evidence but follows the logic of the writer's thoughts.

The time when Picasso was making his first **junk sculptures**[1] was also the time when Duchamp made his first sculpture from readymade materials. It was **a bicycle wheel placed upside down on a stool**[1]. Now, the two objects assembled **here are the most basic objects in man's winning dominion over the earth and in distinguishing himself from the beasts of the field**[2]: the stool, which enables him to sit down off the ground at a height and a location of his choice; the wheel, which enables him to move himself and his objects around. The stool and the wheel are the origins of civilization, and Duchamp rendered them both useless. **Picasso took junk and turned it into useful objects such as musical instruments; Duchamp took a useful stool and a useful wheel and made them useless**[3].

Source Text 6 DAVID SYLVESTER, 'Picasso and Duchamp', 1978/92

Sylvester makes some pretty hefty claims: Picasso's junk sculpture and Duchamp's readymade express what distinguishes a human being from all other earthly life, and do so in opposing ways. That is quite a thought, but Sylvester succeeds by taking his reader step-by-step through his thinking. He doesn't leap from 'Picasso was making his first junk sculptures [...] Duchamp made his first sculpture from readymade materials' to his momentous conclusion: together they represent two antithetical approaches to some big subjects, such as art, usefulness, even humankind's relationship to the animal world. The writer unravels his thoughts one-by-one, accompanying us on a journey, answering the three questions of communicative art-writing:

Q1 **What is it?** [1]
Q2 **What might this mean?** [2]
Q3 **So what?** [3]

Sylvester draws a dramatic concluding distinction between these two seminal 20th-century artists. No fancy words, no jargon, just attentive reflection on what he is looking at, and the original ideas this prompted in him.

> Faulty cause and effect

In unsubstantiated, bad art-writing, the 'meaning' of artworks is blithely asserted without tracing its source. Consider the following example, published on (but since removed from) a museum website that should responsibly speak to a general visitor, accompanying a series of photographs showing artist Haegue Yang's 'assisted readymade' sculptures of an ordinary air-drying clothes-stand, folded this way and that.

> A newly commissioned piece...embraced [the artist's] interest in emotional and sensorial translation. It required her to trespass upon nationalism, patriarchal society as well as recognized human conditions, elaborated with an artistic strategy of abstraction and affect.[59]

The rest of this text was no help. This writer would have benefited from a careful editor raising a few questions, unpicking the faulty cause-and-effects, and shaking some sense out of this blurb:

+ what is meant by 'emotional and sensorial translation' or 'an artistic strategy of abstraction and affect'?
+ how exactly does the artist 'trespass upon nationalism [and] patriarchal society'?
+ how are these two things—air-drying one's laundry, and patriarchy—joined together?
+ how does laundry represent the human condition, again?
+ are people with electric clothes-dryers exempt from suffering 'recognized human conditions'? (Which begs the question, are there *un*recognized human conditions?)

Provide readers with all the steps in your thinking; this will help you disentangle ideas for yourself, too.

The quantum leap here—from laundry-drying device to a treatise on the human condition—is impossible to follow; yet such implausible gaps in logic abound in contemporary art-writing.

Have mercy on your reader. Even the most devoted cannot loop together so many missing links. And your hypothetical hyper-attentive reader, painstakingly piecing together the secret logic behind this unearthly chain of thought, could never be certain the presumed correlations between air-drying and 'an artistic strategy of abstraction and affect' matched those of the writer.

3

The audience: grounding specialists and non-specialists

To paraphrase contemporary artist Tania Bruguera, 'art'—if we dare attempt to define it—might be characterized by its basic instability.[60] Or, as the artist and writer Jon Thompson puts it, for him producing an artwork is 'a shot in the dark'.[61] 'Art' occurs when an artist (or group) brings together a set of materials (or circumstances) and the results—somehow—add up to something greater than its constituent element(s), whether:

+ pigment on a canvas;
+ a shaped block of clay;
+ a set of light-boxes turned to the wall;
+ a group event in a retail shop;
+ a web-based newsfeed projected on a screen;
+ a photograph of a curled sheet of paper;
+ an artist walking the perimeter of his studio;
+ a giant crack down the Tate Modern Turbine Hall floor;
+ a bottle-rack on a plinth, *ad infinitum*.

Good art-writing tries to put into words what somehow happened—*what was inexplicably extra*—when the artist(s) brought together those exact

+ materials,
+ or objects,
+ or technologies,
+ or people,
+ or pictures,
+ *ad infinitum.*

Here's the bad news: stabilizing art through language risks killing what makes art worth writing about in the first place. For this reason, art-writing by definition is a somewhat conflicted and flawed pursuit. Good art-writers accept the paradox of the job, tackling this conundrum head on. Bad art-writing, instead, is unaware of its own precariousness and takes art as a given, a predetermined fixity that requires the embellishment of words to gain significance, which it is not. Often, a good art-writer traces which decisions made by an artist (or artists) seem to have proven most meaningful in the resulting artwork. These decisions can be deliberate, accidental, collaborative, minor, forced, unwanted, ongoing, declared, or otherwise. A good art-writer might *hazard an empathetic guess,* by looking and thinking hard, as to which decision turned out crucial to the whole thing:

+ the material they decided to use;
+ how the shot was framed;
+ the technology they decided to try;
+ the image that inspired them;
+ the site they decided to discover;
+ or the people the decided to work with.

Just as art-commerce sets out to fix art's basic instability by quantifying value in terms of hard currency—a process played out in the auction room, where art's price floats airborne from bidder to bidder, eventually settling down with the bang of the hammer—art-writing is a similarly paradoxical business: fixing unstable art through language.

Although some art-texts may attempt to mimic art's very precariousness, for example in the form of a poem or fiction, *much everyday art-writing attempts to steady art through language.* For this reason, understanding different audiences or readerships means in part gauging how much art-stabilization they require. The less art-experienced your reader, the more grounding they will need. Some readers want to absorb only quantifiable information (statistics; prices; records; dates; audience numbers); feed them these.

When writing for children, for example, quantify with precision: Jeff Koons's *Puppy* (1992) contains 70,000 flowering plants and required 50 people to build.[62] Define every term: 'Pop art', 'abstract', 'portraiture'. Specify exactly what you are asking young readers to look for—how is *Puppy* different from other massive outdoor sculptures, such as the Statue of Liberty in New York?— but respect their ability to think for themselves.

For a general audience, pack your text with physical description, historical knowledge, and/or concise artist's statements—anything to help anchor the viewing experience in hard information. This is not a license to be patronizing, or to insist that all viewers respond to the artwork identically. *Do not pretend to know or dictate what someone else thinks about art* by spelling out how '*bewildering*' and '*thought-provoking*' this artwork is. Readers are perfectly entitled to find the work tedious and juvenile. Conversely, your audience may be even *more* turned on by this art than you are, and attribute the work with crazy magical powers you could not foresee. The toughest skill lies in rendering these general-audience texts also readable for the expert; this can be achieved through careful, up-to-date research and a straightforward, intelligent writing style. Read all you can, perhaps honing in on moments in the artist's decision-making that proved salient, and start there. A specialized art-text, such as

- + an article in an art magazine,
- + an academic assignment,
- + a museum catalogue essay,
- + or an exhibition review,

can venture into somewhat less stable territory, but this does not condone speaking in tongues. Prepared readers can appreciate genuinely adventurous art-writing which attempts to slip toward the unstable plane of art itself: not artspeak babble, but writing that attempts to match art's own dare. Walter Benjamin's startling 'angel of history' paragraph (see Source Text 1, page 37) literally knocks Klee's wide-eyed figure off-balance, rocking the little angel with a tide of rubble, tripping him up as he attempts to stride into the future. This is breathtaking stuff, but such ambitious art-writing entails tremendous skill. Your job usually is to steady and communicate art's basic instability using a few well-chosen ideas expressed in unclichéd and thoughtful words. If you are new at this, stick to that tough-enough job.

4

Practical 'how-to's

The following practical directives are more specific than the general guidelines presented until now. One day you might discard every handy suggestion listed here, and your writing will soar with poetry as a result. In the meantime, it is helpful to become aware of some common art-writing pitfalls, and try these small improvement techniques for yourself.

> Be specific

If you absorb only one recommendation in this book, let it be this: don't dance around art by writing in broad strokes and generic art-patois. Precise, knowledgeable, unexpected use of language in response to a single, well-chosen artwork instantly elevates your writing out of the doldrums. Vague words, swirling aimlessly around an artwork, die on the page:

> Combined in Haroon Mirza's art (**fig. 11**) are multiple technologies. Which resulted in a kind of light show accompanied by a sort of 'music' which the viewer was not expecting.

As with much beginner art-writing, this passage of hypothetical unedited text raises more questions than it answers. Which technologies? Where did the light come from? What 'sort of "music",' and why was this 'unexpected'? Which artwork is the writer talking about? That second phrase is not actually a sentence. Sadly, the verdict here is to rewrite from scratch, bearing the following helpful improvements in mind:

+ be specific: add titles and dates; substantiate and visualize points;
+ combine two fragments into a single coherent sentence;
+ drop messy adverbs and adverbial phrases ('kind of'; 'sort of');
+ avoid the passive and rewrite in the active tense;
+ do not presume what 'the viewer was [...] expecting'.

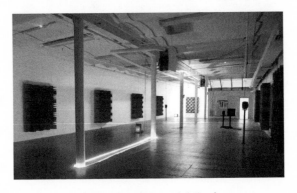

fig. 11 HAROON MIRZA, *Preoccupied Waveforms*, 2012

Consider this rewrite:

> *In* Preoccupied Waveforms, *2012 (**fig. 11**) Haroon Mirza brought together a variety of noisy, light-emitting technologies—from flashing junk-shop television sets, to strips of colorful LED lights— and arranged their humming or buzzing white noises to create a syncopated, rhythmic music.*

Solid nouns (*'junk-shop television sets'*, *'lights'*, *'white noises'*) and precise verbs (here used as descriptors: *'humming'*, *'buzzing'*) set the scene. Avail yourself of visually rich language to help your reader imagine what happened in the gallery. Without that firm basis, the reader is unequipped for what might follow—like your concluding brilliant discussion about Mirza's *son et lumière*. Ground your reader accurately in the experience, so that she may gain the confidence to look further for herself.

> Flesh out descriptions

Don't limit your preamble to, for example, '*Brazilian sculptor Ernesto Neto produces room-sized multi-media installations*'. Could you give us a hint? Color? Materials? Title? Put some meat on those bare-bone descriptions! Tell us about Neto's *Camelocama* (2010; **fig. 12**), a tree-like structure, which

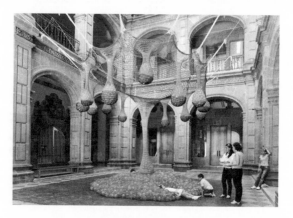

fig. 12 ERNESTO NETO, *Camelocama*, 2010

+ erupts out of the center of an outdoor courtyard;
+ is made from multicolored crocheted rope;
+ has 'branches' formed from a circular canopy suspended on braided yellow ropes, and a 'stem' rooted in a round mattress-like net filled with colorful PVC balls;
+ invites visitors to lie back and stare at the fourteen protuberances above, heavy with orange plastic balls, drooping downwards and looking, well, like glowing alien testicles.

You might talk about the contrast with the classical architecture behind it, or how the sea of multicolored balls recalls the toddler's playroom at IKEA. After your vibrant description, think about what all those goodies might mean. But first, ensure that your readers have grasped the art at hand.

> Keep pictures of the art right in front of you

While penning your description from home, look at the photo from:

+ top to bottom
+ right to left; left to right
+ corner to corner.

This exercise is especially important when looking at two-dimensional works, like paintings or photographs. Do not shrug off the 'edges' or 'empty' parts, but take the entire artwork into account. Working out the 'gaps' in the picture or the film—where 'nothing is happening'—can sometimes be a good place to start, by asking yourself: why might the artist have included these mysterious 'blanks'?

> *Do not 'explain' a dense, abstract idea with another dense, abstract idea*

This tops the list in art-writing malpractice: piling abstract nouns one on top of the other, turning texts into a blur of imprecise, woolly concepts.

Perhaps you too have been confronted by stupefying sentences like the example below, which was published in a group-exhibition catalogue:

> [Ours] is a response to an exigent disparity in critical discourse evident in the putative designation of form as subaltern to content and the posturing of the referent and iconological as the cardinal gateway for all understanding when it comes to contemporary art from the Middle East. [63]

This might as well be written in Chamicuro, an endangered language spoken fluently by a total of eight earthlings. In 46 words, our minds must process at least nine abstract ideas:

+ 'exigent disparity'
+ 'critical discourse'
+ 'putative designation of form'
+ 'form as subaltern to content'
+ 'posturing'
+ 'referent'
+ 'iconological'
+ 'cardinal gateway'
+ 'all understanding'.

That's roughly one undeveloped concept every five words. Who can possibly keep up? What is this writer looking at? How do these words say anything about their art experience?

> Keep your abstract word count low

Employ abstract nouns only once your reader has been firmly grounded in the work's basic description and meaning. A relentless onslaught of abstract ideas is torture; check out the lucky winners of the now-defunct 'Philosophy and Literature Bad Writing Contest'.[64] Top prizes were always reserved for those who stockpile abstractions, one after another, in a single heaving sentence. Here's another example, from a gallery press release:

Always seeking to expand notions of what an image can be, Lassry [fig. 13] produces pictures that escape their indexical relationships by highlighting their formal properties and by opening the way for questions regarding their connection to specific cultural contexts. The pictures become sites where an image becomes a mere object, and thus places where Lassry questions the fundamental conditions of seeing.

In the current exhibition, wall-based sculptural objects that resemble cabinets call to mind several properties (size ratios, seriality, and modularity) characteristic of Lassry's pictures. However, the apparent utility of the cabinets as vessels allows them to be read as paradoxes, photographs that have been fleshed out as objects but evacuated as representations.[65]

More Chamicuro. The first sentence alone is a concoction of six abstractions:

+ 'notions of what an image can be'
+ 'indexical relationships'
+ 'formal properties'
+ 'questions'
+ 'connection'
+ 'cultural contexts'

fig. 13 ELAD LASSRY, *Untitled (Red Cabinet)*, 2011

Such sentences are adrift in space, unanchored by any weighty nouns to tether them to earth. When finally rewarded with a concrete noun, 'cabinets', we are promptly told these are *not* cabinets, but 'paradoxes', 'evacuated as representations', and remain stranded in abstract-noun-land. The mind boggles, and Elad Lassry—with his irresistible pictures of ordinary objects such as cabinets, cats, baguettes, and wigs, artfully photographed as if they were masterworks of sculpture—deserves better.

This book will place great emphasis on **solid, precise wording**. Finding the right, concrete term isn't preferable just because it sounds nice. **Employing the exact, carefully chosen word is the mark of an art-writer** *really attempting to understand art through language, and to communicate their findings to a reader.*

> *Load your text with solid nouns*

Solid nouns are able to produce full mental pictures; for example in Okwui Enwezor's text about the photographs of Craigie Horsfield, 'industrial city', 'street corner', 'factory floor' (see Source Text 2 on page 50, and fig. 5). Remember Goya's 'baker's family'? (Francisco Goya's *The Family of Carlos IV*, *c.* 1800, fig. 4, described by writers including Lucien Solvay, see page 46.) With apologies to that excellent profession (and for the phrase's deplorable 19th-century class-ridden assumptions), a concrete noun like 'baker' condenses a slew of adjectives for the ordinary, garish, undeserving, unfit, uninspiring, vulgar, overfed family on view. See? Save words: use concrete nouns.

'[O]ne of my favorite definitions of the difference between architecture and sculpture is whether there is **plumbing**.'
GORDON MATTA-CLARK[66]

In that definition, the 1970s sculptor/architect Gordon Matta-Clark—who cut giant curves through the walls of abandoned buildings—interjected the word 'plumbing': just the sort of well-chosen, definite noun that brings art-writing alive. Matta-Clark's curious word-choice may seem kooky and random, but actually 'plumbing' communicates his workman-like attitude toward art, and the way he sliced through the walls of functioning buildings, to peer at the pipes and other innards.

> Use picture-making words when describing art

Unless discussing a certain shark floating in a tank, or that porcelain bathroom fixture signed 'R. Mutt', never assume your reader remembers or has seen the art. Even texts accompanied by a photograph—even if placed adjacent to the actual artwork—should usually begin with something the reader can *see or quickly understand*. This goes double if you're among the first to write about an as-yet undiscovered artist, introducing readers to little-known art. Get to the point; what *exactly* is special about this work? Tax your mind and be specific. If your commentary would be more or less applicable to any artwork gracing the cover of *Flash Art* since 2003, you must think harder. Become sensitive to your abstract-noun count. Use abstractions sparingly, and insert meaty nouns instead.

Here's the late Stuart Morgan, describing a painting by Fiona Rae (**concrete, picture-making nouns in bold**):

In Fiona Rae's *Untitled (purple and yellow I)* [1991], an airborne **coffin**, an atomic **cloud**, a plane **crash**, two **ink-blots**, a beached **whale** and a **tree** with a breaking **branch** meet and mingle. That is one way of describing it. It does not account for the ownerless **breasts**, the Hebrew **letter**, the **cock's comb** and badly frayed item of **male underwear** on a flying **visit** from some parallel **universe**.

Source Text 7 STUART MORGAN, 'Playing for Time', in *Fiona Rae*, 1991

Morgan packs his description with feisty nouns ('coffin', 'cloud', 'whale', 'tree'), which economically help us visualize the details in Rae's exuberant painting and, moreover, drive home the breadth of this artist's imagination.

> Adjectives: pick one

One plum adjective can brighten a whole paragraph. The best advice with adjectives is pick *one*, and make it a good one. Can you program your laptop to sound an alarm when you type anemic adjectives?

+ *'challenging'*
+ *'insightful'*
+ *'exciting'*
+ *'contextual'*
+ *'interesting'*
+ *'important'*

These one-size-fits-all adjectives can be loosely applied to any artwork since Tutankhamen. You might collect (in a special file on your laptop) any prize adjectives—'bullet-proof'; 'sunny'; 'moist'—that you come across when reading. Dip into your collection whenever you're tempted to resort lazily to the flatliners listed at the top. (*Note:* A similar collection of jazzy verbs makes the perfect gift for a writer.) Remember: usually your first job is to stabilize the art for the reader. Choose words that ignite precise mental imagery. Even the most ravishing interpretation will flounder if the reader cannot first powerfully picture what you're talking about.

Less is more when it comes to adjectives. Undergraduates will often list three adjectives: '*The art was challenging, insightful, and unforgettable.*' Post-grads whittle this down to two: '*The art was challenging and insightful.*' Many pro's will pinpoint the perfect adjective—avoiding these tiresome descriptors altogether and preferring materially evocative ones:

Concrete (picture-making) adjectives
+ 'overgrown'
+ 'glowing'
+ 'slim'

Abstract adjectives
+ 'formal'
+ 'indexical'
+ 'cultural'

Here is an evocative extract filled with concrete adjectives, from a magazine article by art-critic Dale McFarland (most **adjectives in bold**):

In [Wolfgang Tillmans's] studies of drapery [**fig.** 14]—the **folded and crumpled** fabrics of clothes discarded on a bedroom floor, jeans, T-shirts, details of buttons, pockets and gussets—this classical formalism is highlighted through the most **unexpected** subject matter. The photographs capture a second of visual pleasure in the colors and textures of a pile of **dirty** laundry: the play of light and shade on **blue satin** running shorts, **white cotton** flecked with some **unsavory** stains. They have more than a hint of eroticism, clearly evoking the act of undressing, and appear to retain the warmth and scent of the wearer. They feel **airless,** maybe even **claustrophobic**— like being tangled in **sticky** bedclothes on a **hot summer** night in a **windowless** room. This beauty of mess and ephemerality is in part what Tillmans describes: he has a **heartbreaking** fondness for the moment that will inevitably vanish, and fanatically attempts to record just how **lovely,** how **special** and how **unrepeatable** it is.

Source Text 8 DALE MCFARLAND, 'Beautiful Things: on Wolfgang Tillmans', *frieze*, 1999

One precise adjective ('dirty'; 'windowless'; 'heartbreaking') has more descriptive power than a torrent of indecisive ones. McFarland's doubled descriptors do not contradict each other: 'folded and crumpled' does not indulge in a meaningless '*yeti*' (my term for the self-contradicting paired adjectives that fill the pages of inexperienced writers, i.e., '*crumpled yet smooth*', see page 43). McFarland's is a rather poetic example, but his airy writing is anchored not only by the precision of his adjectives, but by his constant return to concrete nouns, drawn from the artworks: 'a pile of dirty laundry', 'blue satin running shorts'. McFarland also conjurs non-visual sensations which complement the mood of domestic intimacy:

+ *smell*: 'the...scent of the wearer';
+ *touch*: 'sticky bedclothes';
+ *action*: 'undressing'.

Tillmans's luscious photographs *are* a bit like soft-porn poetry; McFarland's atmospheric words suit the art. This text seems to fulfil Peter Schjeldahl's recommendation to the art-writer—'furnish something more and better than we can expect from life without it'—in this case, creating a pitch-perfect written accompaniment to Tillmans's quietly sensual photos.[67]

fig. 14 <u>WOLFGANG TILLMANS</u>, *grey jeans over stair post,* 1991

> *Gorge on the wildest variety of strong, active verbs*

Dynamite verbs charge your writing with energy. The quickest way to enliven a sluggish text is to comb for blah verbs (*'be'*, *'have'*, *'can'*, *'need'*, *'are'*) and replace them with vigorous ones (*'collapse'*; *'whitewash'*; *'smuggle'*; *'corner'*). Lace your text with unexpected actions.

Here's an example from artist and writer Hito Steyerl, in her influential *e-flux journal* essay about the precarious state of digital imagery (most **verbs in bold**) (see fig. 15, Hito Steyerl, *Abstract*, 2012):

The poor image is an illicit fifth-generation bastard of an original image. Its genealogy is dubious. Its filenames are deliberately **misspelled**. It often **defies** patrimony, national culture, or indeed copyright. It is **passed on** as a lure, a decoy, an index, or as a reminder of its former visual self. It **mocks** the promises of digital technology. Not only is it often **degraded** to the point of being just a hurried blur, one even **doubts** whether it could be **called** an image at all. Only digital technology could **produce** such a dilapidated image in the first place.

Poor images are the contemporary Wretched of the Screen, the debris of audiovisual production, the trash that **washes up** on the digital economies' shores. They [...] are **dragged** around the globe as commodities or their effigies, as gifts or as bounty. They **spread** pleasure or death threats, conspiracy theories or bootlegs, resistance or stultification. Poor images **show** the rare, the obvious, and the unbelievable—that is, if we can still **manage** to **decipher** it.

Source Text 9 HITO STEYERL, 'In Defense of the Poor Image', *e-flux journal*, 2009

Look closely at the choice verbs that Steyerl injects into this short passage:

+ 'misspelled'
+ 'degraded'
+ 'defies'
+ 'mocks'
+ 'washes up'
+ 'decipher'.

Notice also how many delicious nouns she employs to convey the variety of degraded images ('bastard', 'decoy', 'bootlegs'). There is a judicious sprinkling of adjectives ('dilapidated', 'vicious') but notice the dearth of adverbs, which would garble Steyerl's powerful writing.

This is not an invitation to abuse your thesaurus and compose purple prose, but to broaden your thinking by expanding your vocabulary. Steyerl's varied nouns and verbs drive home her bigger point: digital imagery is compromised in myriad new ways—a degradation that she expands upon in the rest of her text. In this early paragraph, Steyerl sets the scene, detailing how she is defining 'poor images' and showing how they behave before interpreting what this might imply for 21st-century art.

fig. 15 HITO STEYERL, *Abstract*, 2012

> Verbs: again, pick one

Another artspeak tic is the dreaded DVS: Duplicate Verb Syndrome, as we'll call it, which—like its monstrous cousin, the adjectival '*yeti*' (see page 43)—unnecessarily shoves two terms together where one would suffice. For example, '*This paper will **critique and unpack** the post-colonial legacies of Yinka Shonibare.*' Similarly we read, '*This research/exhibition/artwork will*'—

'challenge and disrupt'
'examine and question'
'explore and analyze'
'investigate and re-think'
'excavate and expose'
'displace and disrupt'

Usually the paired verbs accomplish virtually the same action, and are coupled just to complicate a nothing sentence. If you double up your verbs, make sure they're doing two different things: 'stand and deliver', 'cut and paste', 'rock and roll', 'shake and bake'. Otherwise, shave off that redundant verb.

> *'The road to hell is paved with adverbs.'*

This is more wisdom from Stephen King.[68] Adverbs slow and dull your writing; scratch them out ~~mercilessly~~. Adverbs are like weeds sprouting through the tidy lawn of your text. Few adverbs appear in the examples above (Source Texts 7, 8, and 9): Morgan's text has two, 'badly' and 'some'. McFarland includes 'clearly' and 'inevitably'; Steyerl 'deliberately'. Some modifiers are essential ('*more than*'; '*often*') but expert writers keep their adverb-count low.[69]

> Avoid clutter

This means waging war on adverbs and excess adjectives, as well as the dreaded jargon. Here's John Kelsey's sparse, direct style, filled with image-making nouns (in **bold**):

[Fischli and Weiss's] *Women* come in three sizes: small, medium and large (one meter tall). They come individually and in sets of four (cast in formation, along with the square of floor that supports them). The *Cars* are roughly one-third the actual size of a **car**. These off-scales give them the 'look' of art: Greek or Neoclassical **statuettes** or Minimalist **blocks** presented on **plinths**, they occupy the place of art in a casual way, simply parked or posing here. They might be aesthetic stand-ins or sculptural surrogates [1]. Even in **heels**, the *Women* manage to mimic the relaxed beauty of classical *contrapposto* poses, one **leg** supporting the body's weight, the other slightly bent [...]

They are **stewardesses** and **cars** in the form of décor and vice versa. Returning us to the safety and comfort of a world whose values are always in order, they also haunt this place with their ordinariness and ease. They remind us that this space of inventory is always already filled, like a **parking lot**.

Source Text 10 JOHN KELSEY, 'Cars. Women', in *Peter Fischli & David Weiss: Flowers & Questions: A Retrospective*, 2006

Kelsey's simple and familiar words create mental pictures that match Fischli and Weiss's brilliantly deadpan art, and form the groundwork before he ventures into his brainy observation: *Cars* remind us how a gallery, in practice, functions 'like a parking lot' for art. This writer's abstract ideas are mostly condensed into one line [1]; by then, we are firmly versed in the art's material description, and not thrown by Kelsey's interpretation. Abstract nouns and abstract adjectives, like adverbs, are the dross that clog up art-writing like so much sawdust. Adopt non-picture-forming terms ('stand-ins', 'surrogates') only when you've ensured that your reader knows what you are looking at.

> Order information logically

Unless you're deliberately going for drama, logical order should be preserved at every level—a single sentence, a paragraph, a section, your whole text.

+ Keep to chronological order;
+ move from the general to the specific, often introducing an overall idea, then filling in with detail and examples;
+ prioritize information: key info goes at the end, or front— don't bury it in the middle;
+ keep linked words, phrases, or ideas together.

> A logically ordered sentence

Here is a line by the legendary art historian Leo Steinberg, from a lecture at the Museum of Modern Art, New York, and later published in *Artforum*:

In the year following *White Painting with Numbers* (1949), Rauschenberg began to experiment [1] with objects placed on blueprint paper and exposed to sunlight.

Source Text 11 LEO STEINBERG, 'The Flatbed Picture Plane', 1968

This sentence, which discusses what we recognize as artist Robert Rauschenberg's blueprint photograms, starts by sensibly locating the basics: *when* ('in the year...1949') and *who* (Rauschenberg). Steinberg proceeds logically by first announcing that Robert Rauschenberg was beginning to experiment in his art, then explaining the nature of the experiment: placing objects on blueprint paper and exposing this to sunlight. Logic moves chronologically, and from the general to the specific. To aid clarity, keep the subject right near its verb, as in 'Rauschenberg [*subject*] began to experiment [*predicate*]' [1]. (For general-audience or

journalistic texts, keeping subject and predicate tightly together is practically mandatory.)

In the versions below, Steinberg's sensible order has been poorly rearranged; as a result the sentence turns confusing. In the second example below, not only is the reader forced backwards in time, but *the objects* are now running the experiment, not the artist!

> *Blueprint paper exposed to sunlight, with objects placed upon it, in the year following* White Painting with Numbers *(1949), is how Rauschenberg began to experiment.*

> *Rauschenberg's objects, placed on blueprint paper and exposed to sunlight, began an experiment in the year following his* White Painting with Numbers *(1949).*

The English language allows for substantial freedom in word-placement; learn logical sequence to help you determine optimal order. Carefully rearrange any tangled sentences. If your sentences are littered with commas like the two examples above, chances are your order is scrambled and needs tidying. Sentences whose convoluted construction requires 'is how', 'is what', or 'is why', like the middle version above, are usually begging for a rewrite.

> A logically ordered paragraph

In this *Artforum* article, the critic, filmmaker, and scholar Manthia Diawara examines the work of Seydou Keïta, a Malian studio photographer who, from the 1940s, created stunning black-and-white photos of the elegant bourgeoisie in Bamako, capital city of French Sudan (now Mali). In this close reading of a single portrait centering on a young man holding a flower, Diawara gets to grips with Keïta's exquisite ability to capture the period's cosmopolitan Bamakois. The author first draws our attention to the details observed in this image—the clothes, props, and gestures—and shows how these point toward the broader historical setting, to include education under French colonial rule and West African Modernism.

[Seydou Keïta's] portraits have the uncanny sense of representing us and not-us. Take, for example, the man in white holding a flower in his left hand [fig. 16]. **He is wearing glasses, a necktie, a wristwatch, and, in the embroidered handkerchief pocket of his jacket, a pen** [1]—tokens of his urbanity and masculinity. **He looks like a perfect Bamakois** [2]. However, the way he holds the flower in front of his face constitutes a punctum in the portrait, a moment in which we recognize the not-us. The flower accentuates his femininity, drawing attention to his angelic face and long thin fingers. **It also calls to mind the nineteenth-century Romantic poetry of [...] Stéphane Mallarmé, which was taught at the time in the schools of Bamako** [3]. In fact, the man with the flower reminds me of certain Bamako schoolteachers in the 1950s who memorized Mallarmé's poetry, dressed in his dandied style, and even took themselves for him.

Source Text 12 MANTHIA DIAWARA, 'Talk of the Town: Seydou Keïta', *Artforum*, 1998

The limpid tone of Manthia Diawara's text, coupled with the author's evident appreciation for the modish details observed in this portrait, suits Keïta's elegant photography. We can clearly distinguish between

[1] what's in the picture;
[2] routine assumptions;
[3] and Diawara's personal response.

The use of first-person ('me') is risky, but arguably in sync with the intimacy and directness of the portrait. With satisfying descriptions like this behind him, Diawara can proceed in the rest of his essay to tease apart two functions in this artist's work: 'a decorative one that accentuates the beauty

of the Bamakoises, and a mythological one wrapped up with modernity in West Africa'. Diawara ensures he has established *what the work* is before exploring *what it may mean*, and why it may be worth thinking about.

To re-order these well-behaved sentences would diminish their clarity. To illustrate this point, let's botch one of Diawara's perfect sentences by re-writing it in an unruly, amateur style.

> **Scrambled version:** '*In fact, dressed in a dandy style, certain Bamako schoolteachers took themselves for Mallarmé, like the man with the flower, memorizing his poetry in the 1950s as I recall.*'

> **Diawara:** 'In fact, the man with the flower reminds me of certain Bamako schoolteachers in the 1950s who memorized Mallarmé's poetry, dressed in his dandied style, and even took themselves for him.'

In the top, bungled version, confusions arise.

+ Who was memorizing Mallarmé's poetry, the man with the flower or the schoolteachers?
+ What exactly does the author recall: the man with the flower, the Bamako schoolteachers, the poetry they memorized, or that this occurred in the 1950s?

fig. 16 SEYDOU KEÏTA, *Untitled*, 1959

The badly structured version begins with details from the writer's memories, then backtracks to their source. The subject/verb ('*I recall*') gets tagged at the end, when belatedly we discover that these associations have been drawn from personal recollection. Readers must waste their efforts untangling this jumbled sentence, and may misinterpret its meaning.

In your final edit, check that your sentences and paragraphs pursue logical order. Eventually you will develop an ear for it, but until then—and unless you *want* to shake things up—shift words or phrases around to ensure clarity:

+ follow chronological sequencing;
+ work from the general to the specific;
+ keep related terms or ideas close together.

> *Organize your thoughts into complete paragraphs*

Especially in academic or magazine writing, do not chop your text into fussy little note-like, two-line fragments. You are not composing a bullet-pointed email or Tweet (unless as an exercise, see Source Text 5, page 61) but an elegant piece of prose. Gather ideas into cogent paragraphs. Similarly, do not write in unbroken, page-long blobs. Break up indigestible text-blocks; write in bite-size paragraphs.

What is a paragraph? A paragraph addresses one principal idea, and is comprised of related, complete sentences—not bizarre half-sentences, vague run-ons, or non-sequiturs. Often, the first line introduces a key idea, and transitions smoothly from the preceding paragraph. Generally, a paragraph is composed of a minimum of three sentences, rarely more than ten or 12. Usually it does not end in a quote. The last line(s) develop(s) the first, rounds it all up nicely, and may hint at what's arriving next.

In *Tormented Hope: Nine Hypochondriac Lives* (2009), writer and art-critic Brian Dillon presents nine real-life case studies—from Charlotte Brontë to Andy Warhol and Michael Jackson—of famous sufferers of hyponchondria: the pathological anxiety over one's health. Here Dillon works in a sophisticated form of art-writing that straddles essay-writing, biography, research, and art-criticism. He lists the litany of health complaints that comprised Warhol's childhood and which, as the writer surmises, might account for the artist's lifelong obsession with death:

The origins of Warhol's hypochondria[1], as of the prodigious value he put on physical beauty, are superficially easy to discern. In his 1975 book *The Philosophy of Andy Warhol (From A to B and Back Again)*, he claims to have had 'three nervous breakdowns when I was a child, spaced a year apart. One when I was eight, one at nine, and one at ten. The attacks—St Vitus Dance— always started on the first day of summer vacation.' [2] [...] According to his brother Paul Warhola[3], Andy had already been sickly for some years before the crisis that seems to have changed him for good. At the age of two, his eyes swelled up and had to be bathed with boric acid. At four, he broke his arm [...] He also had scarlet fever at six, and tonsils out at seven [4]. There is nothing singular about those episodes except the meanings he and his family attached to them in retrospect: they were part of the narrative of his physical and emotional enfeeblement.

Source Text 13 BRIAN DILLON, 'Andy Warhol's Magic Disease', in *Tormented Hope: Nine Hypochondriac Lives*, 2009

This paragraph focuses on one point: Warhol's childhood was marked by ill-health, and these repeated episodes fed his self-image as physically frail and emotionally needy. The first sentence spells out exactly what the paragraph sets out to do: explain its origins [1]. We are immediately told how this background relates to Warhol's art-making, with its obsession over physical beauty. Dillon provides plenty of examples to substantiate his argument about Warhol's unhealthy childhood:

[2] quotes from the artist's book;
[3] first-hand observations from the artist's brother;
[4] verified events in Warhol's life: the St Vitus Dance, the swollen eyes, the broken arm, the scarlet fever.

(Source details for these are given in Dillon's notes at the back of the book. In an academic paper, such references are footnoted.)

The writer never loses sight of his main thread—the artist's illness-ridden early years—and the final sentence suggests why this matters: they were part of Warhol's self-narrative about 'physical and emotional enfeeblement'. This last idea leads to the next section, about the ongoing effects of Warhol's sickly childhood in later life. By the essay's end, Dillon has built enough evidence to propose a novel way of looking at Warhol's beauty-obsessed art: its roots may lie in the contrast between his own 'body's frailty and of its potential for perfection'. Dillon begins to abstract meaning only once the reader is so steeped in verifiable details that she can follow the writer's thinking—and choose for herself whether to nod along with the author's interpretation, or not.

Dillon's method—to scrutinize the artist's life and the art in tandem—is disputed by some, who question the validity of extracting details from an artist's biography as informing artworks.[70] In all cases, be careful that you are not psychoanalyzing an artist based on 'symptoms' extracted from the artwork, a bad habit which, you might notice, Dillon avoids. His final interpretation re-thinks the *art*, not the man.

> *Avoid lists*

Unless these are knowingly implemented for dramatic effect to emphasize variety and excess, lists are deadly boring. Avoid listing more than three

+ names,
+ titles of artworks,
+ museums, galleries, or collections.

Drop partial lists, for example listing most—*but not all*—the artists in a group exhibition. In a journalistic or news-oriented piece particularly, if you list participants the roster must be complete. Take advantage of captions or subtitles to include all the names, dates, and venues. Adopt a system that follows a logical sequence; alphabetize indispensable lists of names unless you have reason to prioritize differently. Similarly, when listing artworks or exhibitions, arrange in chronological order (or follow another system suited to your text).

Lists can be stylish and evocative providing *each element is actually of interest*. Here is Dave Hickey, describing what sounds like his favorite decade:

That was the seventies—limos, homos, bimbos, resort communities and cavernous stadiums...the whole culture in a giant, Technicolor Cuisinart, whipping by, and I did love it so.

Source Text 14 DAVE HICKEY, 'Fear and Loathing Goes to Hell', *This Long Century*, 2012

Hickey's rollercoaster rhyming list ('limos, homos, bimbos') has nothing to do with the detestable pile-ups of *Kunsthalles* and *Kunstvereins* some art-writers try to pass off as a legitimate paragraph. Include those awful name-dropping lists *only* as the bottom chunk of a press release, if you must.

> *Avoid jargon*

Recall the 'thick and viscous vocabulary' that Stallabrass translated in his book review (page 14):

> Exhibitions are a coproductive, spatial medium, resulting from various forms of negotiation, relationality, adaptation, and collaboration [...]

This slick of buzzwords will date like fashionable baby names; old-school theory-jargon like 'deconstructivist' or '(meta)narrative' are no less 1980s throwbacks than 'Tiffany' and 'Justin'. In contrast, specialized art terminology is *not* jargon, and usually refers to infrequently recurring media and techniques or movements and art-forms:

+ impasto
+ trompe l'oeil
+ gouache
+ jump-cut
+ Fluxus
+ Arte Povera
+ site-specific art
+ new media art.

Numerous authoritative online resources exist for the precise definition of these.[71] When writing for a general audience, only insert unfamiliar terminology if indispensable, and define in brief; sometimes it's easier just to drop it.

Jargon is defined by the OED as 'any mode of speech abounding in unfamiliar terms, or peculiar to a particular set of persons'. At times perfectly normal words ('collaboration'; 'spatial') are so frequently injected into art-talk they turn jargony. Others are more perfidious: 'relationality'? Find your own words; express your own ideas. Lighten up. Accept that art-writing can be a difficult job, but make the effort *to write*, not recombine jargon and pre-packaged *issues*.

> *When in doubt, tell a story*

This is an efficient but overlooked device in the art-writer's toolbox: storytelling. Robert Smithson begins his illustrated essay 'A Tour of the Monuments of Passaic, New Jersey' (1967) with the story of his train-ride from Manhattan to the barren Hudson River shores, to soliloquize about the nature of industrial ruins. David Batchelor opens *Chromophobia* (2000), an irresistible book on the tyranny of colorlessness in contemporary 'good taste', with a terrifying visit to a well-heeled art collector's oppressively all-white/gray home. Calvin Tomkins's artist biographies—from Duchamp to Matthew Barney—whiz by as a collection of engrossing life-stories.[72]

Storytelling should be used judiciously for any institutional text (academic or museum texts). However, longer articles, artist's statements, blogs, and essays can benefit from good, concise storytelling. An appropriate story makes for appetizing reading and can get plenty of pertinent information across.

The eminent Michael Fried interrupts his monumental 'Art and Object-hood' essay (1967) with a story—artist Tony Smith's evocative account of a night-time car-ride along the empty American highway:

'When I was teaching at Cooper Union in the first year or two of the fifties, someone told me how I could get onto the unfinished New Jersey Turnpike. I took three students and drove from somewhere in the Meadows to New Brunswick. It was a dark night and there were no lights or shoulder markers, lines, railings or anything at all except the dark pavement moving through the landscape of the flats, rimmed by hills in the distance, but punctuated by stacks, towers, fumes, and colored lights. This drive was a revealing experience. The road and much of the landscape was artificial, and yet it couldn't be called a work of art. On the other hand, it did something for me that art had never done. At first I didn't know

what it was, but its effect was to liberate me from many of the views I had had about art [...]. Most painting looks pretty pictorial after that.'

What seems to have been revealed to Smith that night was the pictorial nature of painting—even, one might say, the conventional nature of art.

Source Text 15 MICHAEL FRIED, citing Tony Smith, in 'Art and Objecthood', *Artforum*, 1967

Fried cites Smith's momentous on-the-road revelation at length in order to illustrate his key argument: when Smith decided, by story's end, that traditional (or 'pictorial') painting was limited in comparison to the vast landscape unravelling before him, he was expressing—for Fried—a woeful return to the kind of theatrical experience that Modernist art had heroically defeated. (Fried was subsequently attacked for this eloquently argued, but by-then obsolete, defense of Modernism.)

> Storytelling and time-based media

Storytelling is an especially valuable tool when writing about time-based art, such as film and performance. In *Artificial Hells* (2012), Claire Bishop ably transforms the many performance-based artworks she discusses there—such as Polish artist Paweł Althamer's *Einstein Class* (2005; **fig. 17**) about the unruly goings-on of an artist-led physics class involving a group of troubled teenaged boys—into vivid stories which punctuate her history- and theory-driven text:

One evening **I accompanied Althamer to the science teacher's house** [1], where he wanted to show the first edit of the documentary [*Einstein Class*] to the boys. When we arrived, full-scale mayhem was underway: **the boys were playing gabba music at full blast,**

surfing the internet, smoking, throwing fruit around, fighting and threatening to push each other into the garden pond. In the middle of this frenzy stood an oasis of calm: the science teacher and Althamer, utterly oblivious to the chaos around them [1]. Only a handful of the boys watched the video (which depicted nothing of this bedlam); the rest were more interested in trying to steal my mobile phone or surf the net.

As the evening progressed, it became clear that **Althamer had placed two groups of outsiders together** [2]—the kids and the science teacher—and this social relationship operated as a belated corrective to his own experience of feeling discouraged at school. *Einstein Class*, like many of Althamer's works, is typical of his identification with marginal subjects, and his use of them to realize a situation through which **he can retroactively rehabilitate his own past** [3].

Source Text 16 CLAIRE BISHOP, *Artificial Hells: Participatory Art and the Politics of Spectatorship*, 2012

fig. 17 PAWEŁ ALTHAMER, *Einstein Class*, 2005

Bishop's story-based account serves as a valuable first-hand historical record of the event. Her details corroborate the overall point she will make: that the slick video version of Althamer's event bears no correlation to the chaos of the actual night. We can appreciate

Q1 what occurred [1];
Q2 what it could have meant [2];
Q3 why this might be of greater significance [3].

Overall there is an absence of verbal clutter. You may or may not agree with Bishop's intensely personal interpretation of this artwork, but you have probably acquired a lasting impression of *Einstein Class*.

> Storytelling and writing about one artist

Here it can be a godsend, and sure beats your basic barely alive artist-intro:

Farhad Moshiri is a controversial Iranian artist who creates art about kitsch imagery and aspirational tastes; he lives and works in Tehran.

Compare the opener above with Negar Azimi's vivid storytelling, which begins her article about Moshiri:

A few months ago, the artist Farhad Moshiri received a curious email. 'Hello, Mr. Moshiri,' it read. 'I wish that you would stop producing art.' A few weeks later, an article in a prominent online arts magazine derided **a body of work he showed at the Frieze Art Fair** [1] as 'toys for the anaesthetized new rich'. The author, a fellow artist and gallerist, declared the assembled pieces—a series of elaborately **embroidered** [animals] sparkling in DayGlo colors [2], titled *Fluffy Friends* [**fig. 18**]—'an insult to all brave Iranians who have shed their blood for more freedom'. In a final scabrous blow—**it was only a few months after the contested presidential elections**

of 2009 and all the bloodshed that ensued [3]—the author wrote that the artist had 'amputated his Iranian heart and replaced it with a cash register' [4].

Moshiri, who lives and works in Tehran [5], was delighted. 'I cherish these letters,' he told me [6]. 'They turn out to be like the diplomas people hang. I keep them close.' [7, 8]

Source Text 17 NEGAR AZIMI, 'Fluffy Farhad', *Bidoun*, 2010

Aside from piquing our interest in the provocative Mr Moshiri, the writer manages to squeeze plenty of background into this story-like introduction, establishing some main concerns fleshed out in the rest of the article. The reader

[1] discovers that the artist has shown at an international art fair;

[2] gets an initial impression of his art;

[3] finds out a little about the political situation in Iran;

[4] hears why the artist is criticized by some in the art-world;

[5] learns that Moshiri is from Tehran;

fig. 18 FARHAD MOSHIRI, *Kitty Cat (Fluffy Friends* series), 2009

[6] knows that the author is in direct discussion with the artist;

[7] is shown that Moshiri reacts with indifference to the disapproval of his peers;

[8] acquires a sense of the artist's somewhat twisted sense of humor.

Storytelling can make for gratifying and effortless reading, and—if done skilfully—packs in the information.

> Storytelling and blogging

With its special mix of the journalistic, the critical, and the diaristic, and without the space restraints of paper publishing, blogging is a living platform for storytelling.

Artist Erik Wenzel (whose writing has also appeared on the magnificently named *Bad at Sports* blog) offers this tale as his opener to a review for *ArtSlant* of 'Gallery Weekend' (fig. 19), a Berlin event organized by a select group of galleries:

Recently lots of rumors have surrounded the inner workings of the Berlin art-world. [...]

The best anecdote so far came in Kai Müller's piece in *Der Tagespiegel* last September about a dealer speaking under the condition of anonymity drawing a diagram mapping out the major players in the city and then promptly tearing it up into little pieces and shoving them in his pocket. We can only assume the mysterious dealer, already excluded from the inner circle and fearing further retribution, then disposed of this incriminating evidence by dousing it in kerosene and setting it alight it in some secluded part of Görlitzer Park at 3 o'clock in the morning. [...]

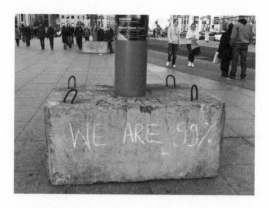

fig. 19 ERIK WENZEL, *Berlin, Potzdamer Platz, October 22, 2011*, 2011

I bring this up, because if you're going to talk about the upcoming Gallery Weekend, you have to mention this cloud that somewhat looms over the affair. The galleries in question that control the Basel selection committee and run the abc (art berlin contemporary) art fair are also the ones who founded the Gallery Weekend. OK maybe Deepthroat has a point [1]. But no one ever said one of the least regulated industries in the world wasn't cliquish.

Source Text 18 ERIK WENZEL, '100% Berlin', *ArtSlant*, 2012

This writer's colloquial tone may not suit an academic or museum-bound text, but it lends the right confidential voice to this informed snapshot of the Berlin inside-track. Hurray for Wenzel for remembering 1970s Watergate mystery man Deepthroat [1], inspirationally injected into this story to enhance its thriller-style plot of intrigue. Wenzel's post then proceeds to examine what's displayed in the galleries, artwork by artwork. With this opener, the writer sets the art well against the backdrop of the local scene, creating an intriguing picture that is accessible to any curious reader, eager for news from hotspot Berlin.

> *When still in doubt, make a comparison*

Comparisons are the oldest art-historical trick in the book, tired already in 1836 when Pugin contrasted the divine glory of Gothic cathedrals with the pagan sin of Classical monuments.[73] Worse still, this trope probably reminds you of freshman year at college, gritting your teeth while comparing Monet to Morisot, Malevich to Mondrian, and 'comparison' seems the least-appetizing candy in the art-writer's chocolate-box. And yet the finest art-writers still use this strategy with cracking results. Intelligently chosen pairings can be super-efficient for covering a lot of material and for seeing both artworks with fresh eyes. For example:

+ a close examination of two photographic works by Cindy Sherman served Rosalind Krauss to dismantle assumptions about this artist (Source Text 4, page 57);

+ the Duchamp/Picasso contrast pushed David Sylvester to his powerful observations about both artists (Source Text 6, page 63);

+ a smart comparison enabled Martin Herbert to span Richard Serra's long career, juxtaposing a recent work with a late one (Source Text 25, page 133).

You might usefully employ comparison for an artist working across media, contrasting a web-based project with a gallery installation, for example.

In Chris Kraus's *Where Art Belongs* (2011), she compares early 'humanist' photography of the 1940s [1] with recent photo-art by George Porcari, to drive home a bigger point: in recent photography, people appear united not by their 'common humanity' but because we share a less ideal identity [5]:

[George] Porcari modestly describes this work as 'photojournalism', but his ability to capture the transient sweep of global commerce and culture makes it 'journalistic' in the largest possible sense. **I'm reminded of Magnum Agency founder Werner Bischof** [1] (about whom Porcari has written). When Bischof abandoned surrealism in the wake of the Second World War [**fig. 20**], he vowed to focus his attention henceforth 'on the face of human suffering'.

[...] There are no portraits in Porcari's work. Everyone in his world is a bystander. Partly for this reason, **his pictures of migrant LA, the Mexican border, and Indian souvenir vendors at Machu Picchu** [2] [**fig. 21**], are consistently realistic representations. There's none of **the 'colorful energy' used as a backdrop for fashion campaigns shot in Morocco** [3] or Central America. Porcari sees the **third world as a participant. His photographs neither depict deplorable squalor** [4] nor suggest any reason to celebrate the **'common humanity'** shared by viewers and subjects [...] **Everyone here is a tourist** [5].

Source Text 19 CHRIS KRAUS, 'Untreated Strangeness', *Where Art Belongs*, 2011

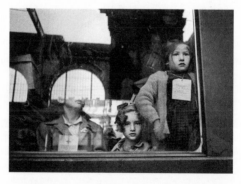

fig. 20 <u>WERNER BISCHOF</u>, *Departure of the Red Cross Train, Budapest, Hungary*, 1947

fig. 21 GEORGE PORCARI, *Machu Picchu Cliff with Tourists*, 1999

There are plenty of subtle contrasts at work here, not just between contemporary Porcari and vintage Bischof, but with exoticizing fashion shoots [3] and third-world documentary photography [4]. Kraus familiarizes readers with specific Porcari photographs [3]; this both helps us picture the photographs' snapshot style and enhances the comparison with Bischof's humanist, black-and-white post-war Europe. In a couple of short paragraphs, Kraus builds a good sense of what the photographs look like [2]; suggests why she admires them; and points toward a bigger reason why we should look at them [5].

> *Simile and metaphor: use with caution*

A simile spells out a comparison using '*as...as*' or '*like*':

> '*It's been a hard day's night, and I've been working **like** a dog.*'
> '*Poking fun at gallery press releases is **like** shooting ducks in a barrel.*'
> '*The intern was kept **as** busy **as** a bee.*'

In contrast, a metaphor shoves together two ordinarily unrelated things; the unlikely comparison heightens meaning. Compare the insipid, '*Art means a lot to me*', with the evangelical: '*Art is my religion*'. Metaphor is a riskier business than simile—and artspeak is awash with metaphor, often inexpertly used.

'*Painting **is** a language.*'

'*The artist **mines South African history** for subject matter.*'

'*The web-based artists' group Heavy Industries **treads a fine line** between art and graphic design.*'

All the 'ground-breaking' or 'earth-shattering' 'seismic shifts' and 'watersheds' that rattle and flood the common press release indulge in the same tired geological metaphor. Become aware of your metaphors; if you endeavor to use them, invent your own.

> Avoid mixed metaphor

Here's an effective metaphor from Jon Thompson's essay accompanying the sculpture exhibition he curated titled 'Gravity and Grace' (Hayward Gallery, London, 1991), which revisited 'the changing condition of sculpture 1965–1975':

By 1967 [...] the 'pure-bred' **aesthetic horse** [of Michael Fried's Modernism] had long since **fled the cultural stable**.

Source Text 20 JON THOMPSON, 'New Times, New Thoughts, New Sculpture', in *Gravity and Grace: The Changing Condition of Sculpture 1965–1975*, 1993

In this sentence, Modernism 'is' a horse, and it flees a stable—as horses will do, and the metaphor is consistent. Compare with:

Mixed metaphor: '*By 1967 [...] the 'pure-bred' **aesthetic horse** [of Michael Fried's Modernism] had long since **taken flight**.*'

Horses don't take flight; this mixed metaphor would need correcting. Sift through your final drafts and correct any mixed metaphors. Expel any lame arty ones, which for some reason run riot in artist's statements ('*My photographs explore space...*'). Become aware of your metaphors, and leave space-travel to the astronauts.

> A good simile requires deliberation and thought

If the art-writer's task is somehow to fix the strange instability of art into language (see page 65), a brilliant simile can really nail it.

Here is the incomparable Brian O'Doherty, likening the white-cube art gallery—'a box so self-aware that it might be neurotic', he remarks—to the po-faced half of a comic duo:

The box, which I have called the white cube, is a curious piece of real estate [...] However roughly treated, the white cube is **like a straight man in a slapstick routine.** No matter how repeatedly hit on the head, no matter how many pratfalls, up it springs, its seamless white smile unchanged, eager for more abuse. Brushed off, pampered, re-painted, it resumes in blankness.

Source Text 21 BRIAN O'DOHERTY, 'Boxes, Cubes, Installation, Whiteness and Money', in *A Manual for the 21st Century Art Institution*, 2009

The simile of contemporary art as a vast comedy, going to any lengths for a laugh, and the hosting gallery well sick of this tired joke by now, is a terrific simile—and includes an extra metaphor, whereby the gallery's whiteness becomes a toothy grin ('its seamless white smile unchanged').

> *Final tips*

Turn *off* the Internet when writing. Do you have an old laptop, or a special spot in your home, library, or local café, that *doesn't* get wifi? *That's* where you want to do the bulk of your concentrated writing. Switching back and forth—checking emails, perusing Facebook, sourcing factual data—will kill your concentration and flow. Go back online when you've finished your first draft.

Revise at least two drafts—but three is better. If possible, *sleep on it; re-edit the next day*. In the morning you awake magically sharp-eyed. The acrid observation that you judged edgy at bedtime, by morning you realize makes you sound vicious and unstable. Your wittiest line is not your own but re-works a put-down Rachel once threw at Chandler. Do not just creep up to your required word count, run a rapid-fire spell-check, and whack 'print' or 'send':

+ re-read, rewrite, re-edit;
+ reword, reorder, reboot;
+ find more and better examples.

Read your text out loud. Check that you're generally adhering to the suggestions listed above: are you piling on inflated abstract ideas like cream puffs in a profiterole? Failing to connect the dots in your thinking? Can you spruce up your vocabulary and simplify your sentences? If it reads like a sermon, or if you need to take a big breath mid-sentence, or if you find your voice lilting into a weird question where there is none, rewrite. I always need to print out and correct on paper; only on hard copy do I notice unwanted adverbs; repetition; missing words; weird cut-and-paste accidents (*'the her art'*) and misspellings (*'artits'* is a recurring favorite) that remain somehow invisible on-screen. But even after the text is published, I notice stray adverbs, begging for the chop. Hit 'send' only when reading aloud feels happy and right; submit only when nothing, not even a comma, requires adjustment.

Define *with precision* the audience for whom you're writing, which might mean putting a real name and face to your reader rather than just imagining a generic 'curious reader'. Some people find it helpful to write to someone in particular—a mentor, hero, or friend. As you write, you might try keeping in mind a face, complete with first name and last name, whose opinion matters to you. (That could mean yourself, of course.)

A cure for writer's block

Whom do you email with delight? When you write to that person, your creative juices flow, the right words present themselves to you as if by magic. You are witty and uninhibited; your vocabulary sparkles; your ideas multiply. *Who is she, or he, for you?* Keep a clear picture of their friendly face in mind; **write directly to them.**

Talk your reader into it. All art-writing—maybe all writing—is ultimately in the business of persuading. Art-writers try to persuade their readers that:

+ they have insight into the subject;
+ the art is (or isn't) worth looking at;
+ they know what they are talking about.

Grant-writing is a sub-genre whose sole purpose is to persuade—in this case, convincing an awarding body that your art project deserves support. Probably, all the 'good' examples in this book succeed because they are persuasive:

+ digital images really do morph and move in a million ways (Steyerl, Source Text 9, page 79);
+ Farhad Moshiri's art really may be as ambiguous as its maker (Azimi, Source Text 17, page 95);
+ sounds like there really might be some gallery cabal in Berlin (Wenzel, Source Text 18, page 97).

The tragedy of the feeblest press releases is that they're so desperately unconvincing. The art described there comes across as hardly worth bothering with: no wonder they struggle to entice the press through the door. As you approach each format in Section Three, you might bear in mind all the helpful hints listed above, and *write like you mean it.*

SECTION THREE

The Ropes

How to Write Contemporary Art Formats

'It is only shallow people who do not judge by appearances'

OSCAR WILDE, 1890[73]

One reason art-writers strain to find their own 'voice' is that the art-world today demands that we speak in tongues, adopting multiple registers—academic for an art-history journal; gossipy on a blog; 'objective' for a book caption; business-like for a funding application—to suit the panoply of evaluating, explaining, descriptive, journalistic, and other text-types required. This section will delineate the tone expected for each format and share tips. A big emphasis will be on *structures*:

+ the *what is it?/what does it mean?/so what?* trio of questions addressed when looking at artworks (page 49);
+ a *basic essay outline* for academic and multi-artist texts (final pages);
+ the *inverted-triangle news format* (big opener; tapering down with details of who/what/when/where/why; ending with a 'sting'; page 126);
+ *identifying a single key idea or principle* to lead your writing through an artwork, project, or artist, which can even be no-frills chronological order.

As you progress, you can relax these frameworks, or mix them—or, better still, when these practised techniques have become habit, *just write*. But if you're starting out, these guiding outlines are your new best friends.

1

How to write an academic essay

> *Getting started*

Whether for class submission or publication in a specialist journal, an academic paper begins with a general area of interest. At worst, this is an anemic topic assigned by your teacher. At best, this is a gripping passion that has so ferociously seized your mind, you cannot sleep. Probably, your

starting point lies somewhere in the middle. Ask your tutor for book/ article recommendations. Or, begin by consulting pertinent anthologies, compendia, and series, such as:

+ Harrison and Wood, *Art in Theory 1900–2000: An Anthology of Changing Ideas*, Oxford and Malden, M.A.: Wiley-Blackwell, 2002;

+ Krauss, Foster, Bois, Buchloh, and Joselit, *Art Since 1900: Modernism, Antimodernism, Postmodernism*, 2nd edn, vols 1-2, London and New York: Thames & Hudson, 2012 (includes an exhaustive bibliography by topic);

+ 'Themes and Movements' series: (*Art and Photography*, ed. David Campany, 2003; *Land and Environmental Art*, ed. Jeffrey Kastner, 1998; *Art and Feminism*, ed. Helena Reckitt and Peggy Phelan, 2001, and more), London: Phaidon Press;

+ 'Documents of Contemporary Art' series: (*Participation*, ed. Claire Bishop, 2006; *Memory*, ed. Ian Farr, 2012; *The Studio*, ed. Jens Hoffman, 2012; *Painting*, ed. Terry Meyer, 2011; *Utopias*, ed. Richard Noble, 2009, and more), Cambridge, M.A. and London: MIT/Whitechapel;

+ Routledge's 'Readers': Nicholas Mirzoeff, *The Visual Culture Reader*, 2012 (3rd edn); Liz Wells, *The Photography Reader*, 2003, London and New York: Routledge.

You cannot rely solely on these overviews, and may need to seek out original full-length versions of abridged texts. All your texts cannot derive from a single anthology. Your sources must vary, and your bibliography demonstrate some effort and originality. Your institution or local library may have access to reliable, searchable online sources such as JSTOR and Questia for specialized articles.

Be smart with Google; one intelligent search leads to the next, but use only trustworthy institutional sources.

You may find an excellent online course, or an academic essay, with a thorough bibliography to begin your research. *Note:* You may *not* plagiarize existing material! Only consult the best-quality bibliographies to begin compiling *your own* first-draft reading list.

Read three or four essential texts on the subject; take notes. Summarize each article or chapter in a few sentences: what was the main point? Write down key information in short snippets, pertinent to your question. You need to collect evidence to substantiate your ideas later on; 'evidence' includes:

+ quotes from artists, critics, and key figures;
+ artworks;
+ exhibitions;
+ market data;
+ and historical facts.

Such evidence is at the service of supporting *your own substantiated ideas*: not just marshaled together to produce a report on the subject, like a fact-driven encyclopedia entry. Remember: a quote is evidence only of one person's viewpoint; it may be well-informed, but is not an incontrovertible truth. (See Explaining v. evaluating, page 20, on artist's quotes.)

Tag evidence with complete bibliography as you go along, so you're not hunting for footnote details at the end: author, title, date, publisher/ city, page number; volume and issue (for a magazine); or website address and date accessed (from a reputable Internet page). Footnotes are not just technical trivia; they show that the author takes seriously the job of substantiating ideas, and acknowledges the work of others.

Jot down any good vocabulary that you come across while reading, listing useful terms or phrases near the section where they might fit—a handy crutch when you're at a loss for words at three o'clock in the morning, the night before submission.

After this brief but solid research, you might draw a freehand flow-chart, or timeline, or idea-map to begin making connections visually, and start clustering and prioritizing your interests in relation to your back-up evidence. You should be able to write down, in 40 words or fewer, an initial, *focused* area of investigation; often this is in the form of a *research question*. This first stab at a query may prove flawed, because it:

+ is a leading question (that suggests a predetermined answer);
+ is based on unqualified assumptions;
+ is too broad;
+ is too narrow;
+ is out-of-date;
+ cannot be researched, because no thorough and reliable information exists or can be accessed;
+ would require powers of clairvoyance.

Your research question may require rewording or refining as you progress; the longer the research time, the more modifications. A PhD inquiry might change a dozen times; a quick, three-week assignment, max once.

> *The research question*

You should not anticipate the answer before you start, determined to 'prove' an idea in your essay. This is like a detective setting out to demonstrate that *the butler did it* instead of asking, *who killed Roger Ackroyd?* The job is not to find evidence to support a predetermined conclusion but to investigate an unknown. Take a look at the following examples:

Leading question: *How have powerful galleries determined the course of art history?*
This assumes that powerful galleries have determined art history, which may be true but needs to be adequately demonstrated. This question excludes innumerable other factors shaping 'the course of art history'.

Unqualified assumption: *How have private collectors today gained more power and influence in the art system than the commercial galleries?*

This 'question' is an assumption in disguise, which asserts that collectors are stronger players than the private galleries today—without qualifying this. Which collectors? In relation to which galleries? How are you measuring 'power and influence'?

Too broad: *What has been the role of commerce in art history?* How many angels fit on the head of a pin?

Impossible to research: *Are powerful galleries the most important factor in an artist's success?*

Too many variables prohibit answering this one plausibly. How do you define success—financial, critical, social, personal? And how do you factor in such unquantifiables as: talent; personal relationships; fashions in the art market; curators' picks; an influential collector's taste—or sheer luck?

Out-of-date: *Do powerful galleries play a role in the validation of new art?*

Absolutely, they do. This is too self-evident nowadays to constitute an actual query.

Requires a crystal ball: *How will emerging art markets affect today's contemporary art system?* No prophesies, please.

Valid research question: *What is the relationship today between commercial art galleries and museums in the UK? A case study on private-gallery acquisitions made by Tate Modern, 2004-14.* This question focuses on a clear period and example, whose results can be determined through studying Tate acquisitions and pertinent comments from galleries, artists, and curators, among other sources.

Once you have formulated a viable question (which will form the basis of your 100–250-word abstract, if required), pursue more directed research. Be sure to elucidate—right away, in your Introduction—why you chose your principal artists, artworks, or case studies as representative, able to answer your research question meaningfully.

Make sure your question can be adequately addressed in the time allotted. Many researchers follow the rule of thirds—devote:

+ a third of your time to research;
+ a third to planning and writing your first draft;
+ a third to polishing your draft.

Quantify the time at your disposal, then divide accordingly. Notice that a good chunk is spent revising your draft; do not underestimate the time you will need to polish and finalize. This might entail some last-minute research to corroborate specific passages in your argument—as well as sharpening up language to ensure it all achieves 'academic tone'. Do not rush that crucial third step!

> Structure

Usually, students are fairly skilled at doing research and gathering pertinent material. Many struggle with the next steps, which distinguish *valid academic research* from just writing a report or pursuing a hunch:

+ focus on a precise, workable question, or corralled field of interest;
+ formulate your own argument(s), out of the evidence found;
+ select and structure all the material that you've dug up, based on your argument.

Here's a basic outline for an academic essay at undergraduate or postgrad level. Make sure your reader is dead-sure what your essay is about by at least the end of paragraph two.

1 **Introduce your question or topic** (one or two paragraphs). Be specific!
 (a) *What is your argument or thesis*, resulting from your research, through which you will approach your essay question or area of interest?
 (b) *Contextualize your topic.* Clarity does not require a personality bypass but can be delivered with style, by

opening, for example, with:
a description of an exemplary artwork or incident;
a well-chosen anecdote;
an over-arching quote.

2 **Give background** (2–4 paragraphs)
 (a) *History:* Who else has thought/written about this?
 What were their main ideas?
 (b) *Define key terms:* What definitions exist? Which will you
 be employing?
 (c) *Why should we care?* What is at stake? Why is this topic
 important to think about now?

3 **1st idea/section** resulting from/building upon the above
 (a) *Example*
 (b) *More examples*
 (c) *1st conclusion* (very short essay: proceed to conclusion
 here)

4 **2nd idea/section** resulting from/building upon the above
 (a) *Example*
 (b) *More examples*
 (c) *2nd conclusion* (short essay: proceed to conclusion
 here)

5 **3rd idea/section** resulting from/building upon the above
 (a) *Example*
 (b) *More examples*
 (c) *3rd conclusion* (longer essay: proceed to conclusion here)

6 **Final conclusion** (not a reiteration of the introduction)
 Summarize main points and re-assert your argument in its
 most evolved form.

7 **Bibliography** and appendices: interview transcripts,
 charts, tables, graphs, questionnaires, maps, emails, and
 correspondence.

Add as many ideas as you like in the mid section. Each idea sub-section should be roughly equal in length. Most doctoral candidates repeat this pattern until they hit 80,000–100,000 words, having articulated a fairly brilliant argument which functions to hold the whole together, and constitutes *the paper's original contribution to the thinking around this topic*.

Articulate an argument—or thesis, or main conclusion, or overall observation—drawn from your research, to guide you through your essay. Just piling on the broadly related information and interesting quotes you've come across, then dumping it all in your paper in a shapeless heap, will not make the grade. However, your thesis does not need to be a ravishing, Nobel-prize-winning theory. Just a plausible angle—like a thread running through the material, keeping your ideas together—is fine.

You must adopt *your own* perspective: the more original the better, it's true, but to begin with, don't sweat it. Keep bringing your reader back to the topic/research question and your argument or angle, perhaps at the end of every section, as a reminder of how each new reference relates to it. New points should develop your argument, adding nuances rather than just turning repetitive.

Don't expect your reader to divine how your chosen examples fuel your idea; you must spell out the links. (See How to substantiate your ideas, page 53.) Become aware of digressive paragraphs or sections of marginal interest that are not wrapped within the main gist of your essay, and drop them. *You will not use all the research you have uncovered*; extract only the powerful examples which inform your exact topic and argument. Do not include *all* the material that you rejected in arriving at your argument, however vital that extraneous stuff was to your early thinking. Keep only what proved directly relevant—which can include a counter-argument, or examples showing that ambiguities exist, or an exception to your basic point.

New writers worry that the standard academic outline is boring or formulaic, and that it will produce an anodyne essay, but they confuse form with content. Pack the framework with compelling evidence, beguiling vocabulary, and dazzling artworks to support your staggering, jargon-free idea(s), and you will instantly triumph over its plain structure.

Some variations can include:

+ re-ordering sections somewhat;
+ offering new definitions and fascinating background throughout, not just at the start;
+ expanding upon, shifting, or even bisecting the argument;
+ introducing a counter-perspective, where the writer asks, *Why might someone dispute my thesis? What might be alternative answers to my question? What are the exceptions to my general conclusion?*
+ posing the central idea more as a second question than an 'answer', prompting new questions.

Always, each new idea is related to the previous one, and is supported by examples and evidence, building up your conclusion.

If you are struggling to organize all the material you have found (quotes, histories, examples), type **a single key word, a thematic header, in front of each 'chunk' of information. Then hit 'Sort'. Hey presto! All related ideas are magically clumped together**, creating the informational backbone of each chapter.

Use the 'Sort' command to put your keyed-in research in order. For example, for a research paper on the contemporary Gothic, you might compile initial evidence into a single massive Word file, heading each piece with a one- or two-word theme ('*ruins*', '*ghosts*', '*haunted houses*'). As research progresses, headers may grow subsections ('*ruins and 18th-century literature*'; '*ruins and modernism*'); just keep track of these expanding themes to ensure consistency, then let 'Sort' cluster all related material together. This gives you an instant sense of which sub-topics are accruing more information, and starts the outline or flow-chart for your paper. Organize the separate sections into a sensible order, and drop any weak ones. From the pieces of evidence gathered for each sub-area, what provisional conclusion can

you reach? Concentrate your energy not on mindless cutting and pasting but on analyzing your grouped information; developing brilliant ideas from the evidence; and devising intelligent transitions to join your sections coherently.

> *Do's and 'don't's*

Don't **plagiarize,** which means taking someone else's work and attempting to pass it off as your own. Plagiarism is cheating; it reflects badly on the offender both ethically and intellectually, and is dealt with severely. Consequences can vary: resubmission; a failed grade or year; expulsion; even legal dispute. Never cut-and-paste off the Internet, unless it's properly cited and verified. A 'borrowed' sentence or paragraph cleverly doctored with the occasional rewording *is still plagiarism.* Double-check your institution's plagiarism policy (university guidelines often available online).[75] You may also consult websites like www.plagiarism.org if you're uncertain about what requires footnoting, how to cite sources properly, and more.

Don't **insert quotes to do the talking for you.** The job is not to pluck out juicy quotes that reaffirm your conclusions—maybe expressing them better than you can—but *to analyze what is said in relation to your thesis.* Don't overquote. Unless vital to your point, include one or two citations per page, tops: *you must do most of the talking.* Rarely extract more than four sentences from a single citation; unless you have good reason, keep quotes brief, usually well under 50 words.

Do **cite reliable sources:** such as an artist's or other qualified figure's quotes extracted from verifiable interviews, newspapers, books, and websites. Quotes should be drawn from an expert on the subject; for example, if your essay is about national arts-funding policies in Europe, it's OK to ask a Madrid museum director about her publicly-funded budget, but—unless she has the proven expertise—not how this compares with, say, state monies available for the arts in Italy. If she offers information outside her expertise, double-check it.

Borrowed words substantiate only *what these sources think.* For example, an artist's idea about her art might authentically express what

she set out to accomplish—but this hope is not necessarily communicated for you in the artworks themselves. Always contextualize quotes by asking yourself, *what larger point is this quote making within my argument?* Make sure your reader knows how the citation has contributed to your thinking; don't toss in quotes and leave your reader to forge connections.

Don't jump from a really sketchy outline to writing full-blown text. The more organized your plan, complete with plenty of precise examples relating to each new idea, the easier the task of writing. Try outlining in reverse: with your completed (or half-completed) essay in hand, describe in a single word or line the gist of each paragraph. Does your 'reverse outline' stand up as a logical order? Does it build an argument? If not, reorganize your paragraphs (perhaps using the 'Sort' command trick to group connected material together, see page 115); drop unrelated sections; and add transitions or missing information still required to build your idea.

Outlining in reverse: if you're struggling to get the hang of outlining before you write, **you can reconstruct your flow-diagram after you've written a first draft.** Professionals often work this way: partially pre-planning; then writing 'as it comes'; and finally revising paragraphs and re-ordering them into optimal sequence afterwards.

Eliminate any repetition, waffle, and digressions from your argument. *Don't* generalize; be specific.

'*Artists in the early 1990s took "site" as central to their art-making.*'

All 1990s artists, in *all* their art? Prefer:

'*Some artists in the early 1990s took "site" as central to certain artworks, such as Mark Dion's* On Tropical Nature *(1991) and Renée Green's* World Tour *(1993).*'

Then go on to explain *how* this idea can be detected in these artworks. **Do use transition words to connect one paragraph to the next,** words such as

> *moreover, in fact, on the whole, furthermore, as a result, for this reason, similarly, likewise, it follows that, by comparison, surely, yet*

Don't enlist artworks or data as illustrations for your preconceived idea. Do not decide in advance what your sources *must mean* in aid of your thesis, turning research into a reversed operation of confirming preconceptions. As ever, look at artworks individually, and if pertinent explain:

Q1 What is it? Dates, location, participants; a description.
Q2 What might it mean?
Q3 What might this add to your thinking, or the world at large?

Do acknowledge contradictory information or limitations in your work. Students often ask:

+ what if I find conflicting evidence: market prices, collections, institutions, or artworks that 'misbehave' within my nice neat thesis?
+ do I just conceal pesky contradictions?

No; almost always there is conflicting evidence. Either acknowledge exceptions upfront

> 'Not all of Thomas Hirschhorn's monuments are dedicated to well-known political figures; for example...'

or allow the 'contradiction' to shape your ongoing research. Admit clearly any limitations in your work:

> 'This paper will not survey the entirety of 1970s performance, but focuses on two salient examples from key figures Marina Abramovic and Vito Acconci.'

You cannot simply omit out-of-whack auction prices, or curators who behave differently from your description. Acknowledge exceptions, perhaps contextualizing their rarity:

'Unlike many earlier Venice Biennale artistic directors, Bice Curiger of the 54th edition took an unusually cross-historical approach...'

However, if exceptions outnumber your thesis examples by a margin of 3:1, your argument is seriously flawed and requires rethinking.

> *Further tips*

If your research paper centers on one or two essential terms treat those special words as precious treasure, to be used sparingly (for example, *'digital imagery'*; *'collaboration'*; *'interactive museum'*; *'emerging markets'*). If your reader encounters them relentlessly in every sentence, those words (and your writing) will turn meaningless and tautological. ('Tautology' occurs when a term is defined by itself, such as 'collaboration is collaborative', or 'interactive museums interact with the visitor'. Tautology is a big no-no.) Read Nicolas Bourriaud's landmark book *Relational Aesthetics* (1998; English edition 2002)[76] and notice how the author (even in translation) goes to great lengths to adopt multiple near-synonyms ('conviviality'; 'inter-human negotiation'; 'audience participation'; 'social exchange'; 'micro-community'), developing nuances within his over-arching idea. Bourriaud limits the repetition of his magic words—'relational aesthetics'—to keep them valuable.

Put effort into your bibliography. Here's a secret: *university lecturers set a lot of store by the quality of your bibliography*, so build this up from the start. You may not have read every reference in depth; that's OK. It must never be shorter than a page and must include plenty of challenging, pertinent books, not just Internet sources. Academics spot-check for 'first-hand sources': make sure you are familiar with Roland Barthes's original *Camera Lucida* (1980) and not just *The New Oxford Companion to Literature in French*, however helpful that might be. If you quote from secondary sources, acknowledge the text's nature as commentary; the original always take primacy.

Never cite a press release, wiki, or other unverifiable text unless you have a valid reason (for example, to quote an example of dubious online

artspeak, see the gallery press release on Elad Lassry, page 73), and have plainly divulged the potential unreliability of this source. Triple-check any information you encounter there, and stick to reputable presses and websites.

First-hand research is a big plus: for example, your own interview with the artist, auctioneer, or curator; or an independent survey. Extract (and footnote) whatever quotes from the interview or survey that contributed to your understanding of the subject, and insert the whole transcript, questionnaire, or survey results in the Appendix. Be sure always to explain each piece of quoted evidence, and show *exactly* how it connects to your conclusions or pushed your thinking forward.

Footnote anything not considered 'common knowledge': quotes, statistics, historic events—particularly any controversial points. Follow the footnote style your institution adheres to, which in the USA and UK is most likely to be 'Chicago', 'MLA', or 'Harvard':

+ University of Chicago Press, *The Chicago Manual of Style: The Essential Guide for Writers, Editors, and Publishers*, Chicago, 1906 (16th edn, Chicago and London, 2010);
+ Modern Language Association of America, *MLA Style Manual and Guide to Scholarly Publishing*, 1985 (3rd edn, New York, 2008);
+ Harvard Style can have minor variations, so check your institution's guidelines. For a UK overview, see Colin Neville, *The Complete Guide to Referencing and Avoiding Plagiarism*, 2007 (Maidenhead: Open University Press, 2nd edn, 2010).

Sometimes institutions combine elements from each of these, or they follow the 'Vancouver' or 'Oxford' systems. If none is specified, pick one, and be consistent. If you're really stuck, grab the most scholarly academic art-book at hand, and copy their system religiously. Footnotes are not a dumping ground to squeeze in extra information and get around stringent word counts. Stick mostly to the plain bibliographic reference. The little superscript footnote number always falls *outside* any punctuation.

Include the original publication date as well as the year of a recent edition. A citation such as 'Immanuel Kant, *Critique of Pure Reason*, 2007'

looks as if the philosopher penned those words supernaturally some two centuries after he was buried. Prefer, for example, 'Immanuel Kant, *Critique of Pure Reason* (1781), Penguin Modern Classics, 2007'.

Here's how a basic outline structure translates into an examplary academic essay, that begins:

Site-specificity used to imply something grounded, bound to the laws of physics. Often playing with gravity, site-specific works used to be obstinate about 'presence', even if they were materially ephemeral, and adamant about immobility, even in the face of disappearance or destruction. Whether inside the white cube or out in the Nevada desert, whether architectural or landscape-oriented, **site-specific art initially took the 'site' as an actual location, a tangible reality** [1] [...] Site-specific works, as they first emerged **in the wake of Minimalism in the late 1960s and early 1970s** [2], forced a dramatic reversal of this modernist paradigm.

Source Text 22 MIWON KWON, 'One Place After Another: Notes on Site Specificity', *October*, 1997

Kwon's essay charts the changes in site-specific art (the term and the works) since the 1960s. Kwon never literally states her research question; I am deducing this from the essay. It is a *big* question—the basis for a PhD; less advanced research would probably narrow this broad question down.

1 **Introduce the question or topic:** *How has 'site-specific art' changed since the 1960s?*

 (a) *What is the argument or thesis?* From her starting point [1], Kwon will show how the idea of 'site', as a physical place, broadened over the decades, and how this shifting definition impacts artworks themselves.

(b) *Contextualize your topic with an emblematic example*:
In her opening section, Kwon examines two key early artists, Robert Barry (quoted in a 1969 interview) and Richard Serra, and their initial ideas about this type of art.

2 **Give background:** Kwon establishes the art-historical framework of modernism.

(a) *History*: [2] Kwon contextualizes her starting dates.
(b) *Define key terms*: Tracking varying definitions of 'site' over the past 40 years constitutes the gist of Kwon's paper, and this task of 'defining terms' recurs throughout.
(c) *Why should we care?*: Kwon takes the compelling case of Serra's controversial *Tilted Arc* (1981) public sculpture, which was locally unpopular and proposed for relocation, and quotes a passionately defensive letter the artist wrote in 1985 explaining why relocating *Tilted Art* would alter, if not destroy, this artwork. (The artist lost his case.)

3 **1st idea/section:** For early practitioners of site-specificity, the important thing was to escape or critique the 'stark white walls' of the gallery.

(a) *Example:* Artist Daniel Buren, and his desire to 'unveil' museum spaces and other art institutions. (page 88 in Kwon's published essay)
(b) *Another example:* Artist Hans Haacke, and his understanding of 'site' as shifting from 'the physical condition of the gallery (as in the artwork *Condensation Cube*, 1963–65) to the system of socio economic relations'. (89)
Another example: Artist Michael Asher's contribution to the Art Institute of Chicago's annual exhibition in 1979, in which he set out to 'reveal the sites of exhibition [as] not at all universal or timeless.' (89)

(c) *1st conclusion*: For this first generation of artists, 'site'
 coincided literally with the physical gallery.

4 **2nd idea/section**: For later practitioners, 'site' shifts from
 a location in the art system to one in the wider world.

(a) *Example*: Artist Mark Dion's 1991 project *On Tropical
 Nature*, set in four different sites from the Orinoco
 River rainforest to gallery spaces. (92–93)

(b) *More examples*: '[I]n projects by artists such as Lothar
 Baumgarten, Renée Green, Jimmie Durham, and Fred
 Wilson, the legacies of colonialism, slavery, racism
 and the ethnographic tradition as they impact on
 identity politics has emerged as an important "site"
 of artistic investigation.' (93)
 Another example: Art historian James Meyer's idea
 of a site as (Kwon quotes) 'a process...a temporary
 thing, a movement, a chain of meanings devoid of a
 particular focus'. (95)

(c) *2nd conclusion*: The idea of 'site' increasingly refers to
 a fluid, ungrounded 'location'.

Kwon continues apace, with new ideas, relevant examples, and intelligent
provisional conclusions, always returning to her main argument: the defi-
nition of 'site' changes over time, and this informs the changing nature of
'site-specific' art.

5 **Final idea/section**: The migration of the site-specific artist
 across international art-projects and events coincides with
 planetary waves of relocated peoples and refugees.

(a) *Example*: A quote from postmodernist theorist David
 Harvey, about our changing 'world of diminishing spatial
 barriers to exchange, movement and communication' (107).

(b) *Another example*: The idea of 'contemporary life as a
 network of unanchored flows' (108) can recall what
 philosopher Gilles Deleuze and Félix Guattari call
 'rhyzomatic nomadism' (109).

Note: Before introducing theorists like Deleuze and Guattari, Kwon has thoroughly grounded her reader in the materiality of the artwork and the history of her subject, applying these philosophers' ideas to an understanding of art—not forcing the artwork to 'obey' their concepts.

(c) *Counter-example*: Kwon recognizes that, although the physical 'site' may have become an abstraction for artists and the high-minded, it remains a material reality for the less privileged, and quotes theorist Homi Bhabha: 'The globe shrinks for those who own it; for the displaced of the dispossessed, the migrant or refugee, no distance is more awesome than the few feet across borders or frontiers.' (110)

6 **Final conclusion:** We might consider redefining 'site' as the differences and relations between locations, rather than reducing sites merely to an undifferentiated series, 'one place after another'.

The purpose here is not to produce CliffsNotes-style bookends around Kwon's important essay; moreover, another reader may interpret this essay's meaning differently from this proposed outline. To save space I have omitted plenty more terrific examples and insights, and all Kwon's perfect footnotes sourcing her claims. My point is to show how a good academic does not cram in every researched example, but selectively hones in on those that enrich her own powerful, guiding observation, building idea-by-idea, example-by-example, a perspective across the material. She does not ignore a counter-argument from Homi Bhabha which might disrupt her neat argument, but allows it to broaden her thinking.

Kwon's essay represents highly accomplished, advanced academic writing; updated and expanded, this paper eventually became the basis for an important volume, *One Place After Another*, published by MIT (2002).[77] Even the sharpest undergrad probably cannot match Kwon's level of research and thought here; but don't be daunted!

- Do solid research;
- ask a workable essay question—don't start with an assumption;
- draw viable conclusions, deducted from the evidence you've gathered (see How to substantiate your ideas, page 53);
- if possible, formulate your own consistent angle through which to organize a pertinent selection of examples.

Lastly, don't forget to check submission requirements. Type up a cover sheet, usually with:

- your name (or student number),
- title of your paper,
- date of submission,
- name of your tutor or lecturer,
- name/city of the institution.

Final checklist: proofread, and double-check unfamiliar spellings. *Re-read* the final draft at least **twice.** Unless otherwise directed, double-space; use point-size 12; insert page numbers; and keep minimum one-inch margins. Make sure paragraphs are indented. Read submission guidelines to ascertain where/when/how your assignment must be delivered. **Submit on time!**

2

'Explaining' texts

> ### How to write a short news article

Brief, art-related news articles can appear today in everything from *Elle Decoration* to the *Artillery* ('killer text on art') website. The level of specialist information may vary, but all news items conventionally adopt the 'inverted triangle' structure—top-heavy, with a summary of the main facts as the opener, then working its way down in increasing detail.

1 **Headline** (and subheader): draw your reader's attention with concise, up-to-date news.

2 **The lead**: front-load with an attention-grabber, perhaps a compelling anecdote that communicates what makes your story unique. Summarize enticingly the main events in first line or paragraph (max 50 words). This is the last place on earth for jargon, abstractions, or philosophical musings.

3 **Who/what/where/when/how**: in clear language, follow with contextualizing details, quantifying and backing up your claims with attributed quotes, numerical data, and other evidence. Avoid partial information.

4 **Wind down and 'end with a sting'**: round off your main point(s).

In short, information is set in order of importance (see Order information logically, page 83). This format can be also applied to a short introduction for a longer article, or to non-journalistic texts such as the catchy website entry for a process-based artwork or an auction catalogue text.

Journalism builds from hard evidence drawn from first-hand data (interviews, eye-witness observation) and publicly available information (press releases, auction results). News articles are usually written in the third person, with little or no interpretative spin; for more opinionated journalism, see How to write op-ed art journalism (page 182).

> Basics

Keep your audience's level of art-preparation in mind; most news articles should be comprehensible to non-specialists but of interest to the insider too. Straightforward, intelligently worded, solid information is readable in both camps. Avoid platitudes, or writing self-evident commentary off the top of your head: '*The contemporary art-world is increasingly affected by market forces*'—no kidding! Be specific and back up your statements with verified hard information, such as:

+ names of artists/galleries,
+ titles and dates of artworks,
+ sales figures,
+ visitor numbers,
+ prices,
+ costs,
+ exact times/dates,
+ dimensions,
+ distances,
+ and percentages.

Don't bore your reader. Find a compelling story and write it up snappily, but don't antagonize or overstate in order to falsely pump up interest levels. Journalism races along in the active tense, with clipped sentences that keep the subject/verb in close proximity, with few modifiers and punchy— never academic—language. Ensure accuracy. If necessary, seek out any missing data from authoritative and attributable sources.

The pages following extract the journalistic building-blocks (listed above) as found in two published news items. The first article contextualized

protests in Brazil, and followed a longer piece about billions being spent on new 'cultural districts' in places as distant from each other as São Paulo, Kiev, Singapore, and Abu Dhabi; the second reported on the newly stabilized Hong Kong art market.

Artists take to the streets as Brazilians demand spending on services, not sport [1]

São Paulo, Rio de Janeiro. 'Come to the streets!' urged the banners held aloft during mass protests in Brazil last month. What started as a rally against a rise in bus fares flared into a nationwide show of discontent as more than a million people marched on 20 June [2] [...] The demonstrators demanded that public services be given priority over the 2014 Fifa World Cup and the 2016 Olympic Games. Huge spending on the events—the cost of stadia and improvements to infrastructure ahead of the World Cup has risen to R$28bn ($12.4bn)—is taking place during an economic slowdown. Last year, the country's growth slowed to less than 1% [3]. 'We're getting first-world stadiums but we don't have first-world education and health', says the curator Adriano Pedrosa, who took to the streets. 'When you have a democratic country of so many sharp contrasts, the population really protests.' [4]

Source Text 23 'C.B.' (CHARLOTTE BURNS), 'Artists take to the streets as Brazilians demand spending on services, not sport', *The Art Newspaper*, Jul/Aug 2013

Hong Kong Spring Sales Reach More Solid Ground [1]

The Spring sales for Sotheby's, in Hong Kong, which took place from 3 to 8 April, came with some reassuring news for Chinawatchers in the auction world. It exceeded expectations coming in at HK$2.18 billion against a pre-sale estimate in excess of HK$1.7 billion [2]. [...] The Asian contemporary sales still seem to be struggling to match earlier higher prices, but were helped past their pre-sale estimates by *You Are Not Alone* by Yoshitomo Nara, which sold for over HK$41 million, more than doubling its pre-sale estimate of HK$18 million. Elsewhere in the contemporary Asian sales some works were left unsold (perhaps because of some ambitious estimates) [3] [...] All in all, the sales sent a message of firmer ground [4].

Source Text 24 UNSIGNED, 'Hong Kong Spring Sales Reach More Solid Ground', *Asian Art*, May 2013

[1] **Headline:** ensure that your 'news' is newsworthy.

[2] **The lead:** a 'hook', which engages a reader's interest.

[3] **Who/what/where/when/how:** be thorough; if pertinent, present different sides of the story. If any information is conjecture, or rumor, either drop it or make its uncertainty evident: 'some works were left unsold (*perhaps* because of some ambitious estimates)'.

[4] **Wind down and 'end with a sting':** encapsulate your main point. Usually, give at least a brief introduction to named sources ('the *curator* Adriano Pedrosa'), and quote their words precisely.

> *How to write a short descriptive text*

+ art-fair catalogue copy
+ museum labels
+ biennale guidebooks
+ art-website blurbs
+ extended captions
+ exhibition wall texts.

The proliferation of bite-size art-copy attests to what can be described as the 'cult of brevity' in today's Twittering art-world whereby art must be grasped rapidly and consumed in bulk. Commissioned mini-text writers—frequently unnamed—often must:

+ balance concise, pertinent, updated facts with meaningful ideas;
+ cater to everyone from schoolchildren to seasoned experts;
+ condense a complicated multi-part artwork into just a few sentences.

Writing these short texts intelligently demands far more skill than is generally recognized, and should *never* be written unguided by inexperienced interns or paid by the word. Agonizing over those precise 150 words requires absolute discipline. Make no mistake: composing smart super-short texts is a disproportionately far tougher job than luxuriating in the 2,000+ words of a roomy catalogue essay.

> Basic technique

Usually, to write a very brief piece, the most common strategy is to identify *one* main theme or angle through which to examine the art. You cannot cover everything, so choose your focus well. It may be:

+ materials,
+ process,
+ symbolism,
+ political content,

+ the artist's archive,
+ biography,
+ a controversy,
+ or technique.

Research the artist, look carefully, and discern *the one key thread* running through the text. You can employ a comparison, which might be a smart metaphor or simile. Be specific; your focus or point can be relatively minor: not *'this artist questions all the ideologies underpinning the spectrum of 21st-century politics'*. You might borrow the news-writing inverted-triangle structure (page 126) to fit all your information in—especially applicable in a newsy promotional blurb. Set your purple-prose radar on high alert; blinding red lights should flash if you write, *'this ravishing artwork laments the heartbreaking puniness of all human existence'*. Stay focused. Make every word count.

Consider viewing/reading conditions: art snippets might be read peering over shoulders in noisy galleries; on a tiny mobile-phone screen; or touring an exhibition, guidebook in hand. Even an 'unsigned' text should display some style, but err on the side of factual rather than flamboyant. Keep sentences crisp and to the point. Your text length may end up determined by the size of a Perspex label holder, usually about 150–200 words. If you are working without the help of an experienced curator, check that your texts will fit in the plastic before writing them. For large exhibitions, consider what belongs in the introductory panel—*which is read by more visitors*—and what goes on the wall labels. Avoid repetition.

If you write your description before the artwork arrives, double-check whatever comes out of the crate matches your words. Reproductions can be deceptive. Very occasionally, *the artwork you unpack may not even be the one you were expecting* (long story). You will then need to scrap your meticulously researched text and frantically rewrite.

Accuracy: all caption details must be checked, double- and triple-checked. You are writing art history; take this seriously. Is it a film, or a video? For references, look to:

+ catalogues raisonnés;
+ first-hand, fact-checked, reliable information;

+ trusted Internet resources (major museums, the artist's own website, Grove Art online);

not any crackpot with a web address. Be careful when translating titles; there may be an official English-language translation that you need to stick to.

When faced with a particularly arduous brief, new art-writers might instantly throw up their hands in defeat. How can we sum up a two-hour film, or a three-month multi-part performance work, even a 50-year career, in just 150 words? What about artworks that are stuffed with unrelated imagery, or open-ended, or deliberately sprawling and chaotic? Isn't reducing these hydra-headed artworks to a tame paragraph an impossible and contradictory task?

Contradictory, perhaps; impossible, no. Of course, one hopes that these mini-texts serve only to *assist*—rather than *replace*—the time readers will spend *looking* at the art. Here are a few special-challenge briefs (writing about a long career; a moving-image work; a highly detailed image; an open-ended or multi-part project; digital media) and a sampling of techniques that art-writers have adopted with them.

> How to write in brief about a long career

Ideally, such a text is penned by a venerable expert, steeped in 30 years' first-hand study and observation, whose scholarship permits them to distill the very essence of an artist's multi-decade *oeuvre*. Let's say that you, in contrast, only learned to pronounce this artist's name correctly five minutes ago. In this case, you will have to hit the library hard. Plan to read about ten or 20 times as much copy on the artist as you are asked to produce.

Here, in an extract from the *Frieze Art Fair Yearbook*, Martin Herbert manages to condense some 50 years' of sculptor Richard Serra's career into a four-sentence paragraph.

Richard Serra, born 1939, lives New York/Nova Scotia

Richard Serra is one of the most significant figures in contemporary sculpture, pivotal enough for **museums and commercial galleries to have scaled their spaces with his enormous steel plates** [1] in mind. **Such monumental works may seem far removed from Serra's thrown lead pieces of the 1960s** [1]: throughout his career, however, he can be seen to have conducted **a pioneering investigation of the properties and poetics of industrial metals** [Th], particularly their **physical and visual weight and occupation of space** [2]. Recent projects such as *Promenade* (2008) [**fig. 22**], his row of 17-metre-high vertical plates [1] for the Grand Palais in Paris, suggest that Serra continues to push the boundaries of this exploration. Here, massiveness combines with subtle irregularities of placement which, **on this scale, have grand effects on the audience** [3].

Source Text 25 MARTIN HERBERT, 'Richard Serra', *Frieze Art Fair Yearbook*, 2008–9

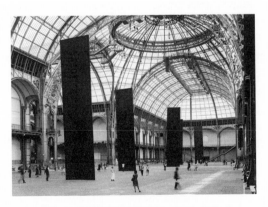

fig. 22 <u>RICHARD SERRA,</u> *Promenade,* 2008

Herbert informs us of the artist's status ('one of the most significant figures in contemporary sculpture'), which for once is justifiable, and substantiates that hefty claim: 'museums and commercial galleries [...] have scaled their spaces with [him] in mind'. He then fulfills the three-part job of communicative art-writing (see page 49). Do not underrate the skill required to single out the right idea, and make it stick.

Theme: 'A pioneering investigation of the properties and poetics of industrial metals.' [Th]

Q1 **What is it?**

A A concise description of the heavy late work is set in contrast with earlier, lighter examples [1].

Q2 **What might it mean?**

A Serra's weighty materials draw attention to two basic attributes of sculpture. [2]

Q3 **So what?**

A Herbert's reiteration of the impressive scale of Serra's sculptures returns neatly to his opener, about museums scaling their spaces around the artist's often gigantic art, and might connect to the viewer's own experience of this mammoth artwork [3].

If you're stuck finding a workable theme to guide you through a big-name long-career artist, you can always 'cheat': recycle a key idea summarized by the artist's associated big-name long-career critic, as found in your initial research. Convey the artist's stature within art history (*Who is he or she?*) without lapsing into hagiography. Get to the crux of what makes the artist important, then back it up with choice examples from varying stages in the career.

> How to write in brief about moving-image art

Inexperienced art-writers ponder how to squeeze a whole film into a short text, plus offer a modicum of analysis. Again, discover a guiding idea that runs through the art, then back it up with a couple of succinctly described examples: whether two separate artworks, or a pair of key moments or images extracted from a single work.

Andrew Dadson, born 1980, lives Vancouver

Andrew Dadson is a mischievous neighbor [Th]. In his series of deviant acts [Th], which he documents in photographs [1], he has literally and figuratively jumped his neighbors' fences [2]. The two-channel looped video *Roof Gap* (2005, [fig. 23]) records him leaping from roof to roof [1] around his neighbors' houses. Following a dispute, Dadson performed and documented *Neighbour's Trailer* (2003), in which the artist gradually moved his neighbor's parked trailer inch by inch closer to his house [1] every night. In a similarly anarchic ongoing series Dadson turns objects of suburban division, such as fences or lawns, into black monochrome paintings using black paint. These irreverent 'Land art' works attempt to reclaim the increasingly privatized suburban landscape by breaching its staid boundaries [3].

Source Text 26 CHRISTY LANGE, 'Andrew Dadson', *Frieze Art Fair Yearbook*, 2008–9

fig. 23 <u>ANDREW DADSON</u>, *Roof Gap*, 2005

**Theme: The artist's identity as a 'mischievous neighbor'
engaged in 'deviant acts' [Th].**

Q1 **What is it?**

A Photographs, as well as two moving-image works, are briefly
described [1].

Q2 **What might it mean?**

A The artist 'literally and figuratively jump[s] his neighbors'
fences' [2].

Q3 **So what?**

A Lange sets Dadson's work both in the context of art history
(Land art) and as a social commentary about the powerful
public/private boundaries that define suburbia [3].

Lange uses storytelling to encapsulate Dadson's two time-based works,
turning each performance piece into a one-line tale to get across her
main theme: the artist-as-mischievous-neighbor. She employs a wealth of
concrete nouns ('fences'; 'roof'; 'houses'; 'trailer'; 'inch') and active verbs
('jumped'; 'leaping'; 'breached') to help readers picture Dadson's 'deviant'
suburban mischief. Don't attempt a blow-by-blow summary; encapsulate
the thrust of the action, then explain why it might matter.

fig. 24 <u>AYA TAKANO</u>, *On the Way to Revolution*, 2007

Multiple unfamiliar figures and objects drift across Aya Takano's artworks; here's how Vivian Rehberg gets to grips with the Japanese artist's floating comicbook fantasyland—while suggesting where it may be heading.

Aya Takano, born 1976, lives Japan

A member of the Kaikai Kiki corporation, founded by Takashi Murakami, **Aya Takano** is known for her **liquescent drawn and painted images** [1] **influenced by popular culture** [Th], and the post-Manga Superflat aesthetic. **Built out of pale washes and colors** [1], her **fantasy worlds** [2] are populated by lean girls with budding breasts and juice-tinted lips, who frequently cavort with animals or other lovely-looking youths in imaginary lands or cityscapes. *On the Way to Revolution* (2007, [**fig. 24**]) is typical of her approach: **a massive horizontal painting** [1] of bright chaos where doe-eyed figures rush and tumble toward the foreground streaming planets, stars, helium balloons, fashion accessories, and creatures **both real and imaginary** [2]. After all, what else should you pack **for a trip to Utopia?** [3]

Source Text 27 VIVIAN REHBERG, 'Aya Takano', *Frieze Art Fair Yearbook*, 2008–9

For the London art-fair crowd reading this text, Rehberg helpfully sets Takano in relation to the noted Japanese Superflat artist with whom her audience may be familiar; then she sets up her theme and addresses the three tasks of communicative art-writing.

Theme: 'images influenced by popular culture' [Th].

Q1 **What is it?**

A 'liquescent drawn and painted images...built out of pale washes and colors'; 'a massive horizontal painting' [1].

Q2 **What might it mean?**

A Takano's 'fantasy worlds' are 'both real and imaginary' [2].

Q3 **So what?**

A The writer imagines that Takano's assortment of goodies could provide the necessities 'for a trip to Utopia' [3].

Notice all the concrete nouns with which Rehberg shows how stuffed Tayano's canvases are with the flotsam and jetsam of Japanese popular culture: 'girls', 'breasts', 'lips', 'animals', 'youths', 'cityscapes', 'planets', 'stars', 'balloons'. Concise description is further achieved through wonderfully picture-forming adjectives ('juice-tinted', 'doe-eyed') and active verbs ('rush and tumble'). Abstract nouns are limited, and arrive mostly at the end, when we've got a handle on the art: 'chaos', 'Utopia'.

> How to write in brief about an open-ended artwork

How can an art-writer encapsulate an artwork that sets out to be limitless, or unpredictable, without betraying the unconfined nature of the art? These writers, Mark Alice Durant and Jane D. Marsching, do not flatten out the maddening heterogeneity of this sprawling sound/Internet/installation artwork, but offer a sampling of the erratic sources one might encounter there.

fig. 25 <u>MARIA MIRANDA AND NORIE NEUMARK (OUT-OF-SYNC)</u>,
Museum of Rumour, 2003

Out-of-Sync, a collaboration between Australian artists Maria Miranda and Norie Neumark, has been producing radioworks, websites and installation for over ten years. Their fictive investigations of the murky border regions include 'anomalies, rumor, difference, Gertrude Stein, ducks, everyday life, trees and frogs, Jules Verne, volcanoes, Jorge Luis Borges [1]— through a variety of "scientific" approaches, from rumourology to emotionography to data collecting' [2]. *Museum of Rumour* [3] [**fig. 25**] is both an Internet work and a site-specific installation, originally installed in 2003, [in which] [p]erfectly reasonable scientific claims are set against random and marginal visions.

Source Text 28 MARK ALICE DURANT AND JANE D. MARSCHING, 'Out-of-Sync', in *Blur of the Otherworldly*, 2006

Durant and Marsching do not attempt to define all the esoteria ('emotionography') tossed into Out-of-Sync's work but hint at the variety of unrelated sources [1] and methods [2] that you might encounter there. The writers borrow a list-like quote from the artists to show the unpredictability of their references, and suggest how, for Out-of-Sync, these mirror the random content of a rumor or some pseudo-sciences. The focus on one specific work, *Museum of Rumour* [3], and visually loaded details ('ducks', 'volcanoes') gives the reader a good general impression of this artwork as a multi-media grab-bag that combines science, literature, film, religion, and more.

> How to write in brief about a multi-part project

Increasingly, 21st-century artists are engaging in complex artworks that unfold over time, involve multiple partners and media, and extend well beyond the gallery walls. In this brief text for the dOCUMENTA (13)

exhibition catalogue, which presents artist Seth Price's year-long project spanning art and fashion, occasional art-writer Izzy Tuason wisely chose to address its two principal elements—clothing and sculpture—by presenting their uniting themes:

A piece of clothing is similar to an envelope [1]: both are cut from a flat template, folded, and secured shut. Each is an empty package, awaiting content and subsequent travel [2].

In 2011, Seth Price designed a group of clothing in collaboration with New York fashion designer Tim Hamilton. Based on military tailoring, the collection of lightweight garments includes a bomber jacket, flight suit, and trench coat, among other items. Outer shells are raw canvas, a fabric with traditional military and artistic uses. The interior lining is printed with security patterns taken from the inside of business envelopes; such patterns typically feature a repeating bank logo or abstraction [...]

Meanwhile, Price prepared a second group of works for dOCUMENTA (13)'s exhibition space at Kassel Hauptbahnhof. **Developed in parallel to the clothing line, these huge, wall-mounted business envelopes are fabricated from the same materials**—canvas shells, logo-patterned liners, pockets, zippers, arms and legs—**and within the fashion industry [3]**, using Hamilton's professional network of seamstresses, pattern-makers, and factories. In the sculptures however, the ratios between the ideas are skewed differently: more ripped-open envelope than garment, they are hardly wearable. Here the human form is tacked on awkwardly, limbs dangling as from animal pelts. [...]

At dOCUMENTA (13) the two groups of work are juxtaposed, one in the exhibition halls, the other available for sale to the public [...] [4].

Source Text 29 IZZY TUASON, 'Seth Price', *The Guidebook*, *dOCUMENTA (13)*, 2012

The writer explains key differences between Price's two 'products', clothing and sculpture (one is wearable while the other is not, for example), but connects them for the reader in multiple ways:

[1] both are inspired by envelope design;
[2] both share a common theme: the empty package;
[3] both are made of canvas and produced by garment workers;
[4] both are 'available' at the exhibition, whether on sale (clothing) or on display (sculpture).

The information has been organized chronologically, working from a general theme (the 'empty package') to the specific details of each intervention. Solid nouns keep the description concise:

+ 'bomber jacket, flight suit, and trench coat'
+ 'business envelopes'
+ 'liners, pockets, zippers, arms and legs'
+ 'seamstresses, pattern-makers, and factories'
+ 'animal pelts'

This writer successfully avoids a few art-writing traps. He does not attempt a potted history of the art/fashion crossover; neither does he attempt to survey this artist's entire, varied career but follows one well-identified theme, chronology, and logical order to describe succinctly this complex artwork.

> How to write in brief about new media art

With new-media art, writing succinctly and labelling accurately have only got harder. Artist and researcher Jon Ippolito has demonstrated how, for computer-based installations and video multicasts, even compiling basic caption information—author, date, medium—can pose a minefield of uncertainty.[78] Digital art is often produced by a shifting cast of collaborators, and varies in format (technologies, dimensions) when relocated from, say, the artist's website to an online art magazine, or public display in a gallery or festival.

The following public-collection website entry regarding one version of a live web-feed work, *Decorative Newsfeeds,* has been modified from artists Thomson & Craighead's own description of their project.[79]

Decorative Newsfeeds (2004) **presents up-to-the-minute headline news from around the world as a series of pleasant animations, allowing viewers to keep informed while contemplating a kind of readymade sculpture or automatic drawing** [1]. Each breaking news item is taken live from the BBC website [2] and presented on-screen according to a simple set of rules, and although the many trajectories these news headlines follow were drawn by the artists and then stored in a database, the way in which they interact with each other is determined by the execution of the computer program. *Decorative Newsfeeds* is **an attempt to articulate the rather complex relationship we all have with rolling news and how such simultaneous reportage on world events impinges on our own lives** [3].

Source Text 30 UNSIGNED, 'Decorative Newsfeeds', Thomson & Craighead, 2004, British Council Collection website

For this complex, constantly evolving new-media work, the short descriptive text assists visitors by explaining exactly what they are looking at. Each of the three sentences assumes one task, albeit inverting the order of what I've called 'The three jobs of communicative art-writing' (see page 49), and answering a question:

Q2 **Why is this meaningful?**

A *Decorative Newsfeeds*, as well as being an artwork, presents newsfeed, 'allowing viewers to keep informed while contemplating a kind of sculpture' [1].

Q1 **What is it?**

A 'News item[s] taken live from the BBC website' that interact with a computer program [2].

Q3 **Why might this be worth thinking about?**

A The work is 'an attempt to articulate [how] world events impinge[] on our own lives' [3].

Website entries for digital art often require constant updating; a new media artwork 'must keep moving to survive'—like a shark, as Ippolito puts it.[80] Dates are especially slippery; an ongoing digital work begun in 2004 but subsequently revised can be dated '2004', '2004–ongoing', '2004/2014', or more. If possible, seek first-hand information directly from the artist or their authorized website.

> ## Notes on exhibition wall labels

Viewers spend an average of ten seconds reading a museum label;[81] a writer will put in hours of research to extract the right ten-second text. Attentive observers like artist Meleko Mokgosi in *Modern Art: The Root of African Savages* (2013, a heavily annotated museum label riddled with her handwritten commentary), can expose the many assumptions therein.

Avoid the Sesame Street-level content of this label, which *Burlington* magazine spotted accompanying a Braque still-life in a Glasgow museum:

If Georges Braque was struggling with a complex painting, he would often paint still lifes to clear his mind. The bowl of fruit in his studio also provided a handy snack![82]

You don't want contemporary-art skeptics to declare that, not only could their three-year-old create better art, she could compose more illuminating text to go with it. Only research raises your label above such infantilizing trivia. Your label may also need to let visitors know what they can or cannot do; whether they are invited to:

+ touch the artwork,
+ operate the handle,
+ move the mouse,
+ take a sheet;

or, as in the case of this label photographed at MuMOK, Vienna in 2012, ignore the artist's original commands (*Franz West self-contradicting museum label*, fig. 26).

Gray

Sit down on the gray chair on the pedestal. If you want, you can also set the gray loop on your head, like a cap. If this head covering does not fit well, then hold it like a vase, with one or with both hands. Stand up and walk back and forth like this—do not leave the gallery though! Consider the fact that you have taken on the topos of art.

Franz West, 1998

For reasons of conservation and contrary to the instructions provided by Franz West, this work mustn't be used or touched.

fig. 26 *Franz West self-contradicting museum label, MuMOK, Vienna.*
Photo Catherine Wood

> On the house: following house style

If you are asked to write for an established museum or collection (or publisher), they will have a 'house style' that ensures consistency across all their texts. Get a copy, and obey it to the letter. Is it circa, *c.* or c.? If you need a reliable example, look up a favorite professional website (say, the Art Gallery of Ontario, or San Francisco MoMA—there are hundreds) and follow their system. Check (or decide, and stick to) policy *for every detail*, and be consistent. For captions, often the order is: artist; title; date; medium; dimensions; collection. Additional information can include: photographer; provenance or acquisition history; collection reference numbers. Unless otherwise specified, for wall labels choose a 14-point font size or larger, always sans serif, to ensure legibility.

> *How to write a press release*

Truly, the saga of the contemporary art press release deserves a chapter unto itself. In most other sectors, this modest sheet of A4 serves merely to:

+ inform the industry, an editor, or a reporter of a newsworthy item, usually bearing a banner-line header for instant communication, in the hope of media coverage;

+ provide journalists with the bare-bones, plain language from which to pen a news item;

+ offer full contact info details (*'for further information, please contact'*); a decent copyright-free picture, and a pertinent quote or two. Job done.

The press release is structured as a no-frills 'inverted triangle' (see page 126): an infomercial that prioritizes news in order of importance. Once upon a time, art-world exhibition press releases were likewise fairly normal, useful one-pagers where a journalist would find straightforward information.

Here are the key elements extracted from two relatively sober examples (by art-world standards): one announcing the recipient of a notable art prize, 'Stan Douglas wins the 2013 Scotiabank Photography Award'; the second about a private gallery solo exhibition, artist Harun Farocki on view at Raven Row, London, 2009.

Scotiabank is thrilled to announce that Vancouver's Stan Douglas has been named winner of the third annual Scotiabank Photography Award [1] [...] The prestigious prize provides the winner with $50,000 in cash, a primary Scotiabank CONTACT Photography Festival exhibition in 2014 and book to be published worldwide by international art publisher Steidl [2].

'Stan Douglas has helped define and enrich the Canadian art and photography landscape with his outstanding artwork,' said Edward Burtynksy, Chair of the Scotiabank Photography Award jury and co-founder of the Award. [3] [...] Based in Vancouver, Stan Douglas has created films, photographs, and installations that reexamine particular locations or past events [4]. [...]

Stan Douglas was selected from a group of three finalists, which included Angela Grauerholz and Robert Walker, by a jury of some of photography's most respected experts: William Ewing, Director of Curatorial Projects, Thames & Hudson [...]; Karen Love, Independent Curator and Writer, Director of Foundation and Government Grants, Vancouver Art Gallery; Ann Thomas, Curator, Photographs Collection, National Gallery of Canada [5].

Source Text 31 UNSIGNED, 'Stan Douglas wins the 2013 Scotiabank Photography Award', 2013, Scotiabank website

[Raven Row announces] the first UK exhibition of the two-screen and multi-screen works of revered German filmmaker Harun Farocki [1]. [...] The survey comprises nine video installations from his first two-screen project *Interface* in 1995 to *Immersion*, 2009, about the use of virtual reality in the treatment of traumatized US soldiers following the occupation of Iraq [2].

Since the sixties, Farocki (born in 1944, living in Berlin) has reinvented what can be described as the film essay. [...] In the mid-nineties, Farocki began making films for two, and occasionally more, screens [4]. [...]

The exhibition is curated by Alex Sainsbury. It is linked to 'Harun Farocki. 22 Films 1968–2009', a season of Farocki's single-screen films and events at Tate Modern, 13 November–6 December 2009, curated by Stuart Comer, Antje Ehmann and the Otolith Group [5].

Source Text 32 UNSIGNED, 'Harun Farocki. Against What? Against Whom?', 2009, Raven Row website

[1] **A one-line header,** or short paragraph, with the main announcement;

[2] **information about the immediate event** or exhibition (up to four lines)—what is the award; which works are on view;

[3] **a pertinent (jargonless) quote;**

[4] **essential background on the artist** (up to four lines);

[5] a short **final paragraph with the fine print.**

In addition, include the gallery's details: address, opening hours, website/email, phone number; name of press contact. (Separately), send a directly relevant, good-quality picture (minimum resolution 300dpi), available for usage, with *all* caption info: artist, title, date, medium, dimensions, venue, name of photographer.

If you follow the above basic model, first take an oath to obey the section, Do not 'explain' a dense, abstract idea with another dense, abstract idea (page 71). And if, despite your efforts, when you've finished writing the press release you are somehow too ashamed or otherwise reluctant to show the artist your text about her own show, *that is a bad sign*. Rewrite it, keeping the words simple but smart.

> Practical tips

Choose the right photograph. A picture is worth a thousand blurbs. You want a clean and highly legible image, usually of a recent work: the press always want super-current—or, even better, tomorrow's—news. To judge how well a photograph will print in a newspaper, photocopy it in black-and-white: if the photo dies in a sea of gray, pick another where the image stands out, with starkly contrasting darks and lights. (This trick works even if the image will be published in color or on the web.)

Presentation and clarity are paramount. For print-outs, prefer double-if-not-triple-spaced, breathable press releases from which the journalist can extract the essential information effortlessly. An art-critic will glance over the press release and absorb the headline artist/gallery/exhibition, or scan for key facts. Be sure always to include any really basic background info: materials; process, or how the work was made; perhaps how the artist arrived at this idea—hard information, rather than conceptual jibber-jabber. A *pertinent artist's, curator's, or critic's state-ment* (always missing; why?) might throw some light on what's going on. Fabulously comprehensive gallery or artist websites, with every scrap of criticism, interviews, artist's statements, catalogue texts, and images of artworks, provide any critic with all the research she will ever need. *Facilitating tactics like these help attract coverage.*

Hooking the press

No member of the press is ever going to open your email and promptly drop everything to rush and see the *'first-ever exhibition in Antwerp of this exciting new-media artist, born 1973 in Wysall'*. For mainstream press interest, you will need a newsworthy, eye-catching, general-audience hook. **Perhaps your exhibition showpieces a human skull, covered in 8,601 diamonds, with a 52.4 carat pink diamond on its forehead and carrying a £50 million price tag?** Or, all proceeds go to Amnesty International; or the artist worked with disadvantaged kids—that sort of thing? At the very least, to gain broad (non-specialist) coverage your exhibition must be connected to a book-launch, new film, or major exhibition; or it must include outrageously rare or valuable work.

Having a genuine art-critic review your show is a subtler endeavor. Art-critics receive daily many dozen gallery press releases, the majority of which they delete unread and in bulk. In general, their review choices are independently made, and drawn from regular rounds of the galleries; occasional leads from trusted colleagues; artist studio visits; art-world buzz; some online research. Artists—when they're not plugging their own shows—can be reliably counted upon for valuable go-see recommendations. If you want the critics to beat a path to your gallery, here's my advice: make friends with as many art-critics as you can, put on the best exhibitions that you are able, then do whatever it takes to get them through the door (see FAQ, How to write an exhibition review for a magazine or blog, page 163)

There is no law stating you must produce a single, one-size-fits-all press pack. Consider tailoring the content and quantity of press materials to suit the needs of your target media.

Make your news super-easy to insert, as is. Galleries expect magazine staff writers to do all the hard work of transforming the impenetrable prose and partial information in their press release into publishable news. No hyperbolic praise seemingly written for and by the artist's mother ('*the world's greatest living sculptor*'); no artspeak lunacy; no missing information (who-what-where-when-how-why, all present and accounted for), with a punchy headline and media-friendly quotes, plus a copyright-free, exclusive, fully captioned, high-res photograph.

> Fifty Shades of Press Release

Oddly, as contemporary art gets hotter, the gallery press release seems only to grow more daft. This curious sheet of A4 persists as our dottiest institution: a law unto itself. Ghostwritten by interns; burdened with the contradictory task of both clarifying and mythologizing the art on view; religiously ignored by the press, 'gallery *press* release' is an accepted misnomer. Yet some day, when these are all professionally compiled by PR firms staffed solely by Ivy-league communications grads, we might miss those nutty print-outs, all typos and non-sequiturs and run-on sentences. The gallery press release is art-writing's favorite problem-child.

Perhaps the press release serves to compensate for the dearth of *actual coverage*, and fulfills mostly ritualistic functions (see page 17 in the Introduction); at least *somebody* wrote *something* if a press release exists. Some have embraced the special weirdness of this document and invented variations based on the paradox of the 'signed press release', likely to leave gallery-goers visibly more—rather than less—mystified. *That is their point.* The press-release-as-mini-exhibition-catalogue can take the form of:

+ **an extended artist's, curator's, or critic's statement:** such as artist Christopher Williams writing on his own show, David Zwirner Gallery, New York, Jan—Feb 2011;[83] critic Mike Sperlinger writing on sculptor Michael Dean, Herald Street Gallery, London, May 2013;[84]
+ **commentary from another artist:** such as artist Francesco Pedraglio, for Marie Lund at Croy Nielsen

Gallery, Berlin, Sept—Oct 2012;[85]
+ **creative writing:** such as J. Nagy, on Loretta Fahrenholz at Halle Für Kunst Lüneburg, May 2013;[86]
+ **innovative graphics/stand-alone artwork:** such as Charles Mayton at Balice Hertling, Paris, Dec 2012;[87]
+ **a collection of 'parables' loosely related to the show's theme:** such as A.E. Benenson, for Torrance Shipman Gallery, Brooklyn, New York, Mar–May 2013.[88]

Curator Tom Morton's revised press release/interview for his 'Mom & Dad Show' at Cubitt Gallery, London (February 2007; the exhibited artists are the curator's parents) revealed all the 'track changes' and behind-the-scenes commentary, to help us grasp what an intensely fraught print-out this is.[89]

These alternatives testify to just how off-the-leash the gallery press release has become, and can be *among the best things in the show*. Generally speaking, these variations imply a confident and knowing author behind them, well-versed in art-world conventions and able to spin off them. If you attempt these options or invent your own, be sure that all involved— artist, gallery—are OK with your novelties. Galleries sometimes have two press releases: one playing it straight, supposedly geared at the press, and a second 'alternative' variation—just like the project space adjacent to the traditional museum.

> ## How to write a short promotional piece

A short promotional text, for a museum brochure or website for example, is a mini-press release, crossed with a mini-news item. Sometimes who/ what/where/when details are piled up near the header, to free the text for a basic descriptive understanding of the exhibition or artist's work.

Robin Rhode: The Call of Walls, 17 May 2013—15 Sep 2013. National Gallery of Victoria International, 180 St Kilda Road [1]

Robin Rhode is a South-African artist based in Berlin who works in photography, animation, drawing and performance [2].

'The Call of Walls' is an exhibition of new works [**fig. 27**] that derive inspiration from **the streets and politics of his hometown Johannesburg** [3]. Rhode's witty, engaging and poetic works make reference to hip-hop and graffiti art; to the histories of modernism; and to the act of creative expression itself.

A special exhibition for youth and families will accompany Rhode's **photographs and animations** [4]. This unique project extends the artist's interest in wall drawing and **encourages participants to come together to draw and color in an interactive installation** [4] of large-scale paste-ups.

Source Text 33 UNSIGNED, 'Robin Rhode: The Call of Walls', 2013, National Gallery of Victoria website

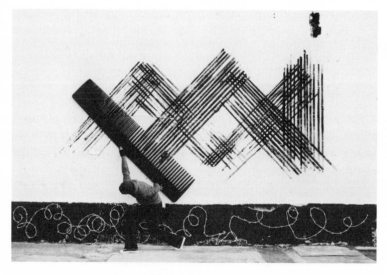

fig. 27 <u>ROBIN RHODE</u>, *Almanac*, 2012–13

This modest 100-word text does not attempt, say, a full-scale analysis of post-apartheid South Africa or a debate on the status of street-art, but sticks to the simple job of explaining:

[1] **Who/what/when/where:** 'Robin Rhode: The Call of Walls, 17 May 2013—15 Sep 2013, National Gallery of Victoria International';

[2] **Media (what kind of work?):** 'photography, animation, drawing and performance';

[3] **Key idea:** 'the streets and politics of his hometown Johannesburg';

[4] **What to expect on your visit:** you will see 'photographs and animations'; also, 'participants [are encouraged] to come together to draw and color in an interactive installation'.

The idea is to entice viewers in straightforward language, hinting at what's on show and suggesting why a visit is worth their while. You want to convince the art habitué she shouldn't miss it, but to avoid alienating potential first-time visitors.

> *How to write an auction catalogue entry*

The auction catalogue blurb is, usually, a classic piece of 'unsigned' art-writing. It pulls together dependable technical and numerical details (dimensions; materials; provenance; and more) and authoritative art-historical information to present artworks in their most attractive light for a potential buyer. In sum, such a text aims to establish worth. In terms of this book's division between art-writing's two main tasks—'explaining' and 'evaluating' art—the auction entry is plainly a paradox (see Explaining v. evaluating, page 20). While clearly in the business of selling and attributing value to artworks (literally, a price), the style and content of auction-house texts revolve around 'straight', research-based, art-historical explanation:

+ how and when the work was made, exhibited, and received;
+ its place within art history, the broader historical context, and the artist's own life and career.

With rare exception, the auction house participates solely in the artwork's *secondary market*, i.e. the acquisition and sale of work that has been owned previously. The catalogue entries on these works are usually written in-house by trained art historians—auction staff writers, researchers, and experts, possibly with the input of others including the Head of Sales. Their length varies immensely, from

+ lengthy technical information (always impeccably compiled) with no added verbiage;
+ longish caption;
+ medium-sized article;
+ to book-length investment

in proportion to the work's significance and expected return. Their content may further benefit from the expertise of

+ outside art-historians;
+ artist's estates;
+ the representative gallery;
+ and, potentially, the artist herself.

The auction catalogue is rarely where new art-historical research will surface. Fanatical accuracy and transparency of sources is imperative. The auction catalogue blurb isn't just informative art-writing; it represents *due diligence*, a legal term.

Due diligence: 'appropriate, sufficient, or proper care and attention, *esp.* as exercised to avoid committing an offence; a comprehensive appraisal undertaken by or on behalf of a prospective buyer'—*OED*.

Research must be flawless, with evidence drawn from

+ first-hand expertise of knowledgeable insiders;
+ the catalogue raisonné (if one exists)—the official, comprehensive publication listing of every work (or type of work) by one artist, meticulously compiled;
+ noted publications from a museum, university press, or a recognized dealer in this artist's career;
+ or the artist's own verifiable words.

It might be described as a compilation of 'unassailable' evidence—if dripping with superlatives. The auction catalogue's *factual* data (technical details such as materials and dimensions; exhibition history; literature; sourced quotes from artists or critics) qualify as the firmest historical information, even for academic work, and are carefully ascertained through uncompromising, verifiable research. Forget anything that smacks of theory, academic jargon, or free-flowing commentary that might declare your own personal, interpretative response. However, the auction blurb should not read as a dry encyclopedia listing or academic treatise, but must be fairly lively and engaging, using (attributed) quotes and anecdotes about the artwork's making, display, or former owner.

All of these, however discreetly, are at the service of confirming the cluster of *values*—whether commercial, art-historical, intellectual, or symbolic—centering on an artwork. This is a minefield: *how do artworks accrue value?* A flourishing sub-genre of research exists, devoted to the big art-story rocking the 21st century: the expanding cosmos of art/money relations.[90] For art-market expert Noah Horowitz, author of *Art of the Deal: Contemporary Art in a Global Financial Market* (2011), the basis for art's value divides into three: economic, critical, and symbolic.[91]

+ **economic:** what were the achieved prices?
+ **critical:** what makes this artwork unique (within art history, the artist's *oeuvre*, the history of the medium)?
+ **symbolic:** what is the artwork's social cachet?

The first, *economic value,* is suggested in the catalogue by market experts, appearing in the estimate bracket. Much auction essay content seems to focus on the second, *critical value.* The last one, *symbolic value,* is also key to the accompanying text, but is swayed by what Horowitz calls 'softer variables'.[92] Whatever finally seals the deal when it comes to the *symbolic value* acquired in contemporary art-buying—the art represents an indispensable addition to an ongoing collection, public or private; or convinces as a sound investment; or 100% resolves an empty stairwell; or just makes the owner happy and proud—is anybody's guess. Symbolic value may accrue through curious stories or details surrounding the artwork's making or its subsequent history that might pique the buyer's interest. Soundly researched, the auction catalogue essay must strike the balance: neither dry art-historical essay nor aggressive sales pitch.

The auction blurb tends to open with a kind of 'lead', or an enticing opening sentence or paragraph. Auction catalogue layouts today can resemble glossy magazines, sometimes displaying full-page bleeds and easy-to-read pull-quotes propping up a big sale. Ideally, the auction catalogue entry is a jargon-free, expertly informed, enthusiastic, readable piece of art-writing.

This example is extracted from an entry for a major painting from the French Modern master Jean Dubuffet, *La Fille au Peigne* (1950), on sale at Christie's, New York, in 2008:

La Fille au Peigne is **one of the very first paintings** that Jean Dubuffet created for his *Corps de Dames* series. This series, which he worked on from April of 1950 to February of 1951, is widely acknowledged as **the most important body of work in Dubuffet's entire career** [1]. The *Corps de Dames* series **consists of only thirty-six works** [2], each dedicated to a monumental female nude, **many of which now belong to prominent international museum collections, including the National Gallery of Art in Washington D.C., the Centre Pompidou in Paris, the National Gallery**

in Berlin, and the Museum of Modern Art in New York [3]. Through the *Corps de Dames*, Dubuffet effectively challenged not only traditional conventions of female beauty, but also **defied all customary aesthetic principles of painting itself** [4]. Dubuffet's dramatic upending of art-historical tradition, which would have wide repercussions in the history of post-war art, is exemplified in the inventive handling of both paint and figure in *La Fille au Peigne*.

Nothing in the history of art quite prepares one for the sight of Dubuffet's *La Fille au Peigne*. **In the catalogue for his retrospective** [5] at the Museum of Modern Art in 1962, Peter Selz declared the *Corps de Dames* as being 'surely among the most aggressively shocking works known to the history of painting [...]' (P. Selz, *Dubuffet*, New York, 1962, p. 48) [...] Although it has some affinities,[93] **such as the corpulent Venus of Willendorf** [6], it goes beyond a mere primitivizing depiction.

Source Text 34 UNSIGNED, 'Jean Dubuffet (1901–1985), *La Fille au Peigne*, (1950)', *Christie's Postwar and Contemporary Art Evening Sale*, 2008, New York

This entry, with its traces of mid-20th-century formal art-talk ('inventive handling of both paint and figure'; 'primitivizing depiction'), brings to mind the old-time *connoisseur*, a figure once closely associated with the big-money art trade. Its hint of plummy speech might still sound classy and reassuring to some buyers. Auction catalogue prose is never over-specialized or polemic. Unlike a museum label potentially geared at school-trippers, auction-text is strictly for grown-ups. Readers are treated flatteringly, as if they are all comfortably conversant in art matters.

Notice how the text establishes economic, critical, and symbolic values for this 'monumental female nude', which:

[1] **holds a special place in the artist's life or career,** for example the artwork is representative of the artist's most recognized style; dates from the period of the artist's finest work; or is a successful example from one body of the artist's *oeuvre*. The artwork's historical significance can be bolstered with relevant archive imagery, such as a preparatory sketch; a photograph of the artwork hanging in the artist's studio or an early exhibition; or the artist's source material, such as an inspirational personal photograph;

[2] **is rare,** for example is recognized as '*among the finest*' of a period; or belongs to a limited series; or is just rarely available to buy;

[3] **belongs or belonged to a noteworthy collection,** public or private. This pedigree is called 'good provenance', and is listed within the extensive caption information;

[4] **is part of 'the literature'.** The writer(s) will research instances in which significant critics and historians have mentioned the work in major catalogues, books from the university presses, and specialist periodicals of note. Was the artwork illustrated?

[5] **has a significant place within art history.** Beyond 'rare', we might dare whisper 'masterpiece': an outmoded term and virtually taboo in any other contemporary art-writing context, it is reserved for a sale's real showstoppers.

[6] **can be compared with another artwork by the same artist, a predecessor, or peer**—because it bears some resemblance, or shared the same concerns. In addition to the Venus of Willendorf, later in this entry *La Fille au Peigne* is compared to Willem de Kooning's *Women* dating from the same period. Other illustrations include female nudes by Degas and Picasso.

All quotes are meticulously sourced within the text (not footnoted). Further in this two-page essay, among other things, we find:

+ *a definition of 'Art Brut'* ('Raw Art'), the specialist term associated with Dubuffet;
+ *relevant information about the artist's interests* (he was keen on the art of children, for example);
+ *artist's quotes*, such as, 'It pleased me [...] to juxtapose brutally in these female bodies the very general and the very particular [...]';
+ *an aside about the textured paint*, possibly mixed with sand and applied with a trowel, not a brush—likening the surface to a kind of 'rugged', earthy terrain;
+ *a final quote* by the noted critic Michel Tapié, who around the time of this artwork wrote that Dubuffet's art is 'profoundly human'.

Attributes of value are gracefully presented in an auction catalogue text: the writer is not just pounding out reasons to buy this artwork. The skill of the job is to intuit the elements about the art, found in careful research, that maximize believably the work's economic–critical–symbolic value.

> The 'art-world's native tongue'?

At its best, the auction catalogue entry sets the standard for accessible and concise scholarship. Perusing these catalogues, one gets the impression that the older the artwork, the more dignified the text. At its worst, this sales pitch can occupy a rung barely a notch above the low-grade gallery press release.

> Simultaneously self-portrait, biomorphic composite and minimal totem, *Nature Study* from 1984 consummately summates Louise Bourgeois' negotiation of sexual politics via an extraordinarily loaded and often surreal host of visual referents. Elegant and luxuriant in appearance, the delicately swollen bronze pillar and polished gold appendage integrates a serene Brancusian aesthetic with an ambiguous articulation of phallic potency and female fertility.[94]

'Consummately summates'? 'Elegant and luxuriant in appearance'? What next, *'fine Corinthian leather'*? Most auction catalogue entries are fairly

Auction catalogues: the fine print

An expert (not the writer/researcher) may furnish or confirm portions of the detailed technical information required. You must check exact guidelines for your company or publication (which may require more, less, or different information), but published auction data might run like this:

Artist(s)'s name(s); dates of birth (and death);

Title—Triple-check this; is the Basquiat drawing called *Furious Man* or *The Furious Man?*

Signature—Give any inscriptions on the reverse or anywhere else on or around, the work; this information is furnished by an expert;

Detailed list of materials—Highly detailed and informed: never *'mixed media'* but, for example, *'cast silicon, bronze, and polyurethane paint'*, or *'oilstick, acrylic, and ink on paper'*;

Dimensions—In *cm* and *in.*, usually measured to the first decimal point (cm), and ⅛ inch;

Date executed (year or years)—Usually, disclose any discrepancies or variations here; this requires research;

Edition—If applicable, including artist's proofs, unique variants and more;

A price estimate—The presale lower and upper estimate, established by auction house experts, in currency (£, Ä, $, ¥, and more, as required). The seller(s)'s reserve price (usually somewhere above the presale low) is conspicuously *never* published. Calculating or anticipating these figures accurately is usually well outside the writer's responsibilities.

Provenance and acquisition history—Where has this work been since it left the artist's studio, up to the current owner? Requires research and expertise.

Exhibition history—Can include all viewings, public or private;

Specific bibliography, or 'literature'—Head for the library; find reputable references (such as exhibition catalogues) that ideally specify *this artwork*. Was this artwork illustrated, in color or black-and-white?

respectable; but the weaker examples can read like over-enthusiastic BA assignments, if professionally fact-checked and proofread.

The open secret is that auction catalogues are consulted mostly because they supply some very special information: an artwork's provenance, exhibition history, and—a drumroll, please—the all-important estimated *price-bracket*. This revelation is so singularly exciting that, frankly, little else on the page can compete. Auction catalogues represent a rare public airing of art prices, however approximate; few real players read past that opening gambit. Even the most meticulously researched, perfectly worded essay will fade to gray when printed beneath a jaw-dropping 6-, 7-, or 8-digit figure.

Here is little-known writer Alice Gregory, whose states that her day job shortly out of college was to pen auction catalogue copy, describing her understanding of the requirements:

The essay copy is mostly a formality, but it plays a role in the auction house's overall marketing strategy. The more text given to an individual piece, the more the house seems to value it. I **sprinkled** about twenty adjectives ('fey', 'gestural', 'restrained') amid a small **repertory** of active verbs ('explore', 'trace', 'question').

I inserted the phrases '**negative space**', 'balanced composition', and 'challenges the viewer' [1] every so often. *X's lyrical abstraction and visual vocabulary* [1]—*which is marked by dogged muscularity* [1] *and a singular preoccupation with the formal qualities of light* [1]—*ushered in some of the most important art to hit the post-war market in decades.*

I described **impasto**—**paint** thickly applied to a **canvas**, often with a **palette knife**—almost pornographically and **joked** with friends on Gchat that I was being paid to write **pulp**. Pulp was exactly what I was writing. It was embarrassingly easy, and might have been the

only truly dishonest part of the […] **enterprise**. In most ways, the auction house is **unshackled** from intellectual pretense by its pure attention to the **marketplace**. Through its **catalogue copy** (and for a time, through me), it makes one small concession to the art-world's native tongue.

Source Text 35 ALICE GREGORY, 'On the Market', *n+1 Magazine*, 2012

Actually, this is pretty good art-journalism. Its mix of insider knowledge and confidential chattiness characterizes one promising strain of Y-generation art-writing. It is disheartening to learn that Ms Gregory felt her auction-house work hinged on disguising her obvious knack for language. Notice how Gregory's words tally with many suggestions in Section Two, 'The Practice': her deliberately 'bad' art-writing is a pile-up of vague abstract concepts [1] (see Do not 'explain' a dense, abstract idea with another dense, abstract idea, page 71). Her good-quality 'real' writing favors solid nouns and well-chosen verbs (in **bold**; see pages 74 and 79, 'Load your text with solid nouns' and 'Gorge on the wildest variety of strong, active verbs'). 'The art-world's native tongue' does *not* need to be crummy writing.

Happily, there are exceptions to Gregory's account. Christie's publication *Andy Warhol's Green Car Crash (Green Burning Car I)*, produced for its May 2007 sale in New York, for example, which includes a short piece by the legendary collector/curator/museum director Walter Hopps, a well-researched essay by Robert Brown, and rare archive photos and texts—while confirming Gregory's volumes of copy: volumes of cash ratio, at 100+ pages—can sit comfortably on any shelf of serious Warhol literature.[95] The freshman level of some auction catalogue content is jarring, because auction specialists are among the most clued-up in the business. No one knows more about market behaviors, or so many artworks' technical nitty-gritty and tangled genealogies, than the top brass at the big auction houses. These pros could write compelling sales-copy in their sleep—plus spice it up with some serious gossip, if that were permissible.

3

'Evaluating' texts

> *How to write an exhibition review for a magazine or blog*

First, go and see plenty of exhibitions. Your city may have a printed or online local gallery guide listing where to go. Most private-gallery exhibitions are free, while public-museum entry fees vary. Check for byzantine opening times, and attend as many

+ gallery shows,
+ openings,
+ performances,
+ art parties,
+ pop-up events,
+ book launches,
+ and art fairs

as you can squeeze your way into. Scour active art neighborhoods, but discover unexplored shows too. Unless you're writing about online art, the web cannot replace face time with the art and the gallery people. Be adventurous. Have a ball.

Choose an exhibition that sticks with you. Unless your tutor or editor selects the show (in which case, see it and respond honestly) choose art that makes an impression on you, good or bad. When you've targeted the right exhibition, spend time there. Look closely; take notes, describe the art to yourself. For a video, installation, or any complex artwork, jot down memorable phrases and images while looking (at the *whole thing*, of course: start to finish). You will need these details later, as examples in your text. Exit the gallery feeling you know the art. While it's fresh in your mind, write any ideas or phrases that come to mind (although many will come later, as you write).

Here's a tip: first consider reviewing an artist *of your generation—maybe even of your culture and outlook*. If you want to sound like you know what you're talking about, then **know what you're talking about. Truth is, most art-writers write best about artists roughly their same age, give or take a decade.**

Unless you've accomplished heaps of pioneering research on a veteran artist and possess a valid new approach (this entails years of work), you will struggle to add convincingly to what's been said, especially in just 500 words. Be realistic: don't pitch an Eva Hesse review to *Artforum*; they've got Briony Fer, who's been writing exquisitely on the late artist for years. Revised perspectives and new ideas are welcome, but beware of coming across as under-qualified, rather than inventive. If you're young, remember that many art mags are searching for hot new art reviewed by hot new critics anyway.

Never, ever assume your reader has seen the exhibition; in fact, assume your audience has never come within a mile of the gallery, or has ever heard of the artist(s)—unless it's a bonafide superstar. Be sure always to explain selectively what the art *is* before extrapolating meaning:

+ what is the art made of?
+ how big is it?
+ how long does it last?
+ what's in the picture?
+ what did the artist do?

Given that you cannot describe every last material property of what's on show, however, you might well ask, '*How do I choose which attributes, or which works or moments of the exhibition exactly, I should describe?*'

To answer this, take inventory of the specific points in the art that seem to hold meaning: which of those details, or artistic decisions, contributed to *your thinking*—or argument, or perspective—on the work? Always introduce one strong idea of your own into your review; you

will not find this in the press release or the curator's statement: only by looking *for yourself*. Think of *one* good way in to the work. Inexperienced reviewers ricochet from one interpretation to the next. First paragraph: it's about gender. Second: it's about national identity. Third: U-turn: it's about the history of photography. Follow one idea through—which of your brilliant angles is the most promising, the most comprehensive to understanding the whole show? To quantify: in 500–800 words, one good idea is plenty. Over a thousand, you may need to stretch your imagination. Under 500, one opinionated, punchy concept is your only hope for making an ounce of sense.

Warning: do not distort your interpretation of the work to vent some madcap thesis. Your idea should genuinely emerge from looking—closely, with curiosity and generosity. **Further warning: your idea should be thoughtful, and fairly original.** If your conclusion is that—lo!—the viewer activates and completes the work, recall that Duchamp said so in 1957, and that is one tired horse. If your 'idea' rehearses comatose notions about **'blurring boundaries'** or **'challenging preconceptions'**, you must work harder. Admit that such 'ideas' are dead-on-arrival. A good idea is risky; **take a risk.**

Seasoned art-writers often form their guiding idea while writing, in an exploratory way; upon its discovery, they polish their main point as they revise. A novice may need actively to discipline their review. Spell out your umbrella concept in a maximum of 25 words and tape it to your laptop. It may be a one-word theme or principle. But remember: *your idea, or observation, does not function to straightjacket the artworks, only to help shape the review's content.* Do not to force the art to comply with your interpretation; just observe where you find—or complicate, perhaps

even contradict—that theme in the art. The idea may change or grow as you write; that's OK. If you set off writing and stumble upon a better thesis, or your first idea isn't working, you may need to trash that attempt and have another crack at it.

Even some very experimental online review writing, such as Hilton Als's evocative response to the exhibition 'Subliming Vessel: The Drawings of Matthew Barney' at the Morgan Library & Museum in New York, revolves around one theme: masculinity, and the ways Matthew Barney's show stirs up Als's memories of his father. This is how he begins:

Let me tell you something about Daddy. He was very handsome, a lady killer who buried two partners while he lived in his own isolation. You could not reach him except by telephone; he was inviolate, the chief citizen in his own word-filled world. Daddy didn't like to share. He had a room in his mother's house, but he preferred his children visit him in a cinema, a restaurant, any place that helped him preserve the sanctity of his own skin and fears.

Source Text 36 HILTON ALS, 'Daddy', 2013

From there Als weaves his intensely private reflections around his recent experience of Barney's exhibition, which spans—among all the arcana gathered there—such testosterone-driven subjects as weight-lifting, Houdini, and Norman Mailer. The writer gracefully intertwines three strands: his childhood, the art, and his own reckoning about 'exhausted masculinity'. Even such unique and personally risky art-reviewing as Als's can be seen as held together by an over-arching idea—masculinity—cohering the whole.

Your shining idea will determine:

+ how to order the material,
+ what to cut,

+ where to pay special attention,
+ which artworks and details to include.

It will shape your descriptions: what exactly in the art provoked your stupendous idea? Your guiding thought will come to your aid especially when discussing:

a moving-image work—
How much of my text is spent just telling the on-screen story?
a group show—
Which artworks and artists do I concentrate on; which can I omit?

Questions such as those—and others raised by inexperienced reviewers—

+ *Do I need to include the artist's biography?*
+ *How many artworks should I talk about?*
+ *Should I quote the artist?*
+ *How much description, and how much analysis?*

—can be answered by asking: does this information fan the principal fiery idea behind your review? If not, drop it.

If you're stuck for an idea, try writing a few pre-idea, stream-of-consciousness pages. Keep only the valuable bits where your theme gains momentum. And, if after thinking hard absolutely no idea hatches in your mind: how about switching exhibition? The trouble might be your lack of imagination—or, this uninspiring show draws a blank. *This 'art' may not be worth pondering.* Either discuss this art vacuum intelligently, or find another show—one that sets your imagination on fire.

In Jan Verwoert's review of Neo Rauch (David Zwirner Gallery, New York, October 2004), he calls into question the painter's relationship to his emphatically Germanic subject matter. Verwoert acknowledges the paintings' perfect craftsmanship, and recognizes their supposed 'ironic distance' from uneasy moments of German history, but suspects that Rauch's virtuoso—but uncritical—paintings only fuel a Teutonic stereotype. In these segments, notice how the critic 'joins the dots' in his interpretation, and substantiates his observations in the artworks themselves (see Follow your thinking, page 62).

Supportive interpreters of Neo Rauch's work have argued that, by re-staging and emptying out the heroic iconography of Socialist Realism in his paintings, Rauch commemorates the death of the ill-fated state-socialist Utopia [Th] of the German Democratic Republic. [...] *Lösung (Solution*, 2005 [**fig. 28**]), for instance, shows a small country house around which figures in period costume from different centuries perform grotesque acts [1]. There is a soldier dressed in a late 18th-century uniform leisurely executing a man in football gear from the 1950s. [...] Admittedly, the scene is absurd; still, the sombre expressions of its cast and the pathos...are what anyone would think of as typically German [2]. [...] Rauch is too much of a virtuoso to seriously question the power of his paintings and dare mess up their perfection. [...] His paintings remain what they are: mythical celebrations of a confused sense of Germanic identity lacking any kind of critical sensibility [3].

Source Text 37 JAN VERWOERT, 'Neo Rauch at David Zwirner Gallery', *frieze*, 2005

Verwoert presents his single idea, then follows it through the text, answering the questions posed by a classic art-writing structure (see The three jobs of communicative art-writing, page 49):

> **Theme:** 'Supportive interpreters of Neo Rauch's work have argued that...Rauch commemorates the death of the ill-fated state-socialist Utopia' [Th].
>
> Q1 **What does the art look like; where can you see this idea?** [1]
> Q2 **What might it mean?** [2]
> Q3 **Why might this matter?** [3]

In the full text, Verwoert provides plenty more evidence to drive home his argument. He never loses sight of his main concept—this artist is out of touch with the reality of contemporary Germany, playing into a worn myth rather than commenting upon it—and Verwoert's chosen details are united by that conclusion. The critic does not attempt to cover every

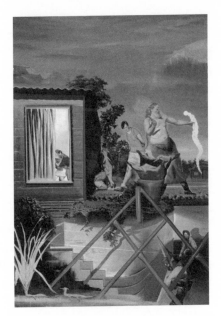

fig. 28 NEO RAUCH, *Lösung*, 2005

painting, nor does he veer off into non-sequiturs (say bringing up Clement Greenberg's painting dogma, out of the blue).

Not everyone was as harsh about Rauch's 'Renegaten' exhibition. *Artforum* reviewer Nico Israel, who also plucked out *Lösung*, thought the opposite: this painting demonstrates the artist's 'pervasive sense of disgust' for his subject matter.[96] In the *Village Voice*, Jerry Saltz shared Verwoert's reservations, but on different terms: 'Rauch's are lifeless, sexless phantoms of a painted world. Although several of these paintings are stunning, I think they could be hard to live with.'[97]

As a reviewer, your singular focus is not purported as the only valid perspective, rather it condenses the gist of your considered opinion, as observed in the art, binding your review together.

> FAQ

1 How do I get published? Can I just send in my review?

Generally, newspapers have staff critics, and will only hire writers with a demonstrable track record (see How to write a review for a newspaper, page 176). For magazines or online journals, check whether or not your desired publication has a policy regarding unsolicited material; if they do, follow their guidelines, and submit a stunningly smart review. Otherwise, there is good news and bad. The good news is, all magazines—art or otherwise—are permanently on the look-out for writers. The bad news is, their ideal is super-literate, outrageously informed, original, talented, witty, charming, and *fits in with their magazine*. The basic art-writing tips elsewhere in this book will help with some of the first six; here let's concentrate on that last requirement: delivering what your magazine wants.

If you hanker after a specific publication, look at and read it closely. Put on your thinking cap, and understand *exactly* what the title publishes. *Examine the length and tone of your chosen magazine, and ensure that your writing literally 'fits'.*

+ *Art Asia Pacific*, *frieze*, and *Art Monthly* are middleweights, 800–1000 words apiece;
+ *Art in America* reviews are a brusque 450 words (approximately) and mostly descriptive;
+ *Art News* varies; choose S, M, or L sizes: 300, 400, or 500 words, depending on 'importance' (usually the editor's call). Same for *Modern Painters*: 450 words, 300, or a two-line, 75-word quickie;
+ *Artillery*'s are about 500–800 words and informal;
+ *Bidoun* or *Texte zur Kunst* reviews are the heavyweights, weighing in at up to 1,500 words, tightly written and knowledgeable;
+ *BlouinArtinfo*'s pithy one-line reviews are the Little League players, and showcase fast-paced art-writing talent;
+ *Burlington*—established 1903—is the duchess of the UK art-world. Many reviewers probably hold a PhD on the work of their chosen artist, so don't pitch your hilarious, experimental review there. As with the academic art journals, submit here only if you have proven authority on your subject;
+ *Cabinet* is a terrific read but scarcely mentions the 'A' word (Art);
+ *Flash Art* or *Art Review* we'll call the flyweights: about 500 words and breezy;
+ *Mousse*'s are shorter still, coming in at about 300 words, devoutly jargon-free and newsy;
+ *Parkett* and *October* do not seem to publish reviews at all;
+ *Third Text* is the industry super-heavyweight, with reviews up to 3,000 words (including footnotes, a rarity for reviews): academic in tone and profoundly researched;
+ *TimeOut* reviews can be lengthy, complete with a mini artist's interview, or almost caption-like in brevity, but always journalistic and youthful.

Be sure to double-check the info listed above; formats change. Besides, there are plenty of others.[98] Conspicuously missing are most online magazines; word-count those for yourself. Tired of them all? Start your own!

If writing for an art magazine, observe their review section. Notice how curiously similar their formats are, conventionally comprised of around three to seven paragraphs. The first paragraph(s) might introduce the guiding theme or principle. The middle section addresses *What is this art?*, bringing in examples that sustain the main idea. Ideally, the last section gets around to the question, *so what?* (see The three jobs of communicative art-writing, page 49).

Do not dismiss this neat little model. As you gain experience, by all means venture into bold uncharted review structures. The expert writer can scramble the basic order, maybe spend a paragraph digressing. His or her guiding idea is probably more sophisticated than a newbie's, and may only begin to cohere while writing, rather than following a pre-planned outline, and take full shape in the final draft. But for now, embrace this tidy formula, and dance with it. Fill the standard handful of paragraphs with a single strong idea, your brainy observations and spectacular vocabulary, and your reviews will soon hold water.

2 Do I show my review to the artist/gallerist/curator before publication?

The official answer is *no.* Publication is the first time your text reaches anyone but the editor. Everything you need to know should be right there, in the exhibition.

In practice, however, if you like meeting artists, review-writing is a handy excuse for a studio visit. Especially if publishing the first-ever text about an artist, you might talk to the artist(s)—not for approval, but to ensure you're getting the facts right about materials or process. Early texts establish the groundwork about artists, and factual errors can dog them for years. (*Note:* Artists can make things up, forget their history, or change their story. That's OK.)

Include a high-res image (minimum 300 dpi), with full caption (artist, title, year, materials, photographer, gallery; you may need copyright clearance). Prefer a never-before-published recent work, ideally dated the current year—one you talk about in your review.

Proofread assiduously. Check exact titles of artworks, and *spell the artist's name right*, consistently—umlauts (¨), accents (ă, é, "), cedillas (ç), hyphens, and all diactricial marks. Don't forget to sign your name; this omission reveals that you are still frightened to consider yourself an opinionated author. Take courage!

If you do not live in a long-established, world art center, do not despair. If you see a notable exhibition elsewhere don't hesitate to write it up, get a picture, and send it in. Good, out-of-the-way information about unusual artists and galleries can be priceless for an art magazine. They've got plenty of people covering London, New York, Los Angeles, and Berlin. Be selective, but know that you may have better odds getting published if you're in Glasgow, Dehli, Melbourne, or Johannesburg. Cover your own patch.

If you choose to repeat what the artist says about the art (not indispensable), then quote directly. Unless you really suspect an artist is churning out deplorably vapid 'art', be sensitive, and remember that this is someone's life's work you're handling. Try to be in sync with whatever you're writing about—even if you're condemning the stuff. You are contributing to a lasting body of written knowledge that will come to surround this art; take the job seriously.

3 Is it OK to write a negative review?

Of course. Whether you respond positively or negatively, substantiate your ideas with the 'proof' on view (see How to substantiate your ideas, page 53). This discipline is especially crucial for a really stinging review: is this art demonstrably bigoted and phoney, infuriating you for good reason? Or did you wake up in a foul mood, hungover from a bad date? The Verwoert example above (Source Text 37, page 168) is a first-class example of a well-argued unfavorable review.

You are not the spokesperson for the exhibition. Your job is to write a thoughtful review. The artist or the curator does not have the last word. Read the artist's statement, or converse with the gallery owner, but remember that you are at liberty to doubt every pearly word of their claims about the art. If these insiders *do* trigger a worthwhile idea, you do not need to repeat their comments verbatim (if you do, however, you should attribute them in quotes). Reviews virtually never include footnotes.

4 How much biographical information should I include?

Never list the stack of biennials, exhibitions, and museums the galleries pile up at the bottom of a press release. Usually, a compact description ('*the New York-born, Berlin-based sculptor*') is plenty, but even this summary can feel plodding if inconsequential to the rest. If biography is central to your idea, selectively include pertinent career info—but do not play amateur sleuth, 'revealing' the artist's alleged personality flaws as 'expressed' in the art and confirmed in your exposé. Generally speaking, concentrate on the art, not the artist.

5 Should I assume the reader has seen the show?

Assume the reader is an agoraphobe who has not left his bedroom since 1998. Always tell us, succinctly and intelligently, what's on view. Of course you must have seen the show, *in person*, to review it!

6 Who picks the exhibition for review, the critic or the magazine?

Usually, the critic. Editors will trust you with this responsibility if you

+ know your local scene well;
+ will choose worthwhile artists/exhibitions/events;
+ will avoid—or at least disclose beforehand—any conflicts of interest (see Artist/dealer/curator/critic/blogger/'Kunstworker'/journalist/historian, page 26).

7 Don't art magazines just publish reviews from their advertisers?

Total myth. *Artforum, Art in America, Flash Art, Art Monthly, TimeOut, Parkett, Tate Etc.*—any reputable magazine—will never

+ nudge you in the direction of (or away from) a gallery to reward their advertisers;
+ doctor your text to reflect a gallery's advertising profile.

Art press/art gallery intricacies may be far more subtle than this, but having written for all those, I promise: I have never sensed any alleged review/advertising cabal. Editors will just remind you when your deadline is looming, then straighten out any wonky syntax. I suspect some inexperienced critics *do* worry about popularity, and self-censor their texts out of fear (see Fear is the root of bad writing, page 43), which may account for the paucity of negative reviews these days. Confident critics, however, speak their minds. Pitch exhibitions for review solely because you think they merit coverage (good or bad), and because you have something to say.

8 How many artworks should I cover?

In 500 words, between two and four works, ensuring you give a fairly comprehensive overview. If the exhibition consists of twelve drawings, a website and a film, you must at least acknowledge the many media—even if you lavish your attention on the fabulous film at the back and barely respond to the rest.

9 Can I write in the first-person, and use 'I'?

This is frowned upon, and usually gets knocked back into the customary third person. Musings about *'my really amazing day looking at art'* are strictly kid stuff and will be instantly binned. However, blogging has opened up an idiosyncratic, first-person style for which 'I'-speak is almost mandatory.

> *How to write a review for a newspaper*

I know: an art-critic for a serious newspaper is unlikely to be reading this 'how-to' book. A good newspaper review reflects an expertise that can't be gleaned from these pages. Combining opinionated and informed art-criticism with the who/what/where/when/why of news-reportage, a newspaper review is expected both to add stimulating new perspectives for the art-devotee and yet be completely accessible to the first-time reader. Even tougher, newspaper copy is frequently penned at breakneck speed in the wee hours of the morning, to meet killer daily deadlines.

The newspaper reviewer's ethical reputation must be spotless. Reviewers risk excommunication if they don't play fair, and must cover their patch broadly—which means plenty of exhibitions they may barely like, while covering possibly a few centuries of art-history. And they write:

+ **Obits:** 'Franz West, Influential Sculptor, Dies at 65'
+ **General art news:** 'Google Art Project Expands'
+ **Op-ed reports:** 'Critic's Notebook: Lessons in Looking'[99]

and must never tire of the gallery, art-fair, and social rounds. To boot, they must convey a unique personality, an ongoing perspective, a dependable

art-voice to which readers can return day after day. This makes good-quality newspaper art-writing sound heroic; maybe it is.

In the following example, Roberta Smith—who's been writing for the *New York Times* for 20 years[100]—went somewhat out on a limb covering little-known 86-year-old painter Lois Dodd, whose work was on view a good distance from art-hub Manhattan, at the Portland Museum of Art, Maine. Perhaps many readers (like me) had never heard of Dodd at the outset; by the end of Smith's piece, they have acquired:

+ a strong impression of Lois Dodd's art over a 60-year career;
+ an understanding of what the exhibition did well, and how it could have been improved;
+ a healthy sense of where this painter fits in art history.

Above all, Smith's review encourages her readers to see Dodd's painted sheds, apple trees, and lawns for themselves. For these reasons, Smith's words add 'something more and better', as Peter Schjeldahl recommended good art-criticism should do.[101]

The following extracts are from Smith's opening paragraphs, plus the final line. Notice the different and shifting kinds of information the newspaper critic must simultaneously deliver: news about the event; biographical info about this unfamiliar artist; description, interpretation, and evaluation—of both the paintings and the exhibition on review.

Lois Dodd paints with an insistent, sometimes daring economy. She **has spent some 60 years making images of her immediate surroundings,** and each painting seems to go emphatically as far as she thinks it should and no further [Th]. No frills attached.

'Lois Dodd: Catching the Light', the modest retrospective **of Ms. Dodd's work at the Portland Museum of Art** here is populated by paintings of landscapes, interiors and river views; of flowers, garden sheds and lawns; of compact clapboard houses and barns, by the light of the moon or sun [...][1].

This list may sound conventional, even pedestrian, but the paintings hold your attention. [...] Behind their veneer of homey familiarity, these paintings are tough and unruly. Their main attitude seems to be a blithe, independent-spirited 'Take it or leave it.' [2]

So far the art establishment has mostly left it. Ms. Dodd is 86, and this is her first museum retrospective. It is being staged some distance from the New York art-world, on whose edges she has quietly lived and worked for decades. [...]

[A] painter who looks carefully and trusts herself can never paint the same thing the same way twice [3].

Source Text 38 ROBERTA SMITH, 'The Colors and Joys of the Quotidian', *New York Times*, 2013

First paragraph: interpretation/news, or theme—*what is an initial idea or 'way in' to this art?* [Th]; second: news/description, packed with solid nouns, to address *what is it?* [1]; third: interpretation/description, or *what might this mean?* [2]. Smith explains who the artist is, and why this news—about the first museum retrospective of this octogenarian artist, overlooked in New York—matters. She ends with a broad statement on how Dodd's work informed her understanding of what good painters do, answering the final question, *so what?* [3] (see The three jobs of communicative art-writing, page 49.)

Before reaching that concluding observation, Smith weighs in with an anecdote from painter Alex Katz; close analysis of individual works, like *Apple Tree and Shed* (2007; fig. 29); plus art-historical contextualization, for example in relation to Minimalist Donald Judd and abstract painter Ellsworth Kelly. This is all accomplished without losing either the plot or the reader, in the informed and generous style for which this world-class critic is known.

fig. 29 LOIS DODD, *Apple Tree and Shed*, 2007

> *How to write a book review*

The ideal book review is written by an expert who knows even *more* about that subject than the author of the reviewed book—probably an unreasonable level of expertise to expect from a student or other newcomer. If you don't know much about the subject of the book that you're reviewing, you probably need to research further before you start.

A review is not a summary, but an analysis. Like an exhibition review, a brief book review can benefit from the critic forming a single, overall perspective or response, which is then supported by evidence (quotes, examples, and passages) extracted from the book. Every piece of analysis should return to the content: where exactly did you find the evidence to support your points?

Most book reviews begin with a short overview, briefly outlining (or hinting at) the main point being made, the assessment. You may introduce relevant information from other publications on the same subject, or your own verifiable knowledge, to support your evaluation, positive or negative. Generally, reviewers identify both the book's weak-points and strengths. Unless you absolutely do not encounter the slightest flaw—or merit—from cover to cover, some equanimity regarding quality is usually expected. Even if you detest the book, ask yourself what the author did well, and vice versa.

When assessing a book for review, you should be looking at:

+ **topicality:** or importance of the content;
+ **argument:** clear and persuasive; or contradictory and difficult to follow;
+ **enjoyability:** the quality of the writing or the imagery;
+ **originality:** evidence of original (or regurgitated) thinking and research;
+ **thoroughness:** accuracy; or factual errors, inconsistencies, or discrepancies;
+ **attributions:** citations and quotations; or assumptions that are ungrounded, highly disputable, or unacknowledged;
+ **examples:** the author's fabulous choices; or missing, overfamiliar, and/or outdated data;
+ **presentation:** layout and design (usually outside the author's remit).

Sarah Thornton's page-turner *Seven Days in the Art World* (2008)[102] was greeted mostly by a wave of favorable press, which applauded the book's engaging writing and vivid depiction of the mysteries of the art industry. In contrast, taking a more critical tack, *Art Monthly*'s Sally O'Reilly compared Thornton's breathless week, jetting across the art-world, with the book-critic's own typical day in the industry's lower-income bracket (see When still in doubt, make a comparison, page 99):

The art-world in which Sarah Thornton has spent seven days is one that I recognize but do not inhabit myself. **It is an art-world of money, power and reputations; it is not one of drudgery, blagging and scraping by** [Th]. [...] Thornton has selected the upper, moneyed echelons for her investigation and, to judge by the list of interviewees at the back of her book, **has been rigorous in connecting with many of the big players.** [...] She is also admirably

direct with her interviewees [...] and asks Marc Jacobs what he thinks of [Takashi] Murakami referring to his design for a Louis Vuitton bag as 'my urinal' [1]. [...]

There may be a few players that sip Bellinis by the Cipriani pool, but this is far from the experience of the majority [...] To take Murakami as the subject of the studio visit chapter is **rather like offering Turkish delight as a typical foodstuff** [2]. [...]

As a form of writing, the ethnographic tilt of *Seven Days* is incredibly interesting, with its **fusion of autobiography, anthropological documentary and Sunday supplement exposé** [3]. When Thornton introduces a person, she describes what they look like and intersperses their reported speech with descriptions such as 'She took a bite of her sandwich and tilted her head'. [...]

Source Text 39 SALLY O'REILLY, 'Review: *Seven Days in the Art World*', *Art Monthly*, 2008

O'Reilly is a long-time art-world member, qualified to compare her experiences with those portrayed in Thornton's book and offer an alternative. The 'Turkish delight' simile is terrific: sticky stuff meant to be irresistible but, for some, cloying and indigestible [2]. It also suggests an exoticizing and touristic approach, which matches O'Reilly's over-arching opinion: Thornton's is a partial view, fuelling a glittering stereotype of art-world life that is unfamiliar—if not undesirable—to many [Th]. Along the way, however, O'Reilly is not indifferent to *Seven Days*'s strong points—Thornton has been both 'rigorous' and 'direct' with her research [1], and the critic is fascinated by the hybridized writing style of the book [3].

The reader may not agree with the reviewer's conclusions, but O'Reilly substantiates every point regarding what she identifies as the

book's weaknesses and strengths with an example or a quote. While *The Sunday Times* lauded *Seven Days* as 'the best book yet about the modern-art boom',[103] in contrast O'Reilly concluded that Thornton's book was a 'missed opportunity' to counter the common perception of contemporary art as 'a plaything of the rich'.Whatever your response, trace exactly the passages or ideas that show where your opinion was formed; while reading, underline or signal for yourself key examples or quotes, and bring these to bear to support your brilliant conclusions.

> *How to write op-ed art journalism*

'Op-ed' (traditionally, printed opposite the editorial page, and written by someone not on staff) art journalism differs from a simple news article by virtue of its frankly opinionated slant. Today's open-mike culture of blogs, Facebook and Twitter accounts provides the perfect 21st-century vehicle for instantaneous, personal views about art—and everything else. However, even strongly biased good commentary is based on persuasive evidence:

+ first-hand accounts,
+ statistical research,
+ knowledgeable observation,
+ and incisive analysis.

Maybe it's because websites like TripAdvisor and Yelp have redefined 'review' as a no-holds-barred platform for complaining about anything from fleabag hotels to disappointing cocktails, online art-writing too can seethe with raw accounts of art-viewing, expressed in a gloves-off critical language almost unheard of in the days of solely paper press.[104] Combining

+ art-criticism,
+ gossip,
+ market highlights,
+ diary-writing,
+ statistical research,
+ personal revelation,

+ snippets of informal interviews,

+ and eye-witness reportage,

op-ed content is still only as good as its writer's knowledge, insider access to the contemporary art players, and talent for well-worded commentary.

A top op-ed critic/journalist—on paper or online—can transform even a short 140-word news item into a smart piece of art-critical/historical reflection:

Haim Steinbach, Hessel Museum of Art and CCS Galleries at Bard College, Annandale-on-Hudson, NY, June 22–December 20, curated by Tom Eccles and Johanna Burton Travels to Kunsthalle Zürich, spring 2014

Conspicuous in his absence from the **generation-defining** [2] 1986 exhibition that catapulted Ashley Bickerton, Peter Halley, Jeff Koons, and Meyer Vaisman (forever after known as **the Sonnabend Four**) into the **blue-chip empyrean, fifth wheel Haim Steinbach** [2] went from white-hot to 'underrecognized' in the hiccup of a SoHo season. Twenty-seven years on, this bolt-from-the-blue survey, tracking the artist's career from his **grid-based paintings of the 1970s to today's large-scale installations** [1], means to lay that epithet to rest. Surely the artist's signature **Formica shelves displaying tidy rows of period-perfect product** [1] rank among the **indelible tokens of their time** [2]. **I, for one, cannot think of another artist whose output I would be greedier to assess with fresh eyes** [3].

Source Text 40 JACK BANKOWSKY, 'Previews: Haim Steinbach', *Artforum*, May 2013

All the tiresome who/what/where/when's are stacked in the header, leaving former *Artforum* editor Bankowsky enough space not only to inform about Steinbach's upcoming retrospective, but succinctly tell us:

Q1 What the art is, and who the artist is [1]?
Q2 What it might mean [2]?
Q3 Why we might care now [3]?

The plugged-in art-critic/journalist is perhaps the most valued conduit to art-industry news, ideally combining the accessibility of journalism with criticism's acute perceptions about art. Jargon-free, the op-ed news story is relayed in a conversational tone that inspires readers' confidence in their privileged informer.

Here is Ben Davis, reporting as the 2012 New York Frieze art fair opened in its swish new tent:

The giant Frieze Tent [1] looks smart; the sweeping venue is filled with natural light (even in the relative gloom of a gray afternoon) and pleasant to navigate, despite its immensity; and **the roster of exhibitors feels well-chosen** [2]. **The crowd is lively and Manhattan's millionaires seem to be in a buying mood** [3]. The space even feels relatively laid back for such a high-stakes affair. Heck, even the bathrooms look great.

Source Text 41 BEN DAVIS, 'Frieze New York Ices the Competition with its First Edition on Randall's Island', *BlouinArtinfo*, 2012

This opener may sound breezy and off-the-cuff, but consider how much hard information Davis gets across effortlessly:

[1] the Frieze art fair is *big*—maybe even growing—in its flash new venue;

[2] the 'right' galleries are in attendance;

[3] moneyed New Yorkers seem to be visiting in droves, and the place is buzzing with trade.

Moreover, as Davis reports, the architecture is a pleasure: bright even on an overcast day, and furnished with impressive bathrooms—the whole suggesting not only understated luxury but the organizer's attention to detail. Here is Davis again, as the fair came to its close:

Racing around Frieze's big tent, I had a sort of epiphany, the equivalent of the moment when you realize that **the outline of the vase is actually two faces looking at each other.** [1] I suddenly had the very strong sense that the art, the supposed point of all this, was the *excuse* for the event itself, rather than the other way around. Background and foreground switched places [...]

Embedded in the environment of the art fair or the art opening, **the objects on view realize their status as 'conversation pieces'** [2], as excuses for a very specific social interaction. In the future, we may remember this epoch of art as being, above all, about the production of some very clever theme parties.

Source Text 42 BEN DAVIS, 'Speculations on the Production of Social Space in Contemporary Art, with Reference to Art Fairs', *BlouinArtinfo*, 2012

The writer updates the old-fashioned, novelty-art reversal [1] to a macro-scale, applying this figure/ground inversion to the current art-world: in the chat-a-thon that is the art fair, artworks end up as serviceable conversation-starters and party backdrops [2].

Davis is witty while offering intelligent reflection on the shape-shifting mechanisms of the art system. And let's face it: weak art-writing is depressing not only for its dense language and unfathomable logic: it is also unrelentingly humorless. If you can bring a smile to readers' lips and still get your facts straight, then—in op-ed journalism, not academic or institutional writing, which demands 'serious'—please do so. Remember

'the baker's family who have just won the big lottery prize' (see page 46): a phrase that manages to turn Goya's line-up of aristocrats into a curtain-call for a theatrical comedy about, well, an 18th-century baker winning the big-prize sweepstakes. Even 160 years later the phrase is still pretty funny, still packing its punch.

> Who's doing the talking?

The eternal mark of a true art-critic is the insistent return, again and again, to the artwork, and art-making itself. The extract from the second of Davis's texts reprinted above (Source Text 42) is just the opening 'hook' and final 'sting'; in between he offers a mini round-up of other art events round town (Marina Abramovic at MoMA; Carsten Höller's funfair slides at the New Museum), all reconnected to his chicken-and-egg question: which comes first, the art object, or the social interaction it generates? Unfailingly, I believe, the true art-critic's eye will drift toward the art. In contrast, a journalist with only the faintest curiosity about art—basically a tourist on a brief stopover in the art-world—is perpetually distracted, turning his attention to anything *but* art. The giant price tag; the glamorous gallerist; the collector's gorgeous beachfront home: the non-art journalist will sooner devote a paragraph to relaying verbatim what an artist ordered for lunch rather than mystify his reader with the art, a subject he has no idea how to talk about (see The first time you write about art, page 44).

As we've seen, the gist of Sally O'Reilly's response to Sarah Thornton's *Seven Days in the Art World* (see How to write a book review, page 179) is not that the book is badly observed or unappealingly written, but that the author seems to tunnel her vision only on the starriest edges of the art-universe, and fails to recognize innumerable other planets: count-less regional scenes; bloggers and small publishers; academics outside Goldsmiths in London or CalArts in Los Angeles; small-scale project spaces and art-dealers; and the millions of non-celebrity artists dependent on their day-jobs to get by. At times these satellites collide, but much of the time they occupy separate galaxies. Good art-critics have a sense of most (if not all) these sub-sets. Many are (or go on to become) lifelong art devotees; instinctively, they write for the like-minded.

The non-specialist journalist probably has a relationship with art more like that of economist Don Thompson, who spent the equivalent of a gap year investigating the big-money, auction-going tip of the art-world to pen the popular *The $12 Million Stuffed Shark*.[105] Compare the passage from Thompson's book immediately below with an *Art in America* op-ed from art veteran Dave Hickey that follows.

What do you hope to acquire when you bid at a prestigious evening auction at Sotheby's? A bundle of things: a painting of course, but also, you hope, a new dimension to how people see you [...]

The motivation that drives the consumer to bid at a branded auction house, or to purchase from a branded dealer, or to prefer art that has been certified by having a show at a branded museum, is **the same as that which drives the purchase of other luxury consumer goods** [1]. Women purchase a Louis Vuitton handbag for all the things it may say about them. The handbag is easily recognized by others, distinguished by its brown color, gold leather trim and snowflake design. [...] **Men buy an Audemars Piguet watch** with its four inset dials and lizard-skin band even though their friends may not recognize the brand name, and will not ask. But experience and intuition tells them it is an expensive brand, and they see the wearer as a person of wealth and independent taste. **The same message is delivered by a Warhol silkscreen on the wall or a Brancusi sculpture in the entrance hall** [2].

Source Text 43 DON THOMPSON, *The $12 Million Stuffed Shark*, 2008

If you look at artworks as I do, **against a field of all the artworks you've ever seen** [1], this intricate flutter of precedents makes for a bigger and more memorable experience [...] [T]hree decades of art theory and art history have destroyed our understanding of art practice. So, let me remind you that the practices of **law, medicine and art are dedicated to maintaining and renewing our ideas of justice, safety and happiness** [2]. To perform these tasks, they each hold a full field of precedents at the ready to cope with the unprecedented present. Everything is always available, because you never know what antique legal decision, herb or icon you will need right now [...] As practical precedents, works of art are orphans, ready to be adopted, nurtured and groomed to the needs of any astonishing new circumstance.

Source Text 44 DAVE HICKEY, 'Orphans', *Art in America*, 2009

Notice how the economist sets art against a backdrop of luxury consumer goods; the art-critic, against his wide knowledge of other artworks [1]. Hickey suggests that art—like the disciplines of law and medicine—aspires to high ideals that are offered to the world at large; in Thompson's text, in the eyes of a collector at least, 'branded' art can at most communicate the wealth-status of a luxury watch, in the privacy of one's well-appointed foyer [2]. Writers from another discipline often conduct attentive research on the art industry in relation to their background and—like the most devoted art-critics—can be effective in tailoring their message to what interests their readers. These audiences, however, can belong to vastly diverging tribes.

If you ask members of the Anglo-Saxon art-world to name their favorite art-writer, from my experience many will intone 'Dave Hickey' without missing a beat.[106] (An academic is more likely to say T.J. Clark. Neville Wakefield [US] and the late Stuart Morgan [UK] come up a lot too.) A

former art-dealer who's followed the art scene since practically the Ashkan School,[107] Hickey is informed, witty, outspoken, and always keeps in mind the Big Picture: art is for everyone and can make life better, *that's why we bother*. His art-resumé is as long as the Mississippi: retired Professor of Practice at The University of New Mexico; former executive director of *Art in America* magazine; a curator of SITE Santa Fe, 2001–2; indefatigable art-writer and -lecturer.[108] Don Thompson is a reputable economist and Senior Scholar and Nabisco Brands Professor of Marketing emeritus at the Schulich School of Business, York University, Toronto.[109] When reading journalism, bear in mind your author's field of expertise. One might reasonably question, for example, whether art-critic Dave Hickey would provide the most reliable opinion regarding, say, optimal branding strategies for the cookie industry—even if he'd spent *a whole year* assiduously researching the light-snack world.

It is likely that an increasing number of non-art specialists (or semi-specialists) will tackle contemporary art—perhaps because open-access art-writing platforms abound online; or perhaps because, despite the growing fascination for contemporary art, specialist art-texts can lean toward the deadly dull. The art-writing gates are growing wider, which may prove beneficial for art-criticism. Dedicated art-critics will have to compete with a new batch of art-commentators who not only will introduce new perspectives but *may be capable, enjoyable writers*. The best combination, however, will remain the formidable art-writer able both to write well and apply real knowledge about art—that is, what *you* aim to be.

> *How to write a catalogue essay or magazine article*

It is worth repeating that you should begin by viewing the art at length in the flesh, then looking some more; reading; and using YouTube, Ubu-Web, and Google to find everything online (of worth—the artist's gallery or own website as well as reputable magazines [see Resources, page 253] are often the most reliable sources).

> A long-form text on one artist

Choose an artist with whose work you really connect. Take notes. Write down the bibliography or credible web address behind the material you've gathered: you may need to double-check sources later. If you are not already in contact, speaking to the artist directly—if possible—is always a big plus, and may be indispensable. But do not stalk artists with requests! Unless he or she is a pal, only attempt contact (through their website or gallery) when you have absorbed all you can about the art, and have formulated some informed questions (not: *Can you tell me about your art?*). Know your subject, and ask precise questions; maybe arrange a studio visit or interview.

Remember the three principal questions an art-writer might pose when looking at art (see The three jobs of communicative art-writing, page 49):

Q1 What does the artwork look like? What is it made of?
Q2 What might this mean?
Q3 How might this be meaningful to the world at large?

This is not a box-ticking operation; just keep these questions in mind as you prepare, write, and edit. Are you

+ substantiating your points with examples?
+ spelling out the logic of your thinking?
+ explaining what the work *is* before expanding on what it *may mean*?
+ looking at the art, work by work?

Content

Assuming you answered 'yes' to the above questions, writing well about one artist (or group) relies on

+ possessing a personal affinity with the art, and some ideas to share;
+ looking, reading, researching all you can;
+ finding the right structure or organizational principle that fits the artist(s), your thinking, and the allotted word length.

For a single-artist catalogue essay or magazine article, you typically have between 1,000 and 4,000 words to play with. Unless you choose to zoom in on a certain period, series or individual artwork, you will probably cover: key artworks (and some lesser-known examples); all the media; and the principal ideas or themes. For an exhibition-specific catalogue or feature, refer principally to the artworks on view. In addition, you might discuss significant moments in the artist's career, such as:

+ a life-changing trip;
+ personal upheaval (a life-event the artist has spoken about openly—not a private revelation);
+ a turning-point exhibition or artwork (subject matter or series);
+ an encounter with an important person or collaborator(s);
+ a change of environment: teaching post; working environment; studio space;
+ any new beginning: new media; technology; city.

and perhaps include artist's statements and key critical commentary on the art. As you do your preliminary research, make a list of these essentials. As with an academic essay, begin by outlining your ideas; this might take the form of a flow-chart or timeline, or other graphic system to organize the information on paper. Choose which examples or points to include, then find their rightful place in your essay. Gauge your audience's level of expertise: art-specialized, or more mainstream?

Often the purpose of a single-artist essay is to give even a first-time reader a solid overview; your words should contribute to the body of writing that will accumulate around her or him. Imagine that yours is the only text on this artist or body of work: how best to cover it all? If your essay will join others in a multi-authored monographic (one-artist) catalogue, be sure fellow-writers are not covering the same ground.

Structure

Many text-structures delineated below are not suited for academic assignments (see How to write an academic essay, page 107), but a catalogue essay or magazine article usually entitles you to more freedom. The list-like biography should get stacked somewhere at the back, and not clutter your clean prose.

Chronological. The most common organizing principle—since at least Giorgio Vasari (1511–1574), arguably the first-ever Western art historian— chronology has the advantage of ensuring a comprehensive logical thread through a life and career. This should not, however, reduce the art to a linear evolution from A (early attempts) to B (first mature triumphs) to C (the masterwork). Some art-writers instinctively recoil at chronology, terrified it will read like an earnest book report: '*Pablo Picasso was born in Málaga, Spain, in 1881. As a boy...*'. However, if suffused with marvelous insights, brilliant vocabulary, and lucid description, this structure can prove surprisingly elastic, accommodating your own insights, and producing an exquisite text.

In this opener on the late Polish sculptor Alina Szapocznikow, curator Adam Szymczyk begins his chronologically arranged article with his first powerful encounter with the art [1], which acts as a kind of Proustian *madeleine*[110] prompting Szymczyk to unravel the art and life of this under-recognized artist [2]. The critic uses this singular, emblematic work, *Journey*, to introduce readers to what initially intrigued him—imbalance; ghostliness; weight; scale [3]—about the art:

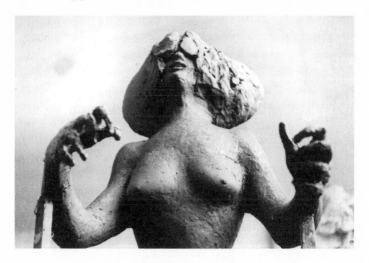

fig. 30 <u>ALINA SZAPOCZNIKOW</u>, *Le Voyage* [*Journey*], 1967

It was the mid 1980s, a bleak, depressed era in post-martial-law Poland, when I first saw Alina Szapocznikow's 1967 sculpture *Le Voyage (Journey)* [1][fig. 30] at Muzeum Sztuki in Lodz. Strolling pretty much alone through the museum's galleries, I came upon it suddenly: a slender waxy-white nude that seemed to recline in the air. **Perched on a tiny metal plinth** and leaning back at a steep angle, **improbably balanced between standing and falling, it denied gravity with the ease of a specter** [3]. Rounded pads of blue-green polyester covered the figure's eyes like the lenses of oversize sunglasses, conveying hippie-era modishness but also evoking blindness, a state of perceptual impairment [...].

[E]manating a sense of lightness, it also seemed strangely aglow, half opaque but translucent enough to absorb and reflect the ambient light. **It was an unforgettable apparition** [2], the more so because of its oddly quiet presence, which set it apart from other pieces by Polish and international artists displayed nearby.

Source Text 45 ADAM SZYMCZYK, 'Touching from a Distance: on the Art of Alina Szapocznikow', *Artforum*, 2011

This single, small sculpture plainly stopped Szymczyk in his tracks; the writer's account of this arresting work displays impressive powers of observation, and might induce a reader to learn more about this curious figurative art. Following this opener, the writer follows rough chronological sequence to trace those initial insights—and new ones that emerge—throughout Szapocznikow's career, covering a good sampling of this artist's sculpture and photographs from her student days in Prague to her Paris sojourn during the 1960s when she made *Journey*, to Szapocznikow's early death in 1972.

Thematic. An essay may have subdivisions feeding into a principal theme, or splinter into multiple themes.

Curator Iwona Blazwick's extended text on Cornelia Parker identifies clusters of themes—'The Found Object'; 'Performance'; 'Abstraction'; 'Knowledge'; 'Power Structures'—in order to navigate through the British sculptor's art:

The found object is distinct from the readymade in that it is, for the most part, unique [1]. Duchamp's paradigmatic readymade—the mass-produced urinal—was never plumbed in or pissed into. [...] By contrast, the found object, as it appears in the assemblages of Robert Rauschenberg or the accumulations of Tony Cragg or the transmutations of Cornelia Parker [2], is singular by virtue of having accrued a history [...] it is second hand [...]

'The established language and connotations around an object give it the potential to "mean something else",' Parker has said. 'I'm interested in taking them and trying to push them [...] as far as they might go.' [3]

Thirty Pieces of Silver (1988–89 [**fig. 31**]) is a sculpture that, like Richard Serra's *Throwing Lead* (1969) [2], first took form as a documented action. Parker arranged hundreds of silver artefacts on a path in the countryside. She then hired a magnificent machine redolent of the nineteenth century—a steamroller—to trundle slowly over them all, squashing them flat [...] these found objects were then suspended from metal wires so that they floated in thirty pools, like ghosts, above the ground [4].

Source Text 46 IWONA BLAZWICK, 'The Found Object', in *Cornelia Parker*, 2013

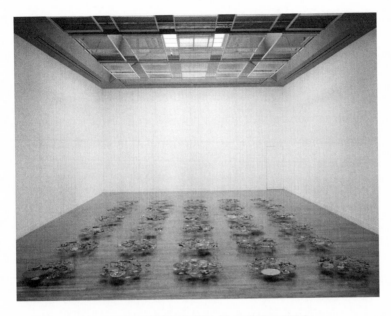

fig. 31 <u>CORNELIA PARKER</u>, *Thirty Pieces of Silver*, 1988–89

Notice how Blazwick elegantly draws in essential information—a definition of 'found object' [1]; art-historical precedents both near and far [2]; an artist's statement [3]—before embarking on a detailed description and her own interpretation of *Thirty Pieces of Silver*: [111] these suspended collections of shiny objects look like supernatural, airborne puddles [4] as readers can verify looking at a nearby image of the work.

Beware: artists' careers will rarely slavishly obey your convenient thematic categories! Some artworks will impertinently straddle themes, or refuse to play along with your neat structure, and may require special accommodation.

Posing a question. An opening question might guide the way into an artist's work. The skill lies in framing the right query, then organizing artworks in terms of possible answers—or the new questions they generate.

Alex Farquharson begins his essay on performance artist Carey Young by asking:

So, what will be required in the future? Answer: 'sole creators... defined by ideas', 'disruptive innovation' and 'a shift from... tangibles to intangibles'. These phrases aren't lifted from an award ceremony speech by the curator of an international Biennale, but from an article in *Fast Company*, a leading business magazine. [1] [...] Never before has the lexicon of contemporary art and leading-edge business, with their mutual emphases on discovery, creativity, and innovation, sounded so alike.

[In the performance work *I am a Revolutionary*, artist] Carey Young, dressed in a smart business suit, paces back and forth in a slick office space. [...] Young is alone in the room with a tall middle-aged man, also smartly dressed, who is in the process of offering her instruction—coaxing her, giving praise and supporting her efforts with constructive advice. 'I am a revolutionary', Young exclaims for the n'th time, weary but determined to better her delivery. Again but with different emphasis" 'I...am a revolutionary.' [...]

[W]hy are these four words causing her so much trouble? Is it because, as an artist, she can't quite bring herself to believe in either the avant-garde or political utopia, if that is her message? Or, as an executive, does she doubt that she is indeed a radical leader, a visionary?

Source Text 47 ALEX FARQUHARSON, 'The Avant Garde, Again', in *Carey Young, Incorporated*, 2002

The critic's recurring questioning suits the open-ended nature of Young's art, which tests today's fuzzy boundaries between art and business. Managerial lingo and artspeak sound more and more alike [1], and this overlap, it so happens, is just what Young's art is all about. In the future, will anyone tell them apart? Farquharson concludes that, for now, they remain in 'parallel worlds' but—as Young's work seems to ask—is the art/business distinction destined to collapse?

Embedding the artwork against the backdrop of life events. Unless you're writing a biography, usually concentrate on the vicissitudes in the art's trajectory, not the artist's personal life. This technique is regularly applied to certain artists' life/work stories, such as Louise Bourgeois's, but increasingly this life-equals-art tactic feels overdetermining, and should be adopted with caution.

A–Z format. Also used, for example, in Louise Bourgeois's Tate Modern catalogue (2007)—as if mirroring the 'encyclopedic' nature of this artist's complicated life/art story. This dictionary style requires plenty of imagination: you will struggle with 'X'. If you take this A–Z route, first insert each of your main points under the right letter, then have fun with filling in the rest.

Numerical lists. Bruce Hainley's survey essay for a monograph on artist Tom Friedman, 'Self-portrait as Untitled (without Armature)',[112] is an idiosyncratic combination of chronology and themes, ordered numerically, weaving Friedman's art through digressive soliloquies on topics veering from Martha Stewart to 'Jack and the Beanstalk'. Written in a confessional tone and with some single-line 'chapters' ('Tom Friedman's studio has no windows'), Hainley's unconventional joy-ride is highly accomplished and suits Friedman's confounding art. This unorthodox structural system can be difficult for the inexperienced to pull off without the text dissolving into a self-indulgent mess. However, if you have the self-discipline to ensure all key material finds its rightful place, and the artwork at hand somehow suits a numbering system, then you might try this structure on for size.

A work of fiction or poetry around the artist. The sky's the limit on this one.

In painter Karin Davie's catalogue for the Albright-Knox Museum, Lynne Tillman pens a tale about flying in response to an image of the painter levitating, and begins:

Davie shows me a photograph she shot of herself levitating...
Why not fly away, defy gravity, why not believe in a world beyond,
one we can't know?

Source Text 48 LYNNE TILLMAN, 'Portrait of a Young Painter Levitating', in *Karin Davie: Selected Works*, 2006

The free-form story that follows suits Davie's gravity-less abstract paintings, and complements Barry Schwabsky's earlier straight catalogue text in the same volume (which revolves around the contrast between the artist's 'floating', curvy brushstrokes and her sturdy rectilinear ones). Schwabsky's comprehensive, work-by-work foundation, systematically covering a range of this artist's work, allows later texts like Tillman's the freedom to explore uncharted territory.

> An article or essay on a group of artists or a concept

A long-form non-academic text for publication—in a book (exhibition catalogue, thematic overview), or magazine—about a group of artists, historical period, medium, or an idea can usually omit footnotes and the wordiness of a scholarly paper, but generally proceeds along similar structural lines (see How to write an academic essay, page 107).

1 **Introduce the group, question, process, or set of interests,** maybe with a story or an example.

2 **Give background**
 (a) *History:* Who else has thought/written about this?
 (b) *Define key terms*

(c) *Why should we care?* Why is this important to look at now?

3 **1st Artist or idea**
 (a) *Example* (artworks, quotes from the artist, critics, philosophers or more)
 (b) *More examples*
 (c) *1st conclusion* (transition to next section)

4 **2nd Artist or idea**
 (a) *Example*
 (b) *More examples*
 (c) *2nd conclusion* (transition to next section)

5 **3rd Artist or idea...**

6 **Conclusion**

7 **Bibliography and appendices** (for a catalogue).

Safely outside the confines of academic protocol, that one-size-fits-all pattern can be tailored to suit any shape, by: reordering or dropping sections; allowing unequal lengths for idea-sections, which can range from just a sentence to novella length; or straying a little to drag in, for example, your penchant for Heavy Metal—assuming this eventually circles back to your main point(s), and you keep the flow. As ever, don't be afraid to acknowledge counter-arguments; consider alternative perspectives; and entertain further questions. No essay perfectly adheres to the standard outline, but this basic structure underlies many thematic or multi-artist texts.

In the following specialist art-magazine article, art-critic T.J. Demos examines recent artworks by a range of artists whose work rethinks the natural environment in the 21st century. For Demos, it seems, these artists foreground the way economics now shape our relationship to nature, and show up not only the perverse 'natural' conditions that result, but the potential dangers of money-driven ecological policies. These extracts are from the opening two paragraphs:

The night sky may never have looked as disturbingly different as it did in *Black Shoals Stock Market Planetarium* (2001/2004 [fig. 32]), for which the London-based artists Lise Autogena and Joshua Portway projected an array of otherworldly constellations onto a planetarium-style dome [1]. Each astral body corresponds not to nature but to a publicly traded company, as a computer program translates the real-time financial activity of the world's stock exchanges into glimmering stars [...] Stars flash brightly whenever the stock is traded, gathering into clusters or dispersing according to market momentum [...] When there's a market downturn, they experience famine and die out, overcome by the darkness.

But this extraordinary ecosystem is also, pointedly, devoid of natural life...[The] **Black-Scholes option-pricing formula, published in 1973** [2a] [...] set the course for the trading of financial derivatives on an unprecedented scale [...] *Black Shoals Stock Market Planetarium* reduces complex calculations of this kind to **the level of a video game's seductive logic** [2b] [...] *Black Shoals*'s creatures are nothing but a purified expression of self-entrepreneurship— approximating **what Michel Foucault, in his later writings on bio-politics, called** *Homo economicus* [2c] [...] The piece is not just a means of visualizing data but an existential model for predatory life under advanced capitalism, within a zone where nothing else— not bodies, social life, religion, or aesthetics—matters.

Source Text 49 T.J. DEMOS, 'Art After Nature: on the Post-Natural Condition', *Artforum*, 2012

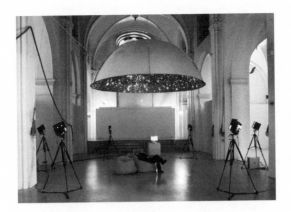

fig. 32 <u>LISE AUTOGENA AND JOSHUA PORTWAY,</u>
Black Shoals Stock Market Planetarium, 2012

How does Demos set the stage for the rest of his article and his ideas to unfold?

1 **Introduction:** *Describes an emblematic artwork* in his opening paragraph, Portway and Autogena's *Black Shoals Stock Market Planetarium.*

2 **Gives background**

 (a) *History:* The Black-Scholes option-pricing formula from 1973;

 (b) *How does the artwork connect to the world at large?* Both at the level of a video game and revealing the vulnerability of life exposed to purely economic rationality;

 (c) *Who else has thought about this topic?* Among others, philosopher Michel Foucault.

In the rest of the approximately 4,000-word article, Demos goes on to outline his thematic ideas, supporting each with examples, partially summarized below.

3 **1st idea:** Legislation to curb climate control such as the Kyoto protocol effectively amounts to 'the selling of the "right" to pollute', and 'each passing year sets a world record for the emission of greenhouse gases'.

(a) *Example:* Amy Balkan, *Public Smog*, 2004–, in which the artist sets up a 'clean-air "park" in the atmosphere' based on emission credits that the artist has purchased.

4 **2nd idea:** Art and ecology are increasingly making an appearance in contemporary art. '[A] growing number of exhibitions, catalogue and critical texts are dedicated to the topic of art and the environment'.

(a) *Example*: 'the 2007 Sharjah Biennial, titled "Still Life: Art, Ecology and the Politics of Change".'
(b) *Example*: Tue Greenfort, *Exceeding 2 Degrees*, 2007. 'The artist also raised the temperature of the entire museum by two degrees Celsius—the interval set as a plausible but now seemingly unreachable goal in the fight against global warming'.

5 **3rd idea:** These 21st-century artists contrast with '1970s pioneers of eco-art [who] tended to posit nature as a separate realm of purity needing protection'.

(a) *Examples (historic):* Artists Joseph Beuys, Agnes Denes, Peter Fend, Hans Haacke, Helen Mayer Harrison and Newton Harrison.
(b) *Example*: Indian scientist and environmental activist Vandana Shiva, who has defined 'the corporate control of life' by means of 'biotechnology and intellectual property law.'
Example: artists' group Critical Art Ensemble project such as *Free Range Grain* (with Beatriz da Costa and Shyh-shiun Shyu, 2003–4), 'a mobile laboratory-cum-performance piece [...] where visitors bring in store-bought groceries for CAE to test for genetically modified ingredients'.

6 **Final conclusion:** 'For many artists who have put [environmental crisis and economic decisions] at the core of their practice, it's perfectly justifiable to claim [...] they are occupying "the most crucial terrain of ideological struggle in our time".'

Demos probably did not plot out his article exactly as I am surmising; often, experienced art-writers structure material intuitively, as they go along. And Demos's piece is considerably more nuanced, with additional detail and analysis. My point isn't to slice this rich essay into bite-size chunks, but to show how even complex and forward-thinking texts are based around a standard structure, sequenced information, and substantiated ideas. The material is ordered less rigidly than an academic essay:

+ a background history of 1970s' art arrives, where it is needed, midway through the essay (5a);
+ some sections are longer, composed of multiple examples; others only one.

The basic structure of such an article can be flexible, and—adjusting for whatever modifications suit your topic—serves to:

+ organize the valuable material you have collected;
+ arrive at original, substantiated conclusions;
+ suggest why this is important to think about now.

The merit of Demos's essay is not its sound structure but the critic's ability to identify a worthwhile topic, gather compelling evidence—

+ current artists,
+ earlier artists,
+ exhibitions,
+ cultural and scientific theories,
+ economic policies and tools

—and persuasively interpret their implications. Demos is also good, I think, at describing complicated artworks succinctly, without narrowing their interpretation.

> How do I get my essay published?

Books are usually commissioned by a publisher's in-house editor. Art books, especially monographs, will be initiated in consultation with the artist and possibly their gallery, who will choose from the pool of well-known art-writers. However well-received your third-year paper (or even PhD dissertation) was, commissioning editors will rarely invite a very green author to pen their monographs—a publishing investment whose success relies on both the artist's and the author's worth and reputation. (They might give you a chance on a smaller project to pen short explanatory intros, captions and blurbs—assuming you write clearly and check your facts meticulously.) If you are convinced that you have an irresistible book idea with a real readership, you can try pitching your idea, in a *very* brief email, to the appropriate commissioning editor. This is, however, a long shot. If you really crave a published book, you might consider self-publishing/-distributing, or contacting the small independent presses—where much exciting new publishing occurs today. [113]

Your chances for publication improve with the quick-turnaround magazines. The advice for getting your essay published by a magazine is much as for a review (see the longer FAQs in How to write an exhibition review for a magazine or blog, page 170). Follow, if available, a magazine's 'unsolicited material' submission policy. You might pitch (again, in a concise email) exciting article-ideas to the editor; or, if you're feeling even luckier, submit your flawlessly polished final text, then cross your fingers. You have far better odds of getting published when writing about an amazing artist who has never, or hardly ever, been covered. You might trawl gallery and museum websites for forthcoming exhibitions, and—if you have something to say about them—pitch articles to magazines in sync with the upcoming art calendar, well in advance. Remember, the aim of the press is to satisfy readers with up-to-the-minute information.

Along with your immaculately proofread article, include a list of four or five images plus a couple of alternatives you'd like as accompanying illustrations (usually recent artworks you talk about). Give contact details for the artists' galleries, from whom you or the magazine will obtain photographs and information regarding permissions to use them.

As always, choose a magazine that suits the tone and length of your writing. Get out your calculator, and work out an approximate word-count for your chosen magazine's articles. Don't attach a 15,000-word MA thesis to a covering letter, then expect the editorial team to whittle it down to their standard 2,500. Make publishing your article *easy*: send perfect, newsworthy, trimmed, finished, highly original, and enchantingly written prose.

Never promise an artist or gallery—or yourself—that your article will get published without 100% confirmation from the editors. Remember: a text rejected from one magazine might be cherished by another, so keep trying. Believe in your writing.

> The multi-artist catalogue

Like the press release, the multi-artist catalogue genre has functioned as an art-world cauldron for bubbling up new format possibilities. The standard group-exhibition catalogue framework—

+ an umbrella essay;
+ a sprinkling of images showing exhibited artworks;
+ relevant comparative pictures;
+ an introduction to each artist

— has felt a little stale since at least 1968, when the late Seth Siegelaub created the *Xerox Book*: a low-cost exhibition-in a-book with specially commissioned projects by seven artists.[114] In practice, probably no actual group-exhibition catalogue has ever followed the generic structure to the letter; intuitively, art-writers and curators bend this framework to suit their needs. It can seem grossly formulaic; vary its components however you please, then fill it with engrossing ideas, inspiring artworks and splendid design to overcome tedium in an instant. A basic introductory text can be supplemented by less predictable essay-formats, images, reprinted texts (ensuring you have secured necessary permissions) and more, brightening up the remainder of your publication.

In curator Polly Staple's introductory text to the group exhibition 'Dispersion' (ICA, 2008–9), she encapsulates what first motivated her to bring these artists together (i.e., 'all of the artists in the exhibition share a preoccupation with appropriating and intercepting images') before introducing each one. This exercise does not lapse into a neat scheme to justify how each artist 'fits' within the curator's interests, but how each problematizes her questions on his or her own terms, often opening new tributaries of thought.

The curator also suggests some commonalities across subsets of artists ('Eichhorn, Lloyd, Steyerl and Olesen all reveal the archive to be totally non-objective') and mentions earlier relevant examples such as video-pioneer Joan Jonas. Toward the conclusion, Staple furthers her observations in relation to the artists' contributions, also benefiting from the writings of architectural theorist Kazys Varnelis.

Staple's solid opening essay, covering the exhibition's premise regarding 'distributed media', frees up the rest of the catalogue to explore more uncharted ground in individual texts for the participating artists, each handled differently, including:

+ a set of '20 Questions' to artist Anne Collier from artist-critic–curator Matthew Higgs;
+ an artist's statement titled 'Two Girls One Cup' from Mark Leckey;
+ an interpretative text by critic Jan Verwoert on Hilary Lloyd's videowork;
+ an extract from *Epistemology of the Closet* (1990) by the late Eve Kosofsky Sedgwick, on behalf of artist Henrik Olesen;

alongside three other artist-specific texts. Following all these, a final, separate set of reprinted essays (collectively titled 'Contextual material') includes pertinent extracts by thinkers including philosopher Giorgio Agamben and academic Jacqueline Rose.

The exhibition catalogue *Dispersion* becomes a 'stand-alone' publication: a book whose longevity extends beyond the exhibition dates, becoming far more than a mere souvenir for gallery visitors. Acquiring a longer shelf-life, the *Dispersion* publication is conceived also to serve

anyone subsequently seeking general material about the artists and topic covered. Staple's clear-headed introduction not only elucidates her curatorial premise, but acts as a foreword to a 'stand-alone' book.

> Variations on a theme

If you're looking for alternative formats, begin by scouring your local museum, gallery, or specialist art bookshop for original alternatives:

+ the text-free image leaflet;
+ the catalogue-in-a-box;
+ the –*zine*;
+ the flexi-catalogue held by ringbinder, its contents rearranged at will.

Copy, elaborate, or invent your own format to the spirit of your project—but beware: bookshops usually resist stocking off-beat book-formats. These are a few pre-digital options; online catalogues appeal as the updateable, cheaper, quicker, flexible, and instantly distributed alternative. However, the printed catalogue maintains the allure of permanence and, from my experience, artists (and many others) still prefer paper to screen. [115]

The anthology

The catalogue can be transformed into a collection of related texts examining an idea; for example *The Potosi Principle: How Can We Sing the Song of the Lord in an Alien Land?* (2010) [116] contains almost no art-related texts (a list of artists and works is at the back), but intensely researched papers about the exhibition's theme: the entangled history of money and art since colonial times.

The rule here: in your group exhibition text or catalogue, either cover all the artists, or none. I recommend treating all the artists in your exhibition/text relatively equally; omissions are a sure-fire way to make an enemy for life.

Cover all your artists, or none. Plucking favorites while ignoring others is not only grossly unfair but will de facto produce inaccurate documentation of the exhibition. This is considered bad practice unless intrinsic to the exhibition idea itself or otherwise justifiable, and presented beforehand. For example, in Polly Staple's ICA publication *Dispersion*, discussed above, artist Seth Price's well-known illustrated essay 'Dispersion' (2002)[117]—which gave rise to the show's title—was understandably privileged.

The thesis

A curator may pen an academic-style paper—built on art-historical or theoretical grounds—which exists alongside the exhibition without necessarily spelling out the direct correlation with each artwork. Jon Thompson's essay for his group exhibition 'Gravity and Grace: The Changing Condition of Sculpture 1965–1975' (1993, the title borrowed from philosopher Simone Weil) delineates the thesis behind his London Hayward Gallery group exhibition: the course of sculpture across the 1960s and 1970s is not as America-centric as some later historians have claimed. The text systematically argues this thesis but eschews any systematic artist-by-artist, work-by-work correspondence.

The graphics/image/text fusion

The catalogue can be an artwork in its own right, released from either 'explaining' or, literally, 'documenting' the exhibition. *For the blind man in the dark room looking for the black cat that isn't there* (2009)[118] confounds all expectations and is a feast of vintage imagery (Harpo Marx, Denis Diderot, Charlie Chaplin) alongside immense pull-quotes ('Artists don't solve problems, they invent new ones'—Bruce Nauman[119]) and short texts ranging in subject from the travels of Charles Darwin to Albert Einstein's 'special relativity'.

The multi-part catalogue

If you've got the budget, there might be good reason to split the catalogue into parts, with distinct sections for:

+ artists' statements;
+ curator's statements;
+ other commentary, or reprinted texts (get permission to reproduce these!);
+ images (ditto: get permission);
+ artist-by-artist info.

Exhibition publications can vary in size from the stapled brochure to a hefty tome. The multi-part catalogue accommodates the many kinds of material that accumulate around an exhibition, and acknowledges that some visitors require only a basic guide, while aficionados might enjoy spending the next year poring over the ideas behind it, for example, dOCUMENTA (13)'s biblically titled *The Book of Books* (2012), a 768-page leviathan with 101 essays on anything from hypnosis to witch-hunting. The weightiest of the catalogues published for this massive exhibition, The *Book of Books* was part of a trio that included an artist-by-artist soft-cover *The Guidebook*; and an archive-like *The Logbook*, which collected the correspondence, emails, conference notes and interviews that document the show's lengthy preparation.[120]

The 'unconventional' text

Assuming you have no outside obligations, enjoy your freedom and consider penning:

+ a piece of fiction or poetry;
+ a list-like collection of extraneous observations;
+ an A–Z or 'index' of loosely affiliated topics;
+ an elaboration on your penchant for Heavy Metal;
+ *ad infinitum.*

You should feel liberated by all these innovations, but be aware that they might clash with the requirements of those you are working with.

4

How to write an artist's statement

Surely, 'How to write an artist's statement' is an oxymoron. The artist's statement is billed as unfettered self-expression, as resistant to formulae as art itself. Some—penned by the likes of Adrian Piper or Robert Smithson—endure among the most exhilarating contemporary art-writings ever, bar none. And yet, searching the phrase 'My art explores...' will return literally millions of Google hits. Tongue-tied artists can access an online 'instant artist statement' generator, which will produce a 'unique' paragraph of sadly recognizable art-filler, along the lines of:

> My work explores the relationship between {gender politics;
> military–industrial complex; universality of myth/the body}
> and {copycat violence; postmodern discourse; unwanted gifts;
> skateboard ethics}. With influences as diverse as {Derrida;
> Caravaggio; Kiergegaard} and {Miles Davis; Buckminster Fuller; John
> Lennon}, new {variations; combinations; synergies} are {synthesized;
> generated; distilled} from both {orderly and random dialogues;
> explicit and implicit layers; mundane and transcendent dialogues}.[121]

My assumption is that you, in contrast, would like to set aside such templates and produce an inspiring text, which

+ **attracts interest in your work** from gallerists,
 collectors, awarding bodies, admissions officers, university
 boards; other artists, and more;
+ **reflects your art** and true interests believably back to
 you;
+ **assists you in your thinking** as you continue making art;

+ **will not make you cringe** and twitch to read it, but sounds like an accurate picture of what you do.

In the pursuit of producing a worthwhile artist's statement, let's examine the hazards of the job. If you can dodge the perils listed below, and apply a few tips from Section Two (The Practice—How to Write About Contemporary Art, pages 42–105), your statement will be off to a flying start.

> *The ten most common pitfalls (and how to avoid them)*

1 They all sound alike

Before setting off on '*My art explores...*', take inventory of the countless other options available (or invent your own). You might begin by reading notable artist's statements—not to copy, or become intimidated, but to identify a tone or slant which appeals. Have a look at Stiles and Selz's *Theories and Documents of Contemporary Art: A Sourcebook of Artists' Writings* (2012),[122] which is pretty comprehensive; or the many artists' website examples. Notice how no two are alike. Smithson's inspirational writings are almost diaristic: about his travels; visionary thoughts of what art could be; and imaginary remaking of the universe, for example. Some are conversational; others almost manifesto-like; others academic. The extracts given in this section deliberately differ from each other, to show myriad options.

2 They are boring

Usually, the boredom factor is in exact proportion to the degree of imprecision; smart *detail* will make your statement stand out and hold interest. Be specific; your statement should be uniquely applicable to your artwork alone. Avoid overused art metaphors; re-read about concrete nouns and adjectives, and creating images through words (see Practical 'how-to's, page 68). Specificity is the distinction between '*I think artists should help the world*' and a statement like Bruce Nauman's (overleaf).

'The true artist helps the world by revealing mystic truths.'
BRUCE NAUMAN[123]

3 They sound phoney

Inexperienced artists can mistakenly believe that their job is to second-guess what readers want to hear. Remember—especially if you're writing for a gallerist, academic, admissions-officer, fund-operator, collector, or curator—your reader may have seen *hundreds* of these. They have an in-built radar to detect false notes just as they are keenly able to spot an original. Usually, your readers are looking for what *honestly motivates you and keeps you going.*

The words should ring true to you; if when re-reading you think 'that should fly' rather than **'that's exactly what I'm thinking'**, something has gone awry. Readers want to hear the voice of a real person behind the work, and get a sense of what makes this work alive and singular, rather than just defensible.

4 They have nothing to say

Some artists work intuitively, and worry that fixing their thoughts in ink on paper might kill them. Many memorable artists' statements boil down to tracking the artist's decisions, such as Marcel Broodthaers's often quoted statement from 1964, explaining his decision, aged 40, to improvise artistic success.[124] Which decision (whether hard-won, accidental, or bearing unanticipated results) produced the most meaningful outcome, for you?

In this example from the journal of Anne Truitt (1929–2004), the late American sculptor gave this anecdotal explanation behind her choice of material:

[...] I thought of making bare, unpainted wooden sculptures for the outdoors. On the National Cathedral grounds in Washington there is a carved wooden bench honed to honey color by weather. It stands under a tree, and so could be a sculpture; this was my thought last spring when I ran my fingers over the pure, bare surface of the bench. I have been thinking about Japanese wood and the heavenly order of humble materials.

I come to the point of using steel, and simply cannot. It's like the marriage proposal of a perfectly eligible man who just isn't loveable [1]. It is wood I love.

Source Text 50 ANNE TRUITT, 'Daybook: The Journal of an Artist, 1974–79', in *Theories and Documents of Contemporary Art: A Sourcebook of Artists' Writings*, 2012

This statement may seem corny to some, but that final paragraph (see Simile and metaphor: use with caution, page 101) about the Mr Right who just turns you off [1] really gets across how Truitt just couldn't help it: metal left her cold; gorgeous wood set her pulse racing. And it sure beats: *My art explores the beauty of wood and simple Japanese forms, and examines how wood—my favourite material—absorbs the elements.*

5 They read OK, but don't actually get at the core of the art

Beware of digressive information about cultural context ('*Women make up 49% of the workforce but constitute 59% of the low-wage workforce*'); these statistics may have spawned your thinking, but ultimately made little impact on the resulting art. Rather than recount *all* your starting points—some of which may have borne little fruit—trace back to find the

real shifts, even slighter ones. Which moments changed everything? What were you really excited about as you worked? Edit out the rest. A good *but very brief* story—if 100% pertinent, and easily told—may be useful here. Sometimes an inspirational quote or statistic can stand outside the body of the text.

6 They are indecipherable

Re-read the section about *not* layering abstractions, and explaining at least in brief *what the art is* before extracting its possible meanings (see Practical 'how to's, page 68, especially points 1–3). Remember that terms such as *ontology, epistemology,* and *metaphysics* carry specific technical meaning; use sparingly, and only if essential. Bringing your ideas round to the media you've chosen is a must. Ground your reader in media or images they can see, in the accompanying work or photograph. You might try techniques suggested elsewhere in this book, such as identifying a key theme, idea, or principle that holds your art together (see How to write a short descriptive text, page 130). What really gives you satisfaction in your work—the materials? The technology? The process of making, or hunting for sources? The human relationships that build? Start there.

7 They're too long

Artists' statements can vary in length from a Tweet to a full-length dissertation. Find the right length for you, but generally, the shorter the better (about 200 words). Some formats—admissions applications; grant proposals; gallery submissions—stipulate a word count. If you are uncertain where to edit, usually chop the preamble. Let your text start only when you really get going.

8 They fail to communicate what the reader wants to know

You might tailor a basic statement to suit different purposes: don't change your art-making, just shift the text's cut or emphasis. A short catalogue introduction is usually an unregulated open space; a funding application may need to fulfill special criteria, so read the fine print. For gallery submissions, for example, you may need to explain why your art

suits the space, perhaps how you envision your work might be installed (with some flexibility, if possible). You may include technical or budget info regarding the feasibility of your show, at least to convince that you are aware of practicalities.

9 They sound megalomaniacal

Avoid sentences that begin, '*Like Matisse, I ...*'. Any influences or parallels should be named with razor-sharp precision, and explained. Injecting other people's praise ('*My work has been described as magical*') is unadvisable; outside endorsements are usually irrelevant. An excellent, brief phrase by someone else about your art which *helped you understand it better* might be a worthwhile addition, but remember: the crux of this exercise is *your* ability to articulate what you do. Telling your reader what to think is another no-no; avoid sentences that begin with '*You will feel...*' or '*The viewer reacts by...*'. That does not mean to start every sentence with 'I', but keep the focus on what *you* do and think, not dictating the reader's response.

Jennifer Angus explains how her artistic interests intertwine with her personal life:

In my work I combine photography with textiles. I have always been drawn toward patterned surfaces, and particularly textiles in which pattern is inherent. Initially, it was simply visual pleasure that entranced me; years later, through study, I am impressed and fascinated by the language of pattern. It can identify a people, a region from which they come, as well as a person's age, profession and social status within a society. Using both patterns occurring in nature and from existing textiles, I create a language that informs the photographed subjects which are juxtaposed with backgrounds of pattern.

The photography is my own, with the exception of obvious historical sources. I have traveled extensively in Northern Thailand, the home of my husband's family. He is of the Karen hilltribe who reside along the Thai/Burmese (now Myanmar) border. My work features the people of this tribe and their neighbors primarily. I am interested in the idea of 'The Other', whether it is my husband within my culture or myself within his.

Source Text 51 JENNIFER ANGUS, 'Artist Statement', *The Centre for Contemporary Canadian Art* website, n.d.

You may not see your art and life as being as enmeshed as they are for this artist, but Angus believably communicates her fields of interest, how these relate to her materials and life circumstances, and what continues to motivate her.

10 Artists communicate better in images than in words

Fortunately, the caricature of the artist as divinely inspired but monosyllabic, awaiting the critic/spokesperson to apply fancy words to the art, has gone the way of the smock and the beret. Dan Graham, Mary Kelly, Jimmie Durham: we can all think of notable exceptions, visual artists also blessed with splendid writing talent.

Perhaps you don't fall in that happy category, and writing is a struggle. Try writing out pages in longhand; from that flood of handwritten text extract and develop the moments that feel most promising. Usually you're writing for a curious, empathetic reader who's interested in your art and wants to know more. To help envision this, imagine you're writing directly to the one person who understands your work best. Keep the image of her or his encouraging face in your mind's eye as you write. If you prefer talking, try asking your art-loving friend to record an 'interview' with you, the transcript of which can provide the basis of a written statement.

> The unspoken eleventh pitfall

11 The statement's fine. It's the art I'm worried about.

A great statement will not compensate for less-than-riveting art. Your statement should not be subtitled Great Expectations; nor should it upstage the art. Ensure the correlation between what others see in your art and what they read matches up. **Write a great statement, then live up to it.** And finally, unless writing is central to your art-making, in general spend heaps more time creating artwork than writing about it.

> *How to write about a single artwork*

An artist's writings about a single artwork can give clues as to what prompted the work's making, as well as underlying themes or processes—and how these might have changed as the work took shape.

Artist and filmmaker Tacita Dean's paragraph below offers an almost literary introduction to her film installation about an abandoned (now demolished) 1970s Modernist structure in Berlin, *Palast*:

It is the building that always catches and holds the sun in the grey centre of the city: its **regime-orange reflective glass** [1] mirroring the setting sun perfectly, as it moves from panel to panel along **its chequered surface** [1], drawing you in to notice it on your way up the Unter den Linden to Alexanderplatz. For a time, when Berlin was still new to me, it was just another abandoned building of the former East that **beguiled me despite its apparent ugliness** [2], tricking and teasing the light and **flattering the sensible and solid nineteenth-century cathedral opposite with its reflections** [1]. Only later did I learn that it was the Palast der Republik and former government building of the GDR, a contentious place that

concealed its history in the opacity of its surface, but had now been run-down, stripped of its trimmings and was awaiting the verdict on its future [...]. [T]here are those who are fighting to keep the Palast standing who believe to level such a building is to level memory, and that **a city needs to keep its scars** [4] [...].

Source Text 52 TACITA DEAN, 'Palast, 2004', in *Tacita Dean*, 2006

Notice how some of the suggestions listed above are at work here. Dean identifies precisely what she is visually intrigued by in this very location [1]. She explains what triggered her curiosity, and how this led to her decision to film the Palast [2]. She articulates a principle at stake for her, which continues to hold her heartfelt interest [4]. Compare Dean's evocative statement with the flatness of '*My art explores the relationship of architecture to history, particularly in Berlin.*' You may not possess Dean's literary flair, but you can fill in some detail.

In this example following, video artist Anri Sala concentrates on the process behind his thinking both before he started and while making a specific artwork. Here, the artist explains his initial decision [1], then describes his thoughts as he watched this idea follow its own course [2]. This style may be too descriptive or poetic for some, but Sala gets across his motivation when he set off on this process-based work, and, using most of the senses—the feel of the wet plastic; the (absent) smell of the night rain; the sound of the heavy raindrops and loud music competing with the fireworks; the image of a 'battled sky'—puts into words the impressions that the actual event triggered in him [2]. Detail makes all the difference between '*My art explores music, sound, and city life*' and:

Soon it will be New Year's Eve. Fireworks and the smell of expended explosives will take over the city. The green sky of the ending year will turn red as the new one approaches [...] **I asked a DJ friend to spend with me this moment of change between the years** [1]. He would play loud against the sky and I would help him. We took position on the roof of a building with an elevated vista and set up an improvised DJ unit under a large plastic sheet. It was raining very hard, but it didn't smell like rain. Official fireworks were quickly overshadowed by people's pyrotechnics. While the music reached a battled sky, **at times I believed that the fireworks were being hijacked and manoeuvred by the beat** [2].

Source Text 53 ANRI SALA, 'Notes for *Mixed Behaviour*', in *Anri Sala*, 2003

I think these evocative artist's notes add something 'more and better' (Schjeldahl, page 18) to this artwork—just as you want your statement to do.

> Final tips

Before sending your statement out, get feedback from a trustworthy reader—or two. In general, and especially if writing doesn't come naturally, keep sentences short and to the point. An artist's statement is not a CV. Do not list your education, exhibitions, press, or awards, which go on a separate sheet. Sometimes artists include a photograph of themselves, maybe in the studio; personally, I find this a little tacky. Admissions offices and galleries accepting artist's submissions may post guidelines or examples online. Take these into account in your lightly adjusted statement. Your words should change over time. Ideally, writing is not just a chore, churned out to satisfy other people, but can help you track and develop your thinking.

5

Writing formats compared: one artist, many writers

As a bonus track, this final section includes multiple short texts on a single subject: the Modernist-façade paintings of American artist Sarah Morris. These examples typify the content and tone generally expected in the spectrum of art-writing formats, suited to a range of purposes and audiences. More than that, they may demonstrate some of the art-writing advice found in previous sections, moving from basic 'explaining' texts to 'evaluating' and interpretative texts, before concluding with the artist's own words. Her website, sarahmorris.info, attests to the volumes of writing on and by this artist.

To facilitate comparison between texts, the chosen extracts concentrate primarily on Morris's abstract works *c.* 2000–7, rather than her films and other painting series. Responses to this artist's widely admired and sought-after architecture-based paintings have been penned by some of the art-world's best-known voices, among them Douglas Coupland and Isabelle Graw; notice how each art-writer applies her or his distinctive art-writing style and perspective to their shared subject.

> A brief introduction

Art Now is a popular survey-book of over 130 contemporary artists, a *who's who* for a quick-fix readership wishing to become—or stay—in the know. Text snippets of little over 100 words introduce hot-list artists to readers with varying levels of art-world literacy. This basic 'explaining text' (see page 20) covers Sarah Morris's films and paintings primarily by identifying a single theme running throughout—the modern city [Th]. The writer provides minimal biographical information [1] before grounding the reader in the artworks' material appearance, to which detail is gradually added

[2]. The writer lists an assortment of city-specific titles of artworks, to reinforce the urban theme [3].

Sarah Morris, 1967 born in London, lives and works in New York (NY) USA, and London, UK [1]

Sarah Morris' colorful images modeled on architectural façades [2] first brought her to public attention. Few artists have been as rigorous as this resident of New York and London [1] in aesthetically translating the themes of 'new urbanism'[Th]. Her main interest is reserved for American conurbations, and in her three most recent projects—*Midtown (New York)*, 1998, *Las Vegas* (2000) and *Capital (Washington)*, 2001 [3]—Morris gave her attention to the special character of these exceptional cities [...] She creates seductive, high-gloss surfaces with foreshortened perspectives and spatial distortions. [2] What at first glance seems like pure abstraction rapidly begins to act as a vortex [4].

Source Text 54 'A.K.' [ANKE KEMPES], 'Sarah Morris', in *Art Now: The New Directory to 136 International Contemporary Artists*, vol. 2, 2005

Toward the end of this overview we find a proto-interpretation through which to consider the art: these dynamic paintings 'act as a vortex' [4]. For some reason, in much introductory-level art-writing one simple idea or catchy term can attach itself almost parasitically to certain artworks, recurring in text after text. In this artist's case, that 'vortex' simile has clung to Morris's glossy surfaces like a barnacle, trawled out in introductions, press releases, and more.[125] Beware of such hubris: all-purpose interpretative slants may be passable in brief overviews like this one, but overused ideas should be marked 'avoid' if you're attempting more developed, original critical writing.

> A museum collection website entry

This signed entry presents a painting in the *Guggenheim Collection Online*. It ventures into somewhat more independent interpretative ground than an exhibition wall-text, while similarly giving full technical details [1]:

Sarah Morris, b. 1967, Kent, UK *Mandalay Bay (Las Vegas)*, 1999 [**fig. 33**, page 224]. Household gloss paint on canvas, 84 × 84 × 2 inches (213.4 × 213.4 × 5.1 cm). Solomon R. Guggenheim Museum, New York. Purchased with funds contributed by the Young Collectors Council, 2000.121. © Sarah Morris [1]

Painter and filmmaker [Sarah Morris's] **colorful large-scale paintings recall early 20th-century hard-edged geometric abstraction and evoke the history of the modernist grid** [2]. [...]

Executed in **household gloss and saturated neon colors to achieve a slick industrial sheen** [3] that echoes their subjects, Morris's paintings isolate and abstract iconic architecture, reducing the façades of various structures to angled grids with colored cells that suggest the reflected glow of the urban environment. *Mandalay Bay (Las Vegas)* belongs to a **series of paintings based on hotels and casinos on the Las Vegas strip** [3]. The artist was interested in the way in which Las Vegas hotels integrate giant electronic billboards that advertise no product but themselves [4], thereby echoing the hermetic and self-referential nature of much of abstract painting. In such works, **Morris mimics the way in which architecture serves as a seductive sign for corporate power—in this case, that of the entertainment industry** [5].

Source Text 55 TED MANN, '*Mandalay Bay (Las Vegas)*: Sarah Morris', *Guggenheim Collection Online*, n.d.

Without going into excessive art-historical detail, writer Ted Mann sets the work in relation to 20th-century abstraction [2]. He succinctly covers the three basic elements of art-writing (see page 49) in this (mostly) 'explaining', general-audience text: what is it? [3]; what might it mean? [4]; and how does this connect to the world at large? [5]

> An exhibition review

Adrian Searle, chief art-critic of the UK's *Guardian* newspaper, is skeptical of Morris's beguiling architectures: the artist has a 'great eye', he recognizes, but he sees her talents better evidenced in her film than the canvases. The paintings at this exhibition, to Searle, look mechanical and 'soulless':

Sarah Morris [...] paints **towering walls of concrete and glass** [2] as **a canvas-filling, yawning grid. Her paintings at MoMA look back at us, flatly** [1]. The architecture pitches upward and away, it slides off at an angle into an unseen distance. Her paintings **stomp out the rhythm** [3] of the city, the glitz and the shimmer, the law of the grid [...] Her paintings are **relentlessly impersonal** [1], **her masking-taped cells of rollered-on household gloss paint** [2] **impervious to the mess of human existence** [1]. It's. It's all **tempo, all beat, all metronomic regularity. The color sings, but it is a synthetic, high-keyed march** [3].

[...] Morris makes painting look like a joyless mechanical work too. **The grid divides as much as it connects** [1]. Morris's paintings would look great in the **loft-style apartments** [2] of the people who might collect her work: soulless paintings for people with grids for brains. [...] Morris has a great eye for filmic composition [4]; why none of this gets into her paintings escapes me.

Source Text 56 ADRIAN SEARLE, 'Life thru a lens', *Guardian*, 4 May 1999

Searle pens an intensely idiosyncratic description of Morris's paintings [1] which reinforces his critical response to them: these are desirable canvases, but for him somewhat deadening. Plenty of solid, visually rich nouns and a few precise adjectives create vivid and tactile sensations for the reader [2]. Notice the consistent musical metaphor [3] (see Avoid mixed metaphor, page 102): 'stomp'; 'rhythm'; 'tempo'; 'metronomic'; 'sings'; 'high-keyed' are used to express what this critic sees as the paintings' confounding mix of harmonious painterly technique and drumming repetition.

Note also how Searle does not respond with a blanket negative verdict on the whole, but weighs up the exhibition's success ('the color sings'; the artist displays considerable instinct for filmic composition) alongside its perceived weakness. This even-handedness does not lapse into wishy-washiness because Searle pinpoints exactly where he has determined the strengths and the failures (see How to substantiate your ideas, page 53). New art-writers can imagine that, to be convincing, their pronouncements must be seamless: a 'negative' review must despair over an unremitting disaster; a 'positive' response glow only with ecstatic praise. Consider both the highs and lows of the exhibition; look at artworks one by one,

fig. 33 SARAH MORRIS, *Mandalay Bay (LasVegas)*, 1999

and take stock of which moments of the exhibition affected you differently. Interestingly, when reviewing a gallery exhibition by this artist almost a decade later, although Searle had softened his opinion about Morris's painting he remained ambivalent: 'Her work at once captivates, intrigues and resists me,' he wrote, echoing this earlier response. [126]

> A review of a group show

'Painting Lab' was a private-gallery group show staged back in 1999, which examined emerging artists who mixed the age-old medium of painting with then-recent advances in photography, science, and graphics. Art-critic Alex Farquharson explained why he was unimpressed by the results:

'Painting Lab' groups together ten London-based artists whose paintings have an angst-free relationship with new technology [...] [1] **Sarah Morris lets the software do much of the work** [1] of turning her photos of '80s corporate offices into glossy, schematic takes on de Stijl painting. It's only the slight perspective described by the window frames that alerts one to the fact that we aren't looking at a grid of colored rectangles [3] [...]

[M]uch of the work is if anything too obedient to the rather strict rules of [curator] Mark Sladen's laboratory. [...] It is a timely essay on painting after the computer [3], but much of the work in 'Painting Lab' reiterates the point made by its neighbor [3], while **substance is sometimes slight** [2] beneath the deliberate banality of the **smooth, synthetic, sweet-shop surfaces.** [2].

Source Text 57 ALEX FARQUHARSON, 'Review of "Painting Lab"', *Art Monthly*, 1999

Farquharson's first line introduces readers to the concept of the show: ten UK painters' relaxed attitude toward digital technology [2]. Notice how, when writing for an art audience, Farquharson can leave art-historical terms such as 'de Stijl' undefined. Each artwork is examined in relation to his overall assessment: for Farquharson, the exhibition's subject may be topical, but the curatorship is over-regimented, and the results repetitious [2]. The critic's analytical description of Morris's painting [3], as with the other examples cited in this review, is in terms of his assessment of the exhibition as a whole. Toward the end, Farquharson singles out the personal intimacy of Jochen Klein's work (featuring 'a boyfriend in a field of dandelions') as an exception to the show's tendency: the equation resulting from the experiments in this 'lab', the critic concludes, might be summed up as 'technology equals monotony'.

> A magazine article (mainstream press)

In this entertaining Sunday-supplement profile, non-art-specialized journalist Gaby Wood integrates first-hand comments drawn from her interviews with Morris with glossy-magazine-style glamour ('today, [Morris] is wearing a tailored black designer suit with a bright yellow shirt') to introduce this artist principally to general readers, with an emphasis on biography and 'lifestyle'. This excerpt briefly addresses the paintings:

[Morris's] paintings—**graphic configurations of color that might be Mondrians seen through a politically inflected kaleidoscope** [1]—use buildings as a starting point (the Pentagon in Washington, the Revlon building in Manhattan, the Flamingo Hotel in Las Vegas, the Department of Water and Power in Los Angeles) and break down the façades to dizzying effect. '**I always thought that the (actual) architecture was beside the point with the paintings,**' Morris explains. '**I'm more interested in strategies of architecture—how it makes the individual feel empowered, or plays with distraction**

or scale.' [2] Douglas Coupland, who has written a catalogue for her forthcoming exhibition at White Cube gallery in London [3], says of Morris's paintings that there is the 'paradoxical suggestion that in reducing these systems of power, in simplifying them, she gestures toward what's left out of the picture—what, you wonder, is behind this after all?' [4]

Source Text 58 GABY WOOD, 'Cinéma Vérité: Gaby Wood meets Sarah Morris', *Observer*, 2004

Wood pithily describes the artworks by grounding her discussion in a famous historical figure (Mondrian) with whom a newspaper audience will be familiar, and naming a few Modernist-style buildings found in the paintings which readers can readily imagine [1]. To broach the art's deeper meaning, the writer wisely quotes the artist directly [2] rather than play art-critic. The timeliness of the interview is established by the forthcoming gallery exhibition—which probably persuaded the editor to splash out on this four-page spread, and hints at top-notch gallery/press relations able to access this scale of mass-media coverage [3]. Students worry about inserting smart critics' quotes in their texts, but pro's like Wood know how to borrow clever lines from writers like Coupland [4] and ride piggyback, letting good-quality secondhand texts spice up their own writing.

> A magazine article (specialist journal)

This feature in art journal *Modern Painters*—similarly published on the occasion of an imminent gallery show—is aimed at the art-initiated reader. Like the *Observer*'s piece above, Christopher Turner's combines accessible writing with first-hand artist's statements; however, the writer demonstrates more attuned art-world knowledge—for example, Turner opens with a studio visit, as compared to the wardrobe report toward the start of the *Observer*'s profile. In this excerpt, the writer offers some basic biographical and source-material background.

Morris, a 41-year-old Brown University semiotics graduate [1] who has always spoken articulately about her work, tells me that she seeks not to represent, but to borrow from architecture. [...] Her sources are eclectic: she's as inspired by the curvaceous and **theatrical buildings of architects such as John Lautner** (who is featured on p. 60) [2] and Morris Lapidus as she is by the **science fiction novels of J.G. Ballard** [3] and 'the way he posits action and ideology in space.' Architecture, for Morris, is above all about **power and psychology,** [4] and the colors and cat's cradle geometry of each series are carefully chosen to create a specific **politics and poetics of place.** [4]

Source Text 59 CHRISTOPHER TURNER, 'Beijing City Symphony: On Sarah Morris', *Modern Painters*, 2008

This extract flows in logical sequence, from the general to the specific and from what the work *is* to what it may *mean*. The writer moves from the figure of the artist herself [1] to outside reference points—in architecture [2] and literature [3]—before venturing into more abstract interpretations [4]. Specific references (Lautner, Lapidus, Ballard) are somewhat more obscure than the *Observer*'s Mondrian; presumably the average *Modern Painters* reader will not balk at these.

> A catalogue essay on one artist (employs comparison)

This is extracted from a touring museum-exhibition catalogue essay, which is usually commissioned by the institution (the director and/or curator) in consultation with the artist and possibly the principal gallery, and always written in a spirit of support and celebration of the artist's work. Author Michael Bracewell is a unique art-writer: an art-critic as well as a novelist and pop-oriented cultural commentator. Bracewell's visual comparison to mid-century Manhattan architecture and 1950s *film noir* adds vintage glamour to Morris's paintings:

The rich tradition of American modernism, as related in the recent paintings and film-work of Sarah Morris, can be seen as derived through the founding architectural statements of architects such as Raymond Hood, in New York—responsible for the Rockefeller Center in Midtown between 1929 and 1939—as much as through the urgent impressionism of Ted Croner's photographic studies of New York's streets and buildings in the late 1940s [**fig. 34**], or the nervous glamour of Alexander Mackendrick's film of [1957], *Sweet Smell of Success.*

Source Text 60 MICHAEL BRACEWELL, 'A Cultural Context for Sarah Morris', in *Sarah Morris: Modern Worlds*, 1999

These comparisons are not injected into Bracewell's text merely to illustrate other pictures that 'look like' Morris's paintings, but to historicize the artist's fascination with the Modern city, and suggest possible precedents we might usefully draw upon when thinking about her art. As Dave

fig. 34 TED CRONER, *Central Park South,* 1947–48

Hickey writes (Source Text 44, page 188), 'works of art [from the past] are orphans, ready to be adopted, nurtured and groomed to the needs of any astonishing new circumstance.'

> A catalogue essay on one artist (employs storytelling)

From the same touring exhibition catalogue, Jan Winkelmann's essay opens with this terrifically breathless, name-dropping and jet-setting back-story. Winkelmann's insider account explains the enigmatic snapshot printed on the artist's invitation card, which shows a woman's perfectly pedicured and sandalled feet against a tiled bathroom floor.

On 19th August 1995, Mike Tyson's first boxing match after his release from prison was to take place in the aforementioned hotel complex. At the eleventh hour, Sarah Morris, Jay Jopling and Jennifer Rubell flew to Las Vegas and succeeded in getting tickets for the big event. The Golden Nugget offered an appropriate setting for the observation of the pseudo-glamorous goings-on of the B-list celebrities and stars of the underworld who shape the atmosphere of this type of event. Iron Mike—living up to his nickname—won by knocking Peter McNeeley out seven seconds before the end of the first round. Sarah Morris took the photo in the bathroom in the MGM just shortly before the fight.

Source Text 61 JAN WINKELMANN, 'A Semiotics of Surface', in *Sarah Morris: Modern Worlds*, 1999

The story is well-chosen: it's good gossip, but above all embeds Morris's art in the 'real' world, and introduces readers to the atmosphere of Las Vegas seedy glamour combined with an off-register grid pattern which, taken together, encapsulate Morris's glitzy painted world.

> A catalogue essay on one artist (substantiating ideas through visual evidence)

These two well-known art-writers—Isabelle Graw and Douglas Coupland—write about Sarah Morris's art partially by conflating the *real viewer* in the art gallery, literally observing these abstract paintings hung on the wall, with an *imagined city-dweller*, walking the street and gazing up at these glass-fronted skyscrapers [1]. Despite these critics adopting virtually the same trope, it leads them in different directions: Graw is inclined toward a political interpretation, and senses that an unnamed power lurks behind these façades; Coupland imagines the façades as faces, and turns the paintings into strange abstract portraits.

'[I]n the artist's recent installation at the Hamburger Bahnhof, [...] the paintings were hung all around the walls so that the viewer was literally encircled by them. Everywhere one looked or turned, there were geometric grids of lines reaching for the skies. And the moment the eye moved on to the next picture, everything began spinning **as if one were actually surrounded by skyscrapers and their glistening façades** [1]. Looking up at them means **losing one's balance** [2]. The hallucinatory effect can of course be read as an illustration of the fact that power cannot be simply viewed with detachment, let alone be objectively analyzed because power is blinding, radiant and even embroiling. And today **there is no 'Center' of power any more—it is everywhere and nowhere.**'[3]

Source Text 62 ISABELLE GRAW, trans. Catherine Schelbert, 'Reading the Capital: Sarah Morris' New Pictures', in *The Mystery of Painting*, 2001

In this passage, critic Isabelle Graw can be said to adopt a *phenomenological approach*, which privileges the first-hand, 'inner', or bodily

experience of *the appearance*—or 'phenomena'—of art [2], putting into words the sensations and associations generated by this experience. Graw likens being surrounded in a gallery by Morris's painted façades first to the dizzying feeling of being encircled by skyscrapers [1], and then abstracts this impression further: the all-over, 'hallucinatory' effect for Graw suggests unseen forces of power permeating all things [2].

Douglas Coupland is among a handful of noted novelists also respected for his ability to write well about art:

As someone who travels a lot, **I have the sensation** [1] that Morris's work is neither a travelogue nor a formal exercise in reduction. It seems to be more **a form of portraiture** [2] and, strangely, nineteenth-century portraiture at that—**lumber barons, textile mill owners and ranchers** [2], all of them exuberant and glossy, plump and enjoying the spoils of industrialized capitalism [3] [...]. The viewer approaches these portraits as outsiders. **Viewers are down on Madison Avenue or the Strip, looking up at the grids** [1]. Viewers are also playing a game in their heads as they do so, wondering just who sits behind those windows, and what sorts of dramas are occurring there—**a hostile takeover or maybe just a copier in need of a new toner cartridge** [4].

Source Text 63 DOUGLAS COUPLAND, 'Behind the Glass Curtain', in *Sarah Morris: Bar Nothing*, 2004

Notice Coupland's use of the first-person 'I' to highlight his strongly idiosyncratic interpretation [1]: Morris's façades are like portraits, an idea enlivened by his picturing a few old-time capitalists whom he imagines somehow depicted on the canvas, vividly described using solid nouns: 'lumber barons, textile mill owners and ranchers' [2]. As a fiction writer,

Coupland conjurs 'faces' behind all those mirror windows [3], imaginary occupants engaged either in corporate violence or office routine [4]. With these words, viewers are invited to approach the paintings 'as outsiders', simultaneously looking at Morris's paintings and walking the city streets, speculating about the goings-on behind glass walls.

> An artist's statement

Morris is an unusually capable spokesperson for her work. In this statement, the artist verbalizes what she thinks art should do [1]; the importance, for her, of how all things—not just art—are consumed and received [2]; and finally identifies with precision (colors, brands) the peculiarly glamorous, inter-continental objects and locations that obliquely inspired her [3].

Art should always do at least two things: make people look good and play with the skepticism toward the institution [1]. Just as you cannot avoid the political whether you are making beautiful loops and scribbles, using industrial materials, reusing pornography, or discussing craft—you cannot deny where things end up and how they are used, including how they are made intelligible by the artist. In other words, **how things are produced is equally important to how things are consumed and how they are received** [2]. A yellow Lamborghini Miura, the interior of the Dulles International Airport, the Princess series of touch-tone phones [1], the red of an Olivetti Valentine, the book jacket of 'Concrete Island', the aqua-marine of the Chinese packets of Lesser Panda cigarettes, Lufthansa blankets and American airlines cocktail napkins [3] could suffice.

Source Text 64 SARAH MORRIS, 'A Few Observations on Taste or Advertisements for Myself', in *Texte zur Kunst*, 2009

CONCLUSION

How to *read* about contemporary art

In some ways the final section on comparative writing formats—and perhaps the book as whole—could just as plausibly been titled How to *Read* About Contemporary Art: *what* do these different authors say, and *how?* For the fledgling art-writer, alongside looking at acres of contemporary art, nothing beats reading all you can, and analyzing closely how your favorite writers—of whatever stripe—get their ideas across. Is it the writer's brilliant intuition about art, or their heart-stopping vocabulary, or the erudition behind their words? Remember to read not just for content (*what* are they saying?) but for style (*how* are they saying it?). Do not plagiarize, but feel free to steal other writers' winning techniques and inspiring vocabulary. You want your writing to speak meaningfully to others interested in art. If your text confuses rather than illuminates, scrap it and start again. If your writing regularly appeals to art-haters, that is nothing to brag about. *Trust your experience of the work, and the thoughts it provoked in you.* Reinforce your thinking by acquiring real knowledge about art—always the shortest route to alleviating art-writing fears.

If a catalogue essay alienates you from an exhibition you'd enjoyed before reading it, or a museum wall-text transforms the interesting artwork on view into something odious, such writing must be deemed unsuccessful. The art-writer's job must be to enhance, not obfuscate or destroy, the pleasure of art. Good art writers never sound as if they are struggling to cook up something to say, or miming words spoken before (by someone else), or clinging to jargon to weigh their words with gravitas. Intimidating the reader is never their goal. Good art-writing knows that *art is meaningful; therefore meaning does not have to be forced upon it*, only discovered, enjoyed, and put into plain words.

Notes

INTRODUCTION

1 John Ruskin, *Modern Painters IV*, vol. 3 (1856), in *The Genius of John Ruskin: Selection from His Writings*, ed. John D. Rosenberg (Charlottesville, VA: University of Virginia Press, 1998), 91.

2 Alix Rule and David Levine, 'International Art English', *Triple Canopy* 16 (17 May–30 Jul 2012); http://canopycanopycanopy.com/16/international_art_english.

3 Andy Beckett, 'A User's Guide to Artspeak', *Guardian*, 17 Jan 2013; http://www.guardian.co.uk/artanddesign/2013/jan/27/users-guide-international-art-english/. Mostafa Heddaya, 'When Artspeak Masks Oppression', *Hyperallergic*, 6 Mar 2013; http://hyperallergic.com/66348/when-artspeak-masks-oppression/. Hito Steyerl, 'International Disco Latin', *e-flux journal* 45 (May 2013); http://www.e-flux.com/journal/international-disco-latin/. Martha Rosler, 'English and All That', *e-flux journal* 45 (May 2013); http://www.e-flux.com/journal/english-and-all-that/.

4 Cf., 'Editorial: Mind your language', *Burlington* 1320, vol. 155 (Mar 2013): 151; Richard Dorment, 'Walk through British Art, Tate Britain, review', *Daily Telegraph*, 13 May 2013, which responded to Tate Britain's new label-free hang with relief at being spared 'garrulous picture labels [that] made the heart sink'; http://www.telegraph.co.uk/culture/art/art-reviews/10053531/Walk-Through-British-Art-Tate-Britain-review.html.

5 Julian Stallabrass, 'Rhetoric of the Image: on Contemporary Curating', *Artforum* 7, vol. 51 (Mar 2013): 71.

6 Cf., MA in Critical Writing in Art & Design, Royal College of Art, London; MFA in Art Writing, Goldsmiths College, University of London; MFA in Art Criticism & Writing, School of Visual Arts, New York; MA in Modern Art History, Theory, and Criticism, School of the Art Institute of Chicago; MA in Modern Art:

Critical and Curatorial Studies, Columbia University, New York.

7 Cf., Dennis Cooper, *Closer* (1989); Tom McCarthy, *Remainder* (2001); Lynne Tillman, *American Genius, A Comedy* (2006); Saul Anton, *Warhol's Dream* (2007); Katrina Palmer, *The Dark Object* (2010). Don De Lillo's novel *Point Omega* (2010) is bracketed by the author's blow-by-blow account of what we recognize as Douglas Gordon's video-installation, *24-Hour Psycho* (1993).

SECTION ONE The Job

8 Peter Schjeldahl, 'Of Ourselves and of Our Origins: Subjects of Art' (2011), from a lecture given at the School of Visual Arts in New York, 18 Nov 2010, *frieze* 137 (March 2011); http://www.frieze.com/issue/article/of-ourselves-and-of-our-origins-subjects-of-art/.

9 Susan Sontag, 'Against Interpretation' (1964), *Against Interpretation* (Toronto: Doubleday, 1990), 14.

10 Peter Schjeldahl, interviewed by Mary Flynn, *Blackbird* 1, vol. 3 (Spring 2004); http://www.blackbird.vcu.edu/v3n1/gallery/schjeldahl_p/interview_text.htm.

11 Barry Schwabsky, 'Criticism and Self-Criticism', *The Brooklyn Rail* (Dec 2012–Jan 2013); http://www.brooklynrail.org/2012/12/artseen/criticism-and-self-criticism/.

12 Arthur C. Danto, 'From Philosophy to Art Criticism', *American Art* 1, vol. 16 (Spring 2002): 14.

13 E.g., this is suggested by Lane Relyea, 'All Over and At Once' (2003), in Raphael Rubinstein, ed., *Critical Mess: Art Critics on the State of the Practice* (Lennox, MA: Hard Press, 2006), 51.

14 Boris Groys, 'Critical Reflections', *Art Power* (Cambridge, MA: MIT Press, 2008), 111.

15 Possibly the earliest art-writings that we know of were found in a Babylonian proto-museum built around the 6th-century BCE. These were stone-tablet 'labels' which accompanied artefacts older than the labels by some 16 centuries, and which explained the ancient objects' forgotten origins. Geoffrey D. Lewis, 'Collections, Collectors and Museums: A Brief

World Survey', *Manual of Curatorship: A Guide to Museum Practice*, ed. John M.A. Thompson (London: Butterworth/The Museums Association, 1984), 7.

16 Andrew Hunt, 'Minor Curating?', *Journal of Visual Arts Practice* 2, vol. 9 (Dec 2010): 154.

17 40% of surveyed American newspaper critics claim to make art themselves. András Szántó, ed., *The Visual Art Critic: A Survey of Art Critics at General-Interest News Publications in America* (New York: Columbia University, 2002), 14; http://www.najp.org/publications/researchreports/tvac.pdf.

18 Schjeldahl, 'Of Ourselves', *op. cit.*

19 Roberta Smith, cited in Sarah Thornton, *Seven Days in the Art World* (London: Granta, 2008), 172.

20 Cf. Noah Horowitz, *Art of the Deal: Contemporary Art in a Global Financial Market* (Princeton, NJ: Princeton University Press, 2011), 135. Ben Lewis, 'So Who Put the Con in Contemporary Art?', *Evening Standard*, 16 Nov 2007; reply from Jennifer Higgie, 'Con Man', *frieze blog*, 3 Dec 2007; http://blog.frieze.com/con_man/.

21 Martha Rosler, 'English and All That', *op. cit.*

22 Dave Hickey, cited in Daniel A. Siedell, 'Academic Art Criticism', in Elkins and Newman, eds.., *The State of Art Criticism* (New York and Oxford: Routledge, 2008), 245.

23 Eleanor Heartney, 'What Are Critics For?', *American Art* 1, vol. 16 (Spring 2002): 7.

24 Lane Relyea, 'After Criticism', *Contemporary Art: 1989 to the Present*, Alexander Dumbadze and Suzanne Hudson, eds. (Oxford: Wiley-Blackwell, 2013), 360.

25 http://www.cifo.org/blog/?p=1161&option=com_wordpress&Itemid=24.

26 John Kelsey, 'The Hack', in Birmbaum and Graw, eds., *Canvases and Careers Today: Criticism and its Markets* (Berlin: Sternberg Press, 2008), 73.

27 Ibid, 70.

28 Frances Stark, 'Pull Quotable', in *Collected Writings 1993–2003* (London: Book Works, 2003), 68–69.

29 http://6owrdmin.org/home.html.

30 Cf., James Elkins, 'Art Criticism', unpublished entry for the *Grove (Oxford) Dictionary of Art*; http://www.jameselkins.com/images/stories/jamese/pdfs/art-criticism-grove.pdf. Thomas Crow, *Painters in Public Life in Eighteenth-Century Paris* (New Haven and London: Yale University Press, 1985), 6.

31 Charles Baudelaire, 'The Salon of 1846' (Paris: Michel Lévy frères, 1846).

32 See Crow, *Painters in Public Life*, 1–3.

33 Szántó, *The Visual Art Critic*, 9; James Elkins, 'What Happened to Art Criticism?' in Rubinstein, ed., *Critical Mess, op. cit.*, 8.

34 Discussed by Kelsey, 'The Hack', in Birnbaum and Graw, eds., *Canvases and Careers Today, op. cit.*, 69; and Lucy Lippard, *Six Years: The Dematerialization of the Art Object from 1966 to 1972* (Berkeley and Los Angeles: University of California Press, 1973).

35 Anna Lovatt, 'Rosalind Krauss: The Originality of the Avant-Garde and other Modernist Myths, 1985', in *The Books that Shaped Art History*, Richard Shone and John Paul Stonard, eds. (London and New York: Thames & Hudson, 2013), 195.

36 E.g., 'Editorial: Mind your language', *op. cit.*

37 Cf., Rule and Levine, 'International Art English', *op. cit.*; Beckett, 'A User's Guide to Artspeak', *op. cit.*

38 A noted example of counter-interpretations regards Greenberg and Harold Rosenberg's opposing views on a movement they both admired, Abstract Expressionism. See James Panero, 'The Critical Moment: Abstract Expressionism's Dueling Dio', in *Humanities* 4, vol. 29 (Jul–Aug 2008); http://www.neh.gov/humanities/2008/julyaugust/feature/the-critical-moment.

39 Stuart Morgan, *What the Butler Saw: Selected Writings*, ed. Ian Hunt (London: Durian, 1996), 14.

40 Oscar Wilde, 'The Critic as Artist', in *Intentions and Other Writings* (New York: Doubleday, 1891) responding to Matthew Arnold, 'The Function of Criticism at the Present Time', *The National Review* (1864), cited in Boris Groys in conversation with Brian Dillon, 'Who do You Think You're Talking To?', *frieze* 121 (Mar 2009); https://www.frieze.com/issue/article/who_do_you_think_youre_talking_to/.

41 Denis Diderot, 'Salon de 1765', in *Denis Diderot:*

Selected Writings on Art and Literature, trans. Geoffrey Bremner (London: Penguin, 1994), 236–39. For a counter-interpretation, see Emma Barker, 'Reading the Greuze Girl: the daughter's seduction', *Representations* 117 (2012): 86–119.

42 http://www.cabinetmagazine.org/information/.

43 Paul de Man, cited in Michael Shreyach, 'The Recovery of Criticism', in Elkins and Newman, eds., *The State of Art Criticism, op. cit.*, 4.

44 This quote has been attributed to many, including comedians Martin Mull and Steve Martin; musicians Laurie Anderson, Elvis Costello, Frank Zappa, and others, but may have existed, with some variation, since the early 20th century; http://quoteinvestigator.com/2010/11/08/writing-about-music/.

45 I.e., applying the suggestion of Ernesto Laclau and Chantal Mouffe, whereby 'language only exists as an attempt to fix that which antagonism subverts'. *Hegemony and Socialist Strategy: Towards Radical Democratic Practice* (London: Verso, 1985), 125.

46 See John Yau, 'The Poet as Art Critic', *The American Poetry Review* 3, vol. 34 (May–Jun 2005): 45–50.

47 Dan Fox, 'Altercritics', *frieze blog*, Feb 2009; http://blog.frieze.com/altercritics/.

48 Jan Verwoert, 'Talk to the Thing', in Elkins and Newman, eds., *The State of Art Criticism, op. cit.*, 343.

49 Louis Aragon, *Paris Peasant* (1926). This quote is from a footnote in the section titled 'The Passage de l'Opera'.

50 Groys, 'Critical Reflections', 117.

51 See Orit Gat, 'Art Criticism in the Age of Yelp', *Rhizome*, 12 Nov 2013, on Yelp critic Brian Droitcour, http://rhizome.org/editorial/2013/nov/12/art-criticism-age-yelp/.

SECTION TWO The Practice

52 Maria Fusco, Michael Newman, Adrian Rifkin, and Yve Lomax, '11 Statements around art-writing', *frieze blog*, 10 October 2011; http://blog.frieze.com/11-statements-around-art-writing/.

53 Stephen King, *On Writing: A Memoir of the Craft* (New York: Scribner; London: Hodder, 2000), 127.

54 Office of Policy and Analysis, 'An Analysis of Visitor Comment Books from Six Exhibitions at the Arthur M. Sackler Gallery' (Dec 2007); http://www.si.edu/content/opanda/docs/Rpts2007/07.12.SacklerComments.Final.pdf.

55 This final iteration, attributed to Alphonse Daudet, appears in Frederick Hartt's textbook *Art: A History of Painting, Sculpture, Architecture* (Englewood Cliffs, NJ: Prentice Hall; New York: Harry Abrams; London: Thames & Hudson, 1976), 317. Other attributions in somewhat modified versions include the art-critic and poet Théophile Gautier (*Goya in Perspective*, ed. Fred Licht, Englewood Cliffs, NJ: Prentice Hall, 1973, 162) and the painter Pierre Auguste Renoir (Edward J. Olszewski, 'Exorcising Goya's "The Family of Charles IV"', *Artibus et Historiae* vol. 20, no. 40 (1999): 169–85 (182–83)). Another popular textbook, *Gardner's Art through the Ages*, 6th edn. (New York: Harcourt Brace Jovanovich, 1975), claims that an unnamed 'later critic' described the royal portrait as the 'grocer and his family who have just won the lottery prize' (1975, 663). Solvay is identified as the first to pen the basic idea in Alisa Luxenberg, 'Further Light on the Critical Reception of Goya's *Family of Charles IV* as Caricature', *Artibus et Historiae* 46, vol. 23 (2002): 179–82.

56 William Strunk, Jr., and E.B. White, *The Elements of Style*, 4th edn. (New York: Longman, 1999), 23.

57 This politicized interpretation has been contested: Goya may have been less of a revolutionary and caricaturist than Solvay and others assumed. See Luxenberg, 'Further Light ...', *op. cit.*

58 Peter Plagens, 'At a Crossroads', in Rubinstein, ed., *Critical Mess, op. cit.*, 117.

59 http://artsheffield.org/artsheffield2010/as/41, accessed Mar 2013. For other accounts of this artist's work, see Clara Kim, 'Vulnerability for an exploration', *Art in Asia* (May–Jun 2009): 44–45; Joanna Fiduccia, 'New skin for the old ceremony', *Kaleidoscope* 10 (Spring 2011): 120–24; Daniel Birnbaum, 'First take: on Haegue Yang', *Artforum*, vol. 41, no. 5 (Jan 2003): 123.

60 Tania Bruguera, 'The Museum Revisited',

Artforum, vol. 48, no. 10 (Summer 2010): 299.

61 Jon Thompson, 'Why I Trust Images More than Words', *The Collected Writings of Jon Thompson*, Jeremy Akerman and Eileen Daly, eds. (London: Ridinghouse, 2011), 21.

62 Amanda Renshaw and Gilda Williams Ruggi, *The Art Book for Children* (London and New York: Phaidon, 2005), 65.

63 Sam Bardaouil, 'The Clash of the Icons in the Transmodern Age', ZOOM Contemporary Art Fair, New York 2010; http://www.zoomartfair. com/Sam's%20Essay.pdf.

64 The 'Philosophy and Literature Bad Writing Contest' ran from 1995 to 1998. http:// denisdutton.com/bad_writing.htm.

65 'Elad Lassry at Francesca Pia', *Contemporary Art Daily*, 16 May 2011; http://www. contemporaryartdaily.com/2011/05/elad-lassry-at-francesca-pia/. For a critic's text on Lassry, see Douglas Crimp, 'Being Framed: on Elad Lassry at The Kitchen', *Artforum* vol. 51, no. 5 (Jan 2013): 55–56.

66 Gordon Matta-Clark, quoted in James Attlee, 'Towards Anarchitecture: Gordon Matta-Clark and Le Corbusier', *Tate Papers—Tate's Online Research Journal*; http://www.tate.org.uk/ download/file/fid/7297.

67 Schjeldahl, 'Of Ourselves', *op. cit.*

68 King, *On Writing*, *op. cit.*, 125.

69 Disclaimer: David Foster Wallace (1962–2008), my guru for all things writing, sometimes threw caution to the wind, stringing together three adverbs or adverbial phrases, plus he split his infinitives to shreds: 'Performers...seem to mysteriously just suddenly appear' or 'He...is hard not to sort of almost actually like'. 'Big Red Son' (1998), in Wallace, *Consider the Lobster and Other Essays* (London: Abacus, 2005), 38; 44. If you have even a fraction of Wallace's talent, you can get away with almost anything. If not, 'kill excess adverbs' remains sound advice.

70 See George Kubler, 'The Limitations of Biography', *The Shape of Time: Remarks on the History of Things* (1962) (New Haven: Yale University Press, 2008).

71 E.g., *The Concise Oxford Dictionary of Art Terms*, Grove Art Online, and art glossaries published on the Museum of Modern Art, New York, and Tate websites, among others. For new media, when I need to explain bitmaps and pixels (which stands for 'Picture Element'), I've bookmarked http://www.mediacollege.com/ glossary.

72 Robert Smithson, 'A Tour of the Monuments of Passaic, New Jersey', *Artforum* vol. 6, no. 4 (Dec 1967); David Batchelor, *Chromophobia* (London: Reaktion, 2000); Calvin Tomkins has been a staff writer at *The New Yorker* since 1960, where he writes the Profiles column.

73 A.W.N. Pugin, *Contrasts: or a Parallel between the Noble Edifices of the Middle Ages and Corresponding Buildings of the Present Day; shewing the Present Decay of Taste* (London, 1836).

SECTION THREE The Ropes

74 Oscar Wilde, *The Picture of Dorian Gray* (chap. 2) (Philadelphia, PA: *Lippincott's Monthly Magazine*, 1890; London: Ward Lock & Co, 1891).

75 E.g. http://writingcenter.unc.edu/handouts/ plagiarism/.

76 Nicolas Bourriaud, *Relational Aesthetics* (1998), trans. Simon Pleasance and Fronza Woods with the participation of Matheiu Copeland (Dijon: Les Presses du Réel, 2002).

77 Miwon Kwon, *One Place After Another: Site-specific Art and Locational Identity* (Cambridge, MA: MIT Press, 2002).

78 Jon Ippolito, 'Death by Wall Label'; http://www. three.org/ippolito/.

79 Thomson and Craighead, 'Decorative Newsfeeds'; www.thomson-craighead.net/docs/ decnews/html.

80 Ippolito, 'Death by Wall Label', *op. cit.*

81 John H. Falk and Lynn Dierking, *The Museum Experience* (Washington, D.C.: Whalesback Books, 1992), 71.

82 'Editorial: mind your language', *op. cit.*

83 'For Example: Dix-Huit Leçons Sur La Société Industrielle (Revision 12)'; http:// www.davidzwirner.com/wp-content/ uploads/2011/10/2011-CW-Press-Release.pdf.

84 I'm not 100% certain this *was* a press release,

except that it sat next to the visitor's book exactly where the press release stack would be, and no other printed material was available. http://moussemagazine.it/michael-dean-herald-street/.

85 'Clickety Click'; http://moussemagazine.it/marie-lund-clickety/.

86 'Episode 1: Germinal'; http://www.contemporaryartdaily.com/2013/05/loretta-fahrenholz-at-halle-fur-kunst-luneburg/#more-83137. Again, I am presuming this *was* a press release.

87 'The Venal Muse'; http://www.contemporaryartdaily.com/2012/12/charles-mayton-at-balice-hertling/.

88 'Hides on All Sides'; http://www.benenson.ae/viewtopic.php?t=20046&p=45050.

89 Tom Morton, 'Second Thoughts: Mum and Dad Show'; http://www.bard.edu/ccs/wp-content/uploads/RH9.Morton.pdf.

90 Cf., Isabelle Graw, *High Price: Art Between the Market and Celebrity Culture* (Berlin: Sternberg Press, 2010); Olav Velthuis, *Talking Prices: Symbolic Meanings for Prices on the Market for Contemporary Art* (Princeton, NJ: Princeton University Press, 2005)—just two such publications in the 15-page bibliography rounding off Horowitz's research-packed *Art of the Deal: Contemporary Art in a Global Financial Market* (Princeton, NJ: Princeton University Press, 2011).

91 Horowitz, *Art of the Deal, op. cit.*, 21.

92 Ibid, 21.

93 Spelled 'affinies' in the original.

94 Sotheby's Contemporary Art Evening Auction, London, 12 October 2012, 152.

95 *Andy Warhol's Green Car Crash (Green Burning Car I)*, Christie's New York, 16 May 2007.

96 Nico Israel, 'Neo Rauch, David Zwirner', *Artforum* 1, vol. 44 (Sep 2005): 301–2.

97 Jerry Saltz, 'Reason without Meaning', *The Village Voice*, 8–14 June 2005, 74.

98 See *frieze* editors, 'Periodical Tables (Part 2)', *frieze* 100 (Jun–Aug 2006); http://www.frieze.com/issue/article/periodical_tables_part_2/. For an up-to-the-minute hot list of art-blogs, see Edward Winkleman, 'Websites You Should Know', http://www.edwardwinkleman.com/.

99 Roberta Smith is the author of all three stories for the *New York Times*: 'Franz West is Dead at 65: Creator of an Art Universe', 26 July 2013, http://www.nytimes.com/2012/07/27/arts/design/franz-west-influential-sculptor-dies-at-65.html?_r=0; 'Google Art Project Expands', 3 April 2012, http://artsbeat.blogs.nytimes.com/2012/04/03/google-art-project-expands/; 'Critic's Notebook: Lessons in Looking', 6 March 2012, http://artsbeat.blogs.nytimes.com/2012/03/06/critics-notebook-lessons-in-looking/.

100 Smith was promoted to co-chief art-critic at the *New York Times* in 2011. Not to be confused with Bob and Roberta Smith, as UK artist Patrick Brill calls himself.

101 Schjeldahl, 'Of Ourselves', *op. cit.*

102 Sarah Thornton, *Seven Days in the Art World* (London: Granta, 2008), *op. cit.*

103 Ben Lewis, '*Seven Days in the Art World* by Sarah Thornton', *The Sunday Times*, 5 October 2008, http://www.thesundaytimes.co.uk/sto/culture/books/article239937.ece.

104 E.g., the penultimate lines to Will Brand's uncompromising review of Damien Hirst's 'The Complete Spot Paintings' at Gagosian Gallery, New York (Jan–Mar 2012): '[W]e hate this shit. Everyone hates this shit.' Will Brand, 'Hirsts Spotted at Gagosian', Art Fag City, 4 January 2012; http://artfcity.com/2012/01/04/hirsts-spotted-at-gagosian/. See also Orit Gat, 'Art Criticism in the Age of Yelp', *Rhizome*, 12 November 2013, http://rhizome.org/editorial/2013/nov/12/art-criticism-age-yelp/.

105 'What follows is my year-long journey of discovery through the workings of the contemporary art market...', Don Thompson, *The $12 Million Stuffed Shark* (London: Aurum; New York: Palgrave Macmillan, 2008), 7.

106 Hickey's ascendancy is not without its critics; see Amelia Jones, '"Every Man Knows Where and How Beauty Gives Him Pleasure": Beauty Discourse and the Logic of Aesthetics', in *Aesthetics in a Multicultural Age*, Emory Elliot, Louis Freitas Caton, and Jeffrey Rhyne, eds. (Oxford and New York: Oxford University Press, 2002), 215–40.

107 In 2012 Hickey announced he was quitting

the 'nasty...stupid' art-world. http://www.
theguardian.com/artanddesign/2012/oct/28/
art-critic-dave-hickey-quits-art-world.

108 https://www.uoguelph.ca/sofam/
shenkman-lecture-contemporary-art-
presents-dave-hickey. Collected volumes
of Hickey's writings include *The Invisible
Dragon: Four Essays on Beauty* (Los Angeles:
Art Issues Press, 1993; revised edn., Chicago,
IL: University of Chicago Press, 2012) and *Air
Guitar: Essays on Art and Democracy* (Los
Angeles: Art Issues Press, 1997).

109 http://www.schulich.yorku.ca/
SSB-Extra/connect2009.nsf/docs/
Biography+-+Don+Thompson.

110 Marcel Proust's novel *Swann's Way* (1913)
includes the famous early scene in which
the narrator takes a bite from a tea-soaked
madeleine cake and this triggers an unexpected
wave of emotion and memories, opening up the
seven volumes of *In Search of Lost Time.*

111 If 'thirty pieces of silver' sounds familiar, that's
because this was the sum Judas Iscariot was
paid to betray Jesus, Matthew 26:14–16.

112 Bruce Hainley, *Tom Friedman* (London and
New York: Phaidon, 2001), 44–85.

113 To explore these, have a look at specialist
venues such as printedmatter.org, the London
Art Book Fair at the Whitechapel Gallery, and
numerous small art book fairs in many cities.

114 Carl Andre, Robert Barry, Douglas Huebler,
Joseph Kosuth, Sol LeWitt, Robert Morris, and
Lawrence Weiner. The resulting A4-format
Xerox Book was then photocopied and printed.

115 'Young adult readers prefer printed to
ebooks', *Guardian*, 25 November 2013; http://
www.theguardian.com/books/2013/nov/25/
young-adult-readers-prefer-printed-ebooks.

116 Curated by Alice Creischer, Max Jorge
Hinderer, and Andreas Siekmann, Haus der
Kulturen Welt, Berlin, 8 October 2010–2 January
2011. A 'straight' exhibition guide, discussing
the artists on view, was available online.

117 Seth Price, 'Dispersion', the 'well-circulated,
illustrated manifesto on art, media,
reproduction, and distribution systems'
(http://www.eai.org/artistBio.htm?id=10202),
was first published for the 2001–2 Ljubljana

Biennial of Graphic Art, and has also been
published as an artist's book. See http://www.
distributedhistory.com/Disperzone.html.

118 Curated by Anthony Hubermann, designed by
Will Holder. Contemporary Art Museum
St. Louis; ICA London; Museum of
Contemporary Art Detroit; De Appel Arts
Centre, Amsterdam; Culturgest, Lisbon.

119 Bruce Nauman, cited in Hubermann *et al.*, *For
the blind man in the dark room looking for the
black cat that isn't there* (Contemporary Art
Museum St. Louis, 2009), 94.

120 Artistic Director, Carolyn Christov-Bakargiev;
Head of Publications, Bettina Funcke.
Ostfildern, Hatje Cantz, 2012.

121 http://www.artybollocks.com/#.

122 Kristine Stiles and Peter Selz, *Theories and
Documents of Contemporary Art: A Sourcebook
of Artists' Writings* (Berkeley and Los Angeles:
University of California Press, 1996; 2nd edn.,
revised and expanded by Kristine Stiles, 2012).

123 Bruce Nauman, text from the 1967 window or
wall sign, illuminated in neon and set in a swirl
pattern. See http://www.philamuseum.org/
collections/permanent/31965.html.

124 Broodthaers: 'Me too, I asked myself if
I could not sell something and succeed in
life. It's been awhile that I've been good for
nothing...'. Invitation card for first gallery
exhibition, Galerie Saint-Laurent, Paris, 1964.
See Rachel Haidu, *The Absence of Work: Marcel
Broodthaers: 1964–1976* (Cambridge, MA: MIT
Press, 2010), 1.

125 Cf., '[T]he abstraction pulls on the viewer
like a vortex', *BlouinArtinfo*, http://www.
blouinartinfo.com/artists/sarah-morris-128620
(cited from Wikipedia); 'Her paintings have
become increasingly disorientating over
time, with their internal vortex-like spaces
working to pull the picture beyond the
reality of the canvas', http://whitecube.com/
exhibitions/sarah_morris_los_angeles_hoxton_
square_2004/, a line repeated with minimal
modification around the web.

126 Adrian Searle, 'Dazzled by the Rings',
Guardian, 29 July 2008; http://www.
theguardian.com/artanddesign/2008/jul/30/art.
olympicgames2008.

RESOURCES

Rules of grammar (and when to break them)

'*I can't get no/Satisfaction*' may be grammatically incorrect, but '*I can't get any satisfaction*' would murder the Rolling Stones's song. Rules can be broken to grand effect, but breaking rules is quite different from being fully ignorant of them. Knowing a few rules and conventions will boost your confidence no end. Tuck these under your belt, then ignore with discretion. This section covers just a few common errors; for comprehensive rules consult style manuals such as those listed on page 120.

> *It's* means 'it is' or 'it has'. *Its* means 'belonging to it'

Two familiar nursery rhymes can help you to learn and remember this simple rule:

It's raining, it's pouring/ The old man is snoring.

It is raining, *it is* pouring; Grandpa sleeps. Apostrophe.

Mary had a little lamb/ Its fleece was white as snow.

The fleece *belonging to it* (Mary's lamb) sure is white. No apostrophe.

It's (with apostrophe) is a contraction of two words, '*it*' + '*is*' (or + '*has*'). *Its* (without apostrophe) is a possessive pronoun and means '*belonging to it*'. The reason that '*it's*' and '*its*' persists as the Bermuda Triangle of correct written English is because '*it*' is an exception. Other possessives *do* require the apostrophe:

Sarah's looking exhausted, because **Sarah's gallery** has done six art fairs this year.

Sarah's looking = '**Sarah is** looking'
Sarah's gallery = 'the gallery *belonging to Sarah*'.
Notice *Sarah's* looks the same in both usages. However, when using 'it', the two usages are written differently:

It's tough spending four days at an art fair, with **its** lack of air and constant noise.

It's tough = '*it is* tough'
its lack of air = 'the lack of air *belonging to it*' (the art fair).

This is not that complicated.

> Whodunnit? Who, whom, and indefinite pronouns

The word 'whom' sounds archaic, so mostly there's no reason to worry about 'who' and 'whom' any more. In some academic (or other formal) writing, keep 'who' as the subject and 'whom' as the object, or use 'whom' after a preposition.

With indefinite pronouns ('its'; 'some'; 'most'), check that your reader can be sure of the referent.

> Confusing: *There are many reasons why collectors buy art, some better than others.*

What is this writer trying to say? This sentence could mean either:

> OK: *There are many **reasons—some better than others**—why collectors buy art.*
> OK: *There are many reasons why collectors buy art; **some collectors are better than others.***

For clarity, rework sentences to keep pronouns near their referent.

> Hyphenate compound adjectives

Art-language is awash with compound adjectives:

> *large-scale, site-specific, anti-art, computer-assisted, text-based, self-taught.*

Alway hyphenate these; use find/replace to ensure you are consistent and not missing any hyphens. Be sure to distinguish between compound adjectives and adjective+noun:

> *Jay DeFeo's* The Rose *is like a **three-dimensional** painting.*
> *Jay DeFeo's* The Rose *is like a painting in **three dimensions**.*

> *Yayoi Kusama may be the most noted **twentieth-century** Japanese artist.*
> *Yayoi Kusama may be the most noted Japanese artist of the **twentieth century**.*

Usually, an adjective is not hyphenated with its adverb: 'poorly written'; 'carefully drawn'. A common exception is 'well-': 'well-known'; 'well-read'; 'well-received'. But don't forget: 'The book was well received' (no hyphen); 'it was a well-received book' (hyphen).

> Avoid splitting infinitves (but keep an open mind)

An assistant to Margaret Thatcher reputedly refused to read any memo with a split infinitive. A split infinitive separates 'to' from the second part of the verb ('to type'; 'to watch'), usually splicing these with the insertion of an adverb ('to quickly type'; 'to actually watch'). This is considered seriously bad English.

Split infinitive: *Each work could be said to, somehow, **represent** the artist.*
Unsplit infinitive: *Each work could be said **to represent** the artist, somehow.*

This would sound even better if you lost the commas and kept the sentence brief:

Best: *Each work somehow **represents** the artist.*

Sometimes the split infinitive actually clarifies meaning: *'to boldly go'* sounds better than *'to go boldly'*. Here's another example:

Split infinitive (best): *I can't bring myself **to really like** messy abstract paintings.*
Unsplit infinitive: *I can't bring myself **really to like** messy abstract paintings.*

The first version, with the split infinitive *'to really like'*, best gets across this person's resistance to sloppy abstraction. Unsplitting your infinitive might change the sentence's meaning:

Changed meaning: *I can't bring myself, **really, to like** messy abstract paintings.*
Changed meaning: *I can't bring myself **to like really messy** abstract paintings.*

This final version implies that the writer dislikes only *'really* messy abstract paintings' when in fact she has an aversion to semi-messy ones, too. Avoid split infinitives, but develop an ear for when unsplitting will wreak havoc on your sentence.

> 'The Case of the Dangling Participle'

Don't misdirect your reader in the hunt for clues as to who is doing what.

Crazy: *Chirping and building nests, the French artist created an aviary-like installation for birds.*

Here, the French artist chirps and builds nests. Probably the writer meant:

OK: *Chirping and building nests, birds filled the aviary-like installation that the French artist had created.*

The artist stops *'chirping and building nests'*, starts making an installation. Somehow this 'dangling participle' error often crops up in cover letters:

Crazy: *Being so hardworking, my previous employer always asked me to organize the booth.*

Surely you're not advertising how hardworking your previous employer was. You mean:

OK: *Being so hardworking, I always organized the booth for my previous employer.*

> Ensure parallel construction

We all can see the parallel construction in '*An American, a Russian, and an Italian walk into a bar*'. Each nationality/noun does the same thing, '*walk into a bar*', so the joke can continue. Here's where it gets tricky:

> Wrong: *Suzanne writes best about sculpture, new British art, and thinking about the legacy of Modernism.*

The last element in this sentence '*thinking about the legacy of Modernism*', does not behave like the other two, '*sculpture*' and '*new British art*'. If you removed those, you'd be left with:

> Crazy: *Suzanne **writes best about thinking about** the legacy of Modernism.*
> Best: *Suzanne writes best about sculpture, new British art, **and the legacy of Modernism.***

In the final corrected version, '*sculpture*', '*new British art*' and '*the legacy of Modernism*' are all nouns—they're all 'parallel', and the grammar police are satisfied.

Bad Grammar Awards often go to those culprits who ignore parallel construction. Transport for London was a recent recipient (*The Idler* magazine, 2013) for the sign:

> *It is safer to stay on the train than attempting to get off.*

That signage mixed up the infinitive ('*to stay*') with the gerund ('*attempting*'). For sticklers, the correct grammar would be one of these:

> *It is safer **to stay** on the train than **to get** off.*
> *It is safer **to stay** on the train than **to attempt** to get off.*
> ***Staying** on the train is safer than **attempting** to get off.*

> Enclose parenthetic phrases within commas.

Recall this sentence from Jerry Saltz's shorthand reports on the art fairs (page 61):

> Best: *This artist, who died young in 1999, is way overlooked.*

Place a comma *on either side* of a parenthetic phrase ('who died young in 1999') just as you would open and close brackets [] or parentheses (). It is acceptable to remove *both* commas, but this can be a mouthful. Best two commas; OK zero commas; but *never* peg-legged parenthetic phrases with only one comma.

> Wrong: *This artist who died young in 1999, is way overlooked.*
> Wrong: *This artist, who died young in 1999 is way overlooked.*
> No commas, OK: *This artist who died young in 1999 is way overlooked.*

> Avoid ending a sentence with a preposition, but be flexible.

OK: 'Quantum dot heterostructures' is something **I'd never heard of**.
Better: **I'd never heard of** quantum dot heterostructures.

A *New York Times* review by Ken Johnson (21 December 2001) of a Sarah Morris exhibition ends with a preposition: '*the paintings are gratifying just to look at*', which is fine. To force that preposition deep inside the sentence—'*the paintings at which we look are just gratifying*'—sounds ridiculous and alters meaning. Another example:

OK: *Bad behavior is something **I will not put up with**.*

This sounds insane when rearranged to avoid that final preposition; it also demonstrates the advantages of reordering to direct speech:

Crazy: *Bad behavior is something **up with I will not put**.*
Best: ***I will not put up with** bad behavior.*

Questions often end with a preposition; that's fine.

Who are you going with? What is it made of?

> Never start a sentence with a digit

Wrong: *1970 marked a watershed year for video.*
OK: *Nineteen-seventy marked a watershed year for video.*
Best: *The year 1970 marked a watershed for video.*

Business English spells out single-digit numbers under 10. David Foster Wallace, in 'Authority and American Usage' (1999), says spell out one through nineteen and write digits over 20. Some publishers' house style spells out one to ninety-nine, digits over 100. Pick one and be consistent.

Use digits for election results ('*he won narrowly, 104 to 101*'), percentages ('*66%*'), measurements ('*the silkscreen is 40 x 40 in.*'), decimal-pointed prices ('*$1.99*'; '*£12.5 million*'), and dates/years ('*29 March 2001*'; '*1998*'), which are all incomprehensible if spelled out.

> British/American English

Unless otherwise directed, pick one and be consistent. For international art-writing, context will dictate but American spelling often prevails. There are exceptions to the differences listed below; and some publishers' house style mixes the two.

	British	**American**
-re/-er	centre	center
-our/-or	colour	color
-ence/-ense	pretence	pretense
-ogue/-og	catalogue	catalog

double consonants	traveller	traveler
	travelled	traveled
double vowels	archaeology	archeology
decades	1970s	1970's

The use of 'single' and "double" quotation marks—or 'inverted commas', as the British call them—is reversed:

American: *"Was this video described as 'pure genius' by the* Chicago Tribune*?" Paula asked.*

British: *'Was this video described as "pure genius" by the* Guardian*?', Maureen asked.*

> The Oxford Comma

I love that name; in the US, its Ivy League equivalent is called 'the Harvard comma', wonderfully enough. This is the 'three or more' or the 'comma before the "and"' rule:

American: *An American,* **a Russian, and an Italian** *walk into a bar.*
British: *An American,* **a Russian and an Italian** *walk into a bar.*

Pick one and be consistent—but remain alert:

I'd like to thank my parents, Nelson **Mandela, and** *Hillary Clinton.*
I'd like to thank my parents, Nelson **Mandela and** *Hillary Clinton.*

Unless you are the love-child of Nelson Mandela and Hillary Clinton, you really need that second comma.

My general rule for commas is: the fewer the better. A sentence peppered with commas could probably stand a good rewrite (see pages 83–84, Steinberg on Rauschenberg).

> Semicolons

Semicolons signal a break stronger than a comma, and are especially helpful when the subject of a sentence changes. This is from David Sylvester (page 63):

Picasso took junk and turned it into useful objects such as musical instruments; Duchamp took a useful stool and a useful wheel and made them useless.

Theses two ideas need to stay connected to make his point, but the subject changes from Picasso to Duchamp: Sylvester judiciously inserts a semicolon. A very long sentence, joined by a semi-colon, may read better split into two.

Semicolons may also be used in a list where each element is a short phrase (recall this promotional blurb, pages 151–52):

Rhode's witty, engaging and poetic works make reference to hip-hop and graffiti art; to the histories of modernism; and to the act of creative expression itself.

> Dash

A long dash interrupts the sentence more forcefully than a comma, to insert details or abruptly add an aside. Michael Fried (page 93):

> *What seems to have been revealed to Smith that night was the pictorial nature of painting—even, one might say, the conventional nature of art.*

It can be used parenthetically—i.e. around an interjection—or singly to add a related but separate point, or to extend the idea of the main clause. Iwona Blazwick (page 194):

> *Duchamp's paradigmatic readymade—the mass-produced urinal—was never plumbed in or pissed into.*

Visually, a dash interrupts the flow of the text; avoid having more than two 'dashed' sentences in a single paragraph.

> Colon

A colon emphatically stops a sentence, usually to introduce a list or a new idea. Use sparingly. John Kelsey (page 82) introduces a short list with a colon:

> [*Fischli and Weiss's*] Women *come in three sizes: small, medium and large.*

> Parentheses

The information inside parentheses is additional information, extraneous to your text, so maybe drop it altogether? Use parentheses only as a last resort. If you open one, be sure eventually to close it. Chris Kraus (page 100):

> *I'm reminded of Magnum Agency founder Werner Bischof (about whom Porcari has written).*

> Last details

An artist's name can stand in for her artwork, but this usage is too colloquial for an academic or museum text. For more informal writing, '*A gallery full of Agnes Martins*' safely communicates that the gallery contains many of this artist's paintings, not her clones or eponymous offspring.

> *Did you like the Lygia Pape?*
> *We saw many Laure Prouvosts on the artist's website.*

And finally, footnote numbers always go outside all punctuation.

Beginning a contemporary art library

The first texts listed below (**in bold**) serve as basic introductions and other essential reading; listed below those are more advanced texts. For further reading, see specialized anthologies and compendia, page 108; manuals of style, page 120; art magazines, page 171; contemporary art-fiction, page 236 footnote 7; on the art market, page 240 footnote 90.

And read plenty of literature, poetry, and non-art books too: art only takes on meaning when plugged in to the rest of the world.

Overviews

Charles Harrison and Paul Wood, eds., *Art in Theory 1900–2000: An Anthology of Changing Ideas* (Oxford: Blackwell, 2003).

David Hopkins, *After Modern Art, 1945–2000* (Oxford History of Art, Oxford: Oxford University Press, 2000).

Jonathan Fineberg, *Art Since 1940: Strategies of Being*, 2nd edn. (New York: Prentice Hall, 2003).

Rosalind Krauss, Hal Foster, Yve-Alain Bois, Benjamin Buchloh, and David Joselit, *Art Since 1900: Modernism, Antimodernism, Postmodernism* (2004), 2nd edn., vols. 1–2 (London and New York: Thames & Hudson, 2012).

Greil Marcus, *Lipstick Traces: A Secret History of the 20th Century* (Cambridge, MA: Harvard University Press, 1989).

Robert S. Nelson and Richard Schiff, eds., *Critical Terms for Art History*, 2nd edn. (Chicago, IL, and London: University of Chicago Press, 2003).

Art into the 21st century

Art Now, vols. 1–4 (Cologne: Taschen, 2002; 2006; 2008; 2013).

Julieta Aranda *et al.*, *What is Contemporary Art?* Available for free at http://www.e-flux.com/ issues/11-december-2009/http://www.e-flux.com/ issues/12-january-2010/.

Daniel Birnbaum *et al.*, *Defining Contemporary Art in 25 Pivotal Artworks* (London: Phaidon, 2011).

Charlotte Cotton, *The Photograph as Contemporary Art*, 3rd edn. (London and New York: Thames & Hudson, 2014).

Julian Stallabrass, *Contemporary Art: A Very Short Introduction* (Oxford: Oxford University Press, 2006).

Claire Bishop, *Artificial Hells: Participatory Art and the Politics of Spectatorship* (London: Verso, 2012).

T.J. Demos, *The Migrant Image: The Art and Politics of Documentary During Global Crisis* (Durham, NC: Duke University Press, 2013).

Rosalind Krauss, *A Voyage on the North Sea: Art in the Age of the Post-medium Condition* (London and New York: Thames & Hudson, 2000).

Peter Osborne, *Anywhere or Not at All: Philosophy of Contemporary Art* (London: Verso, 2013).

Terry Smith, *Contemporary Art: World Currents* (London: Laurence King, 2011).

Barry Schwabsky, ed., *Vitamin P*; Lee Ambrozy, ed., *Vitamin P2: New Perspectives in Painting* (London: Phaidon, 2002; 2012).

Art of the late 20th century

Michael Archer, *Art Since 1960*, 2nd edn. (London and New York: Thames & Hudson, 2002).

Thomas Crow, *Modern Art in the Common Culture* (New Haven and London: Yale University Press, 2005).

Thomas Crow, *The Rise of the Sixties: American and European Art in the Era of Dissent, 1955–1969* (London: Laurence King; New Haven: Yale University Press, 1996).

Tony Godfrey, *Conceptual Art* (London: Phaidon, 1998).

Gillian Perry and Paul Wood, eds., *Themes in Contemporary Art* (New Haven and London: Yale University Press in association with The Open University, 2004).

Arthur C. Danto, *After the End of Art: Contemporary Art and the Pale of History* (Princeton, NJ: Princeton University Press, 1997).

Briony Fer, *The Infinite Line: Re-Making Art After Modernism* (New Haven and London: Yale University Press, 2004).

Lucy Lippard, *Six Years: The Dematerialization of the Art Object from 1966 to 1972* (1973) (Berkeley and Los Angeles: University of California Press, 1997).

Craig Owens, *Beyond Recognition: Representation, Power, and Culture* (Berkeley and Los Angeles: University of California Press, 1992).

Griselda Pollock, *Vision and Difference: Femininity, Feminism and Histories of Art* (London and New York: Routledge, 1988).

Modernism

H.H. Arnason, *History of Modern Art: Painting, Sculpture, Architecture, Photography*, 7th edn. (London: Pearson, 2012).

T.J. Clark, *Farewell to an Idea: Episodes from a History of Modernism* (New Haven and London: Yale University Press, 1999).

Rosalind Krauss, *Passages in Modern Sculpture* (1977) (Cambridge, MA: MIT Press, 1977).

Leo Steinberg, *Other Criteria: Confrontations with Twentieth-Century Art* (London, Oxford, and New York: Oxford University Press, 1972).

Paul Wood, *Varieties of Modernism* (New Haven and London: Yale University Press in association with The Open University, 2004).

Marshall Berman, *All That is Solid Melts into Air: The Experience of Modernity* (Harmondsworth, Middlesex: Penguin, 1982).

Rosalind Krauss, *The Optical Unconscious* (Cambridge, MA: MIT Press, 1993).

Rosalind Krauss, *The Originality of the Avant-Garde and Other Modernist Myths* (Cambridge, MA: MIT Press, 1985).

Clement Greenberg, 'Modernist Painting' (1960), in *Clement Greenberg: The Collected Essays and Criticism*, vol. IV, ed. John O'Brian (Chicago, IL, and London: University of Chicago Press, 1993), 85–93.

Meyer Schapiro, *Modern Art: 19th and 20th Centuries, Selected Papers*, vol. 2 (New York: George Braziller, 1978).

Curating

Tony Bennett, *The Birth of the Museum: History, Theory, Politics* (London: Routledge, 1995).

Iwona Blazwick et al., *A Manual for the 21st Century Art Institution* (London: Koenig Books/ Whitechapel Gallery, 2009).

Bruce W. Ferguson, Reesa Goldberg, and Sandy Nairne, *Thinking about Exhibitions* (London: Routledge, 1996).

Brian O'Doherty, *Inside the White Cube: The Ideology of the Gallery Space* (1976), 6th edn. (Oakland, CA: University of California Press, 2000).

Hans Ulrich Obrist, *A Brief History of Curating* (Zurich: JRP Ringier, 2008).

Bruce Altshuler, *Salon to Biennial: Exhibitions that Made Art History*, vol. 1: 1863–1959; *Biennials and Beyond: Exhibitions that Made Art History*, vol. 2: 1962–2002 (London: Phaidon, 2008; 2013).

Douglas Crimp, *On the Museum's Ruins* (Cambridge, MA and London: MIT Press, 1993).

Elena Filipovic, Marieke Van Hall, and Solveig Østebø, eds., *The Biennial Reader: An Anthology on Large-Scale Perennial Exhibitions of Contemporary Art* (Bergen: Bergen Kunsthall, and Ostfildern: Hatje Cantz Verlag, 2010).

Susan Hiller and Sarah Martin, eds., *The Producers: Contemporary Curators in Conversation* (Gateshead: Baltic Centre for Contemporary Art, 2000).

Christian Rattemeyer and Wim Beeren, *Exhibiting the New Art: 'Op Losse Schroeven' and 'When Attitudes Become Form' 1969* (London: Afterall, 2010).

Artist's Writings

Alexander Alberro and Blake Stimson, eds., *Institutional Critique: An Anthology of Artists' Writings* (London and Cambridge, MA: MIT Press, 2009).

Andrea Fraser, *Museum Highlights: The Writings of Andrea Fraser*, ed. Alexander Alberro (London and Cambridge, MA: MIT Press, 2005).

Robert Smithson, *Robert Smithson: The Collected Writings*, ed. Jack Flam (Berkeley and Los Angeles: University of California Press, 1996).

Kristine Stiles and Peter Selz, eds., *Theories and Documents of Contemporary Art: A Sourcebook of Artists' Writings* , 2nd edn. (Berkeley and Los Angeles: University of California Press, 2012).

Andy Warhol, *The Philosophy of Andy Warhol (From A to B and Back Again)* (New York: Harcourt Brace Jovanovich, 1975).

John Cage, *Silence: Lectures and Writings* (Middletown: Wesleyan University Press, 1961).

Hollis Frampton, *Circles of Confusion: Film, Photography, Video: Texts 1968–1980* (Rochester: Visual Studies Workshop Press, 1983).

Dan Graham, *Two-Way Mirror Power: Selected Writings by Dan Graham on his Art*, ed. Alexander Alberro (London and Cambridge, MA: MIT Press, 1999).

Mike Kelley, *Foul Perfection: Essays and Criticism* (Cambridge, MA: MIT Press, 2003).

Hito Steyerl, *The Wretched of the Screen* (New York and Berlin: *e-flux journal* and Sternberg Press, 2012).

Philosophy and theory

Gaston Bachelard, *The Poetics of Space* (1958), trans. Maria Jolas (Boston: Beacon Press, 1994).

Roland Barthes, *Camera Lucida: Reflections on Photography* (1980), trans. Richard Howard (New York: Farrar, Straus and Giroux, 1981).

Roland Barthes, *Image, Music, Text*, trans. Stephen Heath (New York: Hill and Wang, 1977).

Jean Baudrillard, *The System of Objects* (1968), trans. James Benedict (London and New York: Verso, 2005).

Walter Benjamin, *Illuminations*, ed. Hannah Arendt, trans. Harry Zohn (London: Pimlico, 1955/1999).

Homi Bhabha, *The Location of Culture* (1991) (New York: Routledge, 1994).

Pierre Bourdieu, *Distinction: A Social Critique of the Judgment of Taste* (1979), trans. Richard Nice (Cambridge, MA: Harvard University Press, 1984).

Judith Butler, *Gender Trouble: Feminism and the Subversion of Identity* (New York and London: Routledge, 1990).

Guy Debord, *The Society of the Spectacle* (1967), trans. Donald Nicholson-Smith (New York: Zone Books, 1995).

Michel de Certeau, *The Practice of Everyday Life* (1974), trans. Steven Rendall (Berkeley and Los Angeles: University of California Press, 1984).

Gilles Deleuze and Félix Guattari, *A Thousand Plateaus: Capitalism and Schizophrenia* (1980), trans. and foreword by Brian Massumi (Minneapolis: University of Minnesota Press, 1987).

Michel Foucault, *This is Not a Pipe* (1973), trans. and ed. James Harkness (Berkeley and Los Angeles: University of California Press, 1983).

Sigmund Freud, *The Uncanny* (1919), trans. David McLintock (Harmondsworth, Middlesex: Penguin Classics, 2003).

Stuart Hall, *Representation: Cultural Representations and Signifying Practices* (London: SAGE, 1997).

Michael Hardt and Antonio Negri, *Empire* (Cambridge, MA: Harvard University Press, 2000).

Maurizio Lazzarato, 'Immaterial Labour' (1996), trans. Paul Colilli and Ed Emory, in Paolo Virno and Michael Hardt, eds., *Radical Thought in Italy* (Minneapolis: University of Minnesota Press, 1996), 132–46.

Henri Lefebvre, *The Production of Space* (1974), trans. Donald Nicholson-Smith (Oxford: Blackwell, 1991).

Jean-Luc Nancy, *The Ground of the Image* (2003), trans. Jeff Fort (New York: Fordham University Press, 2006).

Jacques Rancière, *The Emancipated Spectator*, trans. Gregory Elliott (London and New York: Verso, 2009).

Jacques Rancière, *The Politics of Aesthetics: The Distribution of the Sensible* (2004), trans. and introduction by Gabriel Rockhill (London and New York: Continuum, 2006).

Edward W. Said, *Orientalism* (New York: Vintage Books, 1979).

Susan Sontag, *On Photography* (New York: Farrar, Straus and Giroux, 1977).

Art blogs and websites
(see also the websites of print magazines:
artforum.com; blog.frieze.com/ *et al.*)
http://www.art21.org/
http://www.artcritical.com/
http://artfcity.com
http://artillerymag.com/
http://www.artlyst.com/
http://badatsports.com/
http://www.blouinartinfo.com/
http://brooklynrail.org/
http://www.contemporaryartdaily.com/
http://dailyserving.com/
http://www.dazeddigital.com/artsandculture
http://dismagazine.com/
http://www.edwardwinkleman.com/
 (*also for listings of new art blogs*)
http://www.e-flux.com/journals/
http://galleristny.com/
http://hyperallergic.com/
horrid.giff
http://www.ibraaz.org/
http://www.metamute.org/
http://rhizome.org/
http://www.thisistomorrow.info/
http://www.ubuweb.com/
http://unprojects.org.au/
http://www.vulture.com/art/
http://we-make-money-not-art.com/

Bibliography and e-sources

Michael Archer, 'Crisis, What Crisis?', *Art Monthly* 264 (Mar 2003): 1–4.

Jack Bankowsky, 'Editor's Letter', *Artforum* 10, vol. X (Sept 1993): 3.

Oliver Basciano, '10 Tips for Art Criticism', *Specularum*, 12 Jan 2012; http://spectacularum. blogspot.co.uk/2012/01/10-tips-for-art-criticism-from-oliver.html.

Sylvan Barnet, *A Short Guide to Writing About Art* (Boston, MA: Pearson/Prentice Hall, 2011).

Andy Beckett, 'A User's Guide to Artspeak', *Guardian*, 17 Jan 2013; http://www. guardian.co.uk/artanddesign/2013/jan/27/ users-guide-international-art-english.

Eugenia Bell and Emily King, 'Collected Writings' (on historic art magazines), *frieze* 100 (Jun–Aug 2006), http://www.frieze.com/issue/article/ collected_writings/.

Walter Benjamin, 'The Writer's Technique in Thirteen Theses' (1925–26), trans. Edmund Jephcott and Kingsley Shorter, from 'One-Way Street', in *One-Way Street and Other Writings* (London: NLB, 1979), 64–65.

Daniel Birnbaum and Isabelle Graw, eds., *Canvases and Careers Today: Criticism and Its Markets* (Berlin: Sternberg Press, 2008).

'Editorial: Mind your language', *Burlington* 1320, vol. 155 (Mar 2013).

Jack Burnham, 'Problems of Criticism', in *Idea Art: A Critical Anthology*, Gregory Battcock, ed. (New York: Dutton, 1973), 46–70.

David Carrier, *Rosalind Krauss and American Philosophical Art Criticism: From Formalism to Beyond Postmodernism* (Westport, CT: Praeger, 2002).

—*Writing about Visual Art* (New York: Allworth, 2003).

T.J. Clark, *The Sight of Death: An Experiment in Art-writing* (New Haven: Yale University Press, 2008).

Thomas Crow, *Painters and Public Life in Eighteenth-Century Paris* (New Haven and London: Yale University Press, 1985).

Arthur C. Danto, 'From Philosophy to Art Criticism', *American Art* 1, vol. 16 (Spring 2002): 14–17.

Denis Diderot, 'Salon de 1765', in *Denis Diderot: Selected Writings on Art and Literature*, trans. Geoffrey Bremner (London: Penguin, 1994), 236–39.

Georges Didi-Huberman, 'The History of Art Within the Limits of its Simple Practice' (1990), *Confronting Images: Questioning the Limits of*

a Certain History of Art, trans. John Goodman (PA: Pennsylvania State University Press, 2005), 11–52.

James Elkins, What Happened to Art Criticism? (Chicago, IL: Prickly Paradigm, 2003).

—and Michael Newman, eds., The State of Art Criticism (New York; Oxford: Routledge, 2008).

Hal Foster, 'Art Critics in Extremis', in Design and Crime (London; New York: Verso, 2003), 104–22.

Dan Fox, 'Altercritics', frieze blog, Feb 2009; http://blog.frieze.com/altercritics/.

frieze editors, 'Periodical Tables (Part 2)', Frieze 100 (Jun–Aug 2006); http://www.frieze.com/issue/article/periodical_tables_part_2/.

Maria Fusco, Michael Newman, Adrian Rifkin, and Yve Lomax, '11 Statements Around Art-writing', frieze blog, 10 October 2011; http://blog.frieze.com/11-statements-around-art-writing/.

Dario Gamboni, 'The Relative Autonomy of Art Criticism', in Art Criticism and its Institutions in Nineteenth-Century France, ed. Orwicz (Manchester University Press, 1994), 182–94.

Orit Gat, 'Art Criticism in the Age of Yelp', Rhizome, 12 Nov 2013; http://rhizome.org/editorial/2013/nov/12/art-criticism-age-yelp/.

Eric Gibson, 'The Lost Art of Writing About Art', Wall Street Journal, 18 Apr 2008; http://online.wsj.com/article/SB120848379018525199.html#printMode.

Boris Groys, 'Critical Reflections', in Art Power (Cambridge, MA: MIT Press, 2008), 111–29.

— in conversation with Brian Dillon, 'Who do You Think You're Talking To?', frieze 121 (Mar 2009); https://www.frieze.com/issue/article/who_do_you_think_youre_talking_to/.

Philip A. Hartigan, 'How (Not) to Write Like an Art Critic', hyperallergic, 22 Nov 2012; http://hyperallergic.com/60675/how-not-to-write-like-an-art-critic/.

Jonathan Harris, The New Art History: A Critical Introduction (London: Routledge, 2001).

Eleanor Heartney, 'What Are Critics For?', American Art 1, vol. 16 (Spring 2002): 4–8.

Mostafa Heddaya, 'When Artspeak Masks Oppression', hyperallergic, 6 Mar 2013; http://hyperallergic.com/66348/when-artspeak-masks-oppression/.

Martin Heidegger, 'The Thing', in Poetry, Language, Thought, trans. and introduction Albert Hofstadter (New York and London: Harper and Row, 1975), 161–84.

Jennifer Higgie, 'Please Release Me', frieze 103 (Nov–Dec 2005); https://www.frieze.com/issue/article/please_release_me/.

Margaret Iversen and Stephen Melville, Writing Art History: Disciplinary Departures (Chicago, IL: University of Chicago Press, 2010).

Amelia Jones, '"Every Man Knows Where and How Beauty Gives Him Pleasure": Beauty Discourse and the Logic of Aesthetics', in Aesthetics in a Multicultural Age, Emory Elliot, Louis Freitas Caton, and Jeffrey Rhyne, eds. (Oxford; New York: Oxford University Press, 2002), 215–40.

Jonathan Jones, 'What is the point of art criticism?', Guardian art blog, 24 April 2009; http://www.guardian.co.uk/artanddesign/jonathanjonesblog/2009/apr/24/art-criticism.

John Kelsey, 'The Hack', in Birmbaum and Graw, eds., Canvases and Careers Today: Criticism and its Markets (Berlin: Sternberg Press, 2008), 65–74.

Jeffrey Khonsary and Melanie O'Brien, eds., Judgment and Contemporary Art Criticism (Vancouver: 'Folio Series', Artspeak/Filip, 2011).

Pablo Lafuente, 'Notes on Art Criticism as a Practice', ICA blog, 4 December 2008; http://www.ica.org.uk/blog/notes-art-criticism-practice-pablo-lafuente.

David Levi Strauss, 'From Metaphysics to Invective: Art Criticism as if it Still Matters', The Brooklyn Rail, 3 May 2012; http://www.brooklynrail.org/2012/05/art/from-metaphysics-to-invective-art-criticism-as-if-it-still-matters

Les Levine, reply to Robert Hughes, 'The Decline and Fall of the Avant-garde', in Idea Art: A Critical Anthology, ed. Gregory Battcock (New York: Dutton, 1973), 194–203.

Alisa Luxenberg, 'Further Light on the Critical Reception of Goya's Family of Charles IV as

Caricature', *Artibus et Historiae* 46, vol. 23 (2002): 179–82.

Maurice Merleau-Ponty, 'Eye and Mind', in *The Merleau-Ponty Reader: Philosophy and Painting*, ed. Galen Johnson (Evanston, IL: Northwestern University Press, 1993), 121–49.

W.J.T. Mitchell, 'What Is an Image?', in *Iconology: Image, Text, Ideology* (Chicago, IL: University of Chicago Press, 1986), 7–46.

Stuart Morgan, *What the Butler Saw: Selected Writings*, ed. Ian Hunt (London: Durian, 1996).

— *Inclinations: Further Writings and Interviews*, Juan Vicente Aliaga and Ian Hunt, eds. (London: Durian, 2007).

Michael Orwicz, ed., *Art Criticism and its Institutions in Nineteenth-Century France* (Manchester, UK: Manchester University Press), 1994.

James Panero, 'The Critical Moment: Abstract Expressionism's Dueling Dio', in *Humanities* 4, vol. 29 (Jul–Aug 2008); http://www.neh. gov/humanities/2008/julyaugust/feature/ the-critical-moment.

Michel Pepi, 'The Demise of *Artnet* Magazine and the Crisis in Criticism', *Artwrit* 17 (September 2012); http://www.artwrit.com/article/the-demise-of-artnet-magazine-and-the-crisis-in-criticism/.

Peter Plagens, 'At a Crossroads', in Rubinstein, ed. *Critical Mess* (Lennox, MA: Hard Press, 2006), 115–20.

Lane Relyea, 'All Over and At Once' (2003), in Rubinstein, ed., *Critical Mess* (Lennox, MA: Hard Press, 2006), 49–59.

—'After Criticism', in *Contemporary Art: 1989 to the Present*, Alexander Dumbadze and Suzanne Hudson, eds. (Oxford: Wiley-Blackwell, 2013), 357–66.

Martha Rosler, 'English and All That', *e-flux journal* 45 (May 2013); http://www.e-flux.com/journal/ english-and-all-that/.

Raphael Rubenstein, ed., *Critical Mess: Art Critics on the State of the Practice* (Lennox, MA: Hard Press, 2006).

Alix Rule and David Levine, 'International Art English', *Triple Canopy* 16 (17 May–30 Jul 2012); http://canopycanopycanopy.com/16/ international_art_english.

John Ruskin, *Modern Painters IV*, vol. 3 (1856), in *The Genius of John Ruskin: Selection from His Writings*, ed. John D. Rosenberg (Charlottesville, VA: University of Virginia Press, 1998), 91.

Peter Schjeldahl, 'Dear Profession of Art Writing' (1976), in *The Hydrogen Jukebox: Selected Writings of Peter Schjeldahl, 1978–1990*, ed. Malin Wilson (Berkeley and Los Angeles; London: University of Califormia Press, 1991), 180–86.

Barry Schwabsky, 'Criticism and Self Criticism', *The Brooklyn Rail*, (Dec 2012–Jan 2013); http://www.brooklynrail.org/2012/12/artseen/ criticism-and-self-criticism.

Martha Schwendener, 'What Crisis? Some Promising Futures for Art Criticism', *The Village Voice*, 7 January 2009; http://www.villagevoice. com/2009-01-07/art/what-crisis-some-promising-futures-for-art-criticism/.

Richard Shone and John Paul Stonard, eds., *The Books that Shaped Art History* (London and New York: Thames & Hudson, 2013).

Daniel A. Siedell, 'Academic Art Criticism', in Elkins and Newman, eds., *The State of Art Criticism* (New York; Oxford: Routledge, 2008), 242–44.

Michael Shreyach, 'The Recovery of Criticism', in Elkins and Newman, eds., *The State of Art Criticism* (New York; Oxford: Routledge, 2008), 3–26.

Susan Sontag, 'Against Interpretation' (1964), *Against Interpretation* (Toronto: Doubleday, 1990), 3–14.

Hito Steyerl, 'International Disco Latin', *e-flux journal* 45 (May 2013); http://www.e-flux.com/journal/ international-disco-latin/.

William Strunk, Jr., and E.B. White, *The Elements of Style*, 4th edn. (New York: Longman, 1999).

András Szántó, ed., *The Visual Art Critic: A Survey of Art Critics at General-Interest New Publications in America* (New York: National Arts Journalism Program, Columbia University, 2002); http://www. najp.org/publications/researchreports/tvac.pdf.

—'The Future of Arts Journalism', *Studio360*, 15 May

2009; http://www.studio360.org/2009/may/15/.

Sam Thorne, 'Call Yourself a Critic?', *frieze* 145 (March 2012); http://www.frieze.com/issue/article/call-yourself-a-critic/.

Lionello Venturi, *History of Art Criticism*, trans. Charles Marriott (New York: Dutton, 1936).

Jan Verwoert, 'Talk to the Thing', in Elkins and Newman, eds., *The State of Art Criticism* (New York; Oxford: Routledge, 2008), 342–47.

David Foster Wallace, *Consider the Lobster and Other Essays* (London: Abacus, 2005).

Lori Waxman and Mike D'Angelo, 'Reinventing the Critic', *Studio 360*, 15 May 2009; http://www.studio360.org/2009/may/15/.

Richard Wrigley, *The Origins of French Art Criticism: From the Ancien Régime to the Restoration* (Oxford: Clarendon, 1993).

Theodore F. Wolff and George Geahigan, *Art Criticism and Education* (Urbana, IL: University of Illinois, 1997).

John Yau, 'The Poet as Art Critic', *The American Poetry Review* 3, vol. 34 (May–Jun 2005): 45–50.

List of Source Texts

1 **Walter Benjamin**, 'Theses on the History of Philosophy' (1940), trans. Harry Zohn, in *Illuminations*, ed. Hannah Arendt (London: Pimlico, 1999), 249.

2 **Okwui Enwezor**, 'Documents into Monuments: Archives as Meditations on Time', in *Archive Fever: Photography between History and the Monument*, ed. Enwezor (New York: International Center for Photography; Göttingen: Steidl, 2008), 23–26.

3 **Thomas Crow**, *The Rise of the Sixties* (1996) (London: Laurence King, 2004), 23–24.

4 **Rosalind Krauss**, 'Cindy Sherman: Untitled' (1993); first published in *Cindy Sherman 1975–1993* (New York: Rizzoli International, 1993); in *Bachelors* (Cambridge, MA: MIT Press, 2000), 118; 122.

5 **Jerry Saltz**, '20 Things I Really Liked at the Art Fairs', *New York Magazine*, 25 March 2013; http://www.vulture.com/2013/03/saltz-armory-show-favorites.html.

6 **David Sylvester**, 'Picasso and Duchamp' (1989, revised from a 1978 lecture); previously published as 'Bicycle Parts', in *Scritti in onore di Giuliano Briganti* (Milan: Longanesi, 1990); *Modern Painters* 4, vol. V, 1992; in *About Modern Art: Critical Essays 1948–96* (London: Chatto & Windus, 1996), 417.

7 **Stuart Morgan**, 'Playing for Time', in *Fiona Rae* (London: Waddington Galleries, 1991), n.p.

8 **Dale McFarland**, 'Beautiful Things: On Wolfgang Tillmans', *frieze* 48 (Sept–Oct 1999); http://www.frieze.com/issue/article/beautiful_things/.

9 **Hito Steyerl**, 'In Defense of the Poor Image', *e-flux journal* 10 (November 2009), n.p.; http://www.e-flux.com/journal/in-defense-of-the-poor-image/.

10 **John Kelsey**, 'Cars. Women', in *Peter Fischli & David Weiss: Flowers & Questions: A Retrospective* (London: Tate, 2006), 49–52; 50–51.

11 **Leo Steinberg**, 'The Flatbed Picture Plane', from a lecture at the Museum of Modern Art, New York, 1968; first published as 'Reflections on the State of Criticism', *Artforum* 10, no. 7 (March 1972): 37–49; reprinted in *Other Criteria: Confrontations with Twentieth-Century Art* (Chicago, IL: University of Chicago Press, 2007), 61–98.

12 **Manthia Diawara**, 'Talk of the Town: Seydou Keïta' (1998); first published in *Artforum* 6, vol. 36, February 1998; in Olu Oguibe and Okwui Enwezor, eds., *Reading the Contemporary: African Art from Theory to the Marketplace* (London: Iniva, 1999), 241.

13 **Brian Dillon**, 'Andy Warhol's Magic Disease', in *Tormented Hope: Nine Hypochondriac Lives* (London: Penguin, 2009), 238.

14 Dave Hickey, 'Fear and Loathing Goes to Hell', *This Long Century*, 2012. http://www.thislongcentury.com/?p=958&c=13.

15 Michael Fried, citing Tony Smith, 'Art and Objecthood', *Artforum* 5 (June 1967): 12–23.

16 Claire Bishop, *Artificial Hells: Participatory Art and the Politics of Spectatorship* (London: Verso, 2012), 256–57.

17 Negar Azimi, 'Fluffy Farhad', *Bidoun* 20 (Spring 2010); http://www.bidoun.org/magazine/20-bazaar/fluffy-farhad-by-negar-azimi/.

18 Erik Wenzel, '100% Berlin', *ArtSlant*, 22 April 2012; http://www.artslant.com/ber/articles/show/30583.

19 Chris Kraus, 'Untreated Strangeness', *Where Art Belongs* (Los Angeles: Semiotext[e], 2011), 145–46.

20 Jon Thompson, 'New Times, New Thoughts, New Sculpture', first published in *Gravity and Grace: The Changing Condition of Sculpture 1965–1975* (London: Hayward, 1993); in *The Collected Writings of Jon Thompson*, Jeremy Akerman and Eileen Daly, eds. (London: Ridinghouse, 2011), 92–123.

21 Brian O'Doherty, 'Boxes, Cubes, Installation, Whiteness and Money', in *A Manual for the 21st Century Art Institution* (Cologne: Koenig; London: Whitechapel, 2009), 26–27.

22 Miwon Kwon, 'One Place After Another: Notes on Site Specificity', *October* vol. 80 (Spring 1997): 85–110.

23 Charlotte Burns, 'Artists take to the streets as Brazilians demand spending on services, not sport', *The Art Newspaper* 248 (Jul–Aug 2013): 3.

24 unsigned, 'Hong Kong Spring Sales Reach More Solid Ground', *Asian Art* (May 2013): 1; http://www.asianartnewspaper.com/sites/default/files/digital_issue/AAN%20MAY2013%20web.pdf.

25 Martin Herbert, 'Richard Serra', *Frieze Art Fair Yearbook* (London: Frieze, 2008–9), n.p.

26 Christy Lange, 'Andrew Dadson', *Frieze Art Fair Yearbook* (London: Frieze, 2008–9), n.p.

27 Vivian Rehberg, 'Aya Takano', *Frieze Art Fair Yearbook* (London: Frieze, 2008–9), n.p.

28 Mark Alice Durant and Jane D. Marsching, 'Out-of-Sync', in *Blur of the Otherworldy: Contemporary Art, Technology and the Paranormal* (Baltimore, MD: Center for Art and Visual Culture, University of Maryland, 2006), 134.

29 Izzy Tuason, 'Seth Price', *The Guidebook*, *dOCUMENTA (13)* (Ostfildern: Hatje Kantz Verlag, 2012), 264.

30 unsigned, 'Decorative Newsfeeds', Thomson & Craighead, 2004, British Council Collection website, n.d.; http://collection.britishcouncil.org/collection/artist/5/19193/object/49377.

31 unsigned, 'Stan Douglas wins the 2013 Scotiabank Photography Award', Scotiabank website, 16 May 2013; http://www.scotiabank.com/photoaward/en/files/13/05/Stan_Douglas_wins_the_2013_Scotiabank_Photography_Award.html.

32 unsigned, 'Harun Farocki. Against What? Against Whom?', Raven Row website, November 2009; http://www.ravenrow.org/exhibition/harunfarocki/.

33 unsigned, 'Robin Rhode: The Call of Walls', National Gallery of Victoria website, May 2013; http://www.ngv.vic.gov.au/whats-on/exhibitions/exhibitions/robin-rhode.

34 unsigned, 'Jean Dubuffet (1901–1985), *La Fille au Peigne* (1950)', *Christie's Postwar and Contemporary Art Evening Sale*, 12 November 2008, New York.

35 Alice Gregory, 'On the Market', *n+1 Magazine*, 1 March 2012; http://nplusonemag.com/on-the-market.

36 Hilton Als, 'Daddy', May 2013, http://www.hiltonals.com/2013/05/daddy/.

37 Jan Verwoert, 'Neo Rauch at David Zwirner Gallery', *frieze* 94 (October 2005), http://www.frieze.com/issue/review/neo_rauch1/.

38 Roberta Smith, 'The Colors and Joys of the Quotidian', *New York Times*, 28 February 2013; http://www.nytimes.com/2013/03/01/arts/design/

lois-dodd-catching-the-light-at-portland-museum-in-maine.html?pagewanted=1.

39 Sally O'Reilly, 'Review: *Seven Days in the Art World*', *Art Monthly* (November 2008): 32.

40 Jack Bankowsky, 'Previews: Haim Steinbach', *Artforum* vol. 51 no. 9 (May 2013): 155.

41 Ben Davis, 'Frieze New York Ices the Competition with its First Edition on Randall's Island', *BlouinArtinfo*, 4 May 2012; http://www.blouinartinfo.com/news/story/802849/frieze-new-york-ices-the-competition-with-its-first-edition-on.

42 Ben Davis, 'Speculations on the Production of Social Space in Contemporary Art, with Reference to Art Fairs', *BlouinArtinfo*, n.p., 10 May 2012; http://www.blouinartinfo.com/news/story/803293/speculations-on-the-production-of-social-space-in-contemporary-art-with-reference-to-art-fairs.

43 Don Thompson, *The $12 Million Stuffed Shark: The Curious Economics of Contemporary Art and Auction Houses* (London: Aurum, 2008), 13–14.

44 Dave Hickey, 'Orphans', *Art in America* (January 2009): 35–36.

45 Adam Szymczyk, 'Touching from a Distance: on the Art of Alina Szapocznikow', *Artforum* vol. 50, no. 3 (November 2011), 220.

46 Iwona Blazwick, 'The Found Object', in *Cornelia Parker* (London and New York: Thames & Hudson, 2013), 32–33.

47 Alex Farquharson, 'The Avant Garde, Again', in *Carey Young, Incorporated* (London: Film & Video Umbrella, 2002); http://www.careyyoung.com/essays/farquharson.html.

48 Lynne Tillman, 'Portrait of a Young Painter Levitating', in *Karin Davie: Selected Works* (New York: Rizzoli and Albright Knox Museum, Buffalo, NY, 2006), 149.

49 T.J. Demos, 'Art After Nature: on the Post-Natural Condition', *Artforum* 50, no. 8 (Apr 2012): 191–97.

50 Anne Truitt, 'Daybook: The Journal of an Artist, 1974–79', in Kristine Stiles and Peter Selz, eds.,

Theories and Documents of Contemporary Art: A Sourcebook of Artists' Writings, 2nd edn. (Berkeley and Los Angeles: University of California Press, 2012, revised and expanded by Kristine Stiles), 100.

51 Jennifer Angus, 'Artist statement', The Centre for Contemporary Canadian Art website, n.d.; http://ccca.concordia.ca/statements/angus_statement.html.

52 Tacita Dean, 'Palast, 2004', in Jean-Christophe Royoux, *Tacita Dean* (London: Phaidon, 2006), 133.

53 Anri Sala, 'Notes for *Mixed Behaviour*' (2003) Mark Godfrey, *Anri Sala* (Phaidon, 2006), 122.

54 Anke Kempes, 'Sarah Morris', in *Art Now: The New Directory to 136 International Contemporary Artists*, vol. 2, Uta Grosenick and Burkhard Riemschneider, eds. (Cologne and London: Taschen, 2005), 196.

55 Ted Mann, '*Mandalay Bay (Las Vegas)*: Sarah Morris', *Guggenheim Collection Online*, n.d.; http://www.guggenheim.org/new-york/collections/collection-online/artwork/9426?tmpl=component&print=1.

56 Adrian Searle, 'Life thru a lens', *Guardian*, 4 May 1999; http://www.theguardian.com/culture/1999/may/04/artsfeatures4.

57 Alex Farquharson, 'Review of "Painting Lab"', *Art Monthly* 225 (April 1999): 34–36.

58 Gaby Wood, 'Cinéma Vérité: Gaby Wood meets Sarah Morris', *Observer*, 23 May 2004; http://www.theguardian.com/artanddesign/2004/may/23/art2.

59 Christopher Turner, 'Beijing City Symphony: On Sarah Morris', *Modern Painters* (Jul–Aug 2008): 57.

60 Michael Bracewell, 'A Cultural Context for Sarah Morris', in *Sarah Morris: Modern Worlds* (Oxford: Museum of Modern Art; Leipzig: Galerie für Zeitgenössische Kunst; Dijon: Le Consortium, 1999), n.p.

61 Jan Winkelmann, 'A Semiotics of Surface', in *Sarah Morris: Modern Worlds*, trans. Tas Skorupa (Oxford: Museum of Modern Art;

Leipzig: Galerie für Zeitgenössische Kunst;
Dijon: Le Consortium, 1999), n.p.

62 Isabelle Graw, 'Reading the Capital: Sarah
Morris' New Pictures', trans. Catherine
Schelbert, in Ingvild Goetz and Rainald
Schumacher, eds., *The Mystery of Painting*
(Munich: Kunstverlag Ingvild Goetz, 2001), 79.

63 Douglas Coupland, 'Behind the Glass Curtain',
in *Sarah Morris: Bar Nothing* (London: White
Cube, 2004), n.p.

64 Sarah Morris, 'A Few Observations on Taste or
Advertisements for Myself', in *Texte zur Kunst*
75 (September 2009): 71–74.

List of figures

Measurements are given in centimetres followed
by inches, height before width before depth, unless
otherwise stated.

Index

First published in 2014 in paperback in the United
States of America by Thames & Hudson Inc., 500
Fifth Avenue, New York, New York 10110

thamesandhudsonusa.com

Library of Congress Catalog Card Number
2014932798

ISBN 978-0-500-29157-3

Printed and bound in China by Toppan Leefung
Printing Limited

Dedicated, with much love and a big thank you,
to Steve Ruggi.

In memory of Callie Angell, 1948–2010

Special thanks to the following, who read draft
chapters and gave me their valuable comments:
Sally O'Reilly, Marina Delaney, Tamsin Perrett,
Jacky Klein, Madeleine Ruggi, Edgar Schmitz,
Marcus Verhagen, Andrew Renton, Naomi Dines,
Iwona Blazwick, Richard Noble, Lisa LeFeuvre,
and Simon Sheikh.

Acknowledgments: Claudia Aires, David Batchelor,
Jenny Batchelor, Giovanna Bertazzoni, Ele
Carpenter, Tom Clark, Becky Conekin, Jonathan
Lahey Dronsfield, James Elkins, Ian Farr, Stephen
Friedman, Anne Gallagher, Adrian George, Cornelia
Grassi, Caro Howell, Jemima Hunt, Phyllis Lally,
Eleanor Marshall, Tom Morton, Gregor Muir, Hana
Noorali, Jill Offman, Elvira Dyangani Ose, Barnie
Page, William Paton, Claire Pauley, Andrea Philips,
Aude Raimbaud, Gary Riley-Jones, Lucy Rollins,
Alex Ross, Barry Schwabsky, Adam Smythe, John
Stack, Kate Stancliffe, Valerie Steele, Julia Tarasyuk,
Amy Watson, Celia White, and Catherine Wood.

I am grateful to all the writers, artists, translators,
and photographers whose work appears in this
book, with particular thanks to Sarah Morris.